Doris Kutschbach

LIVING MONET THE ARTIST'S GARDENS

PRESTEL
Munich · London · New York

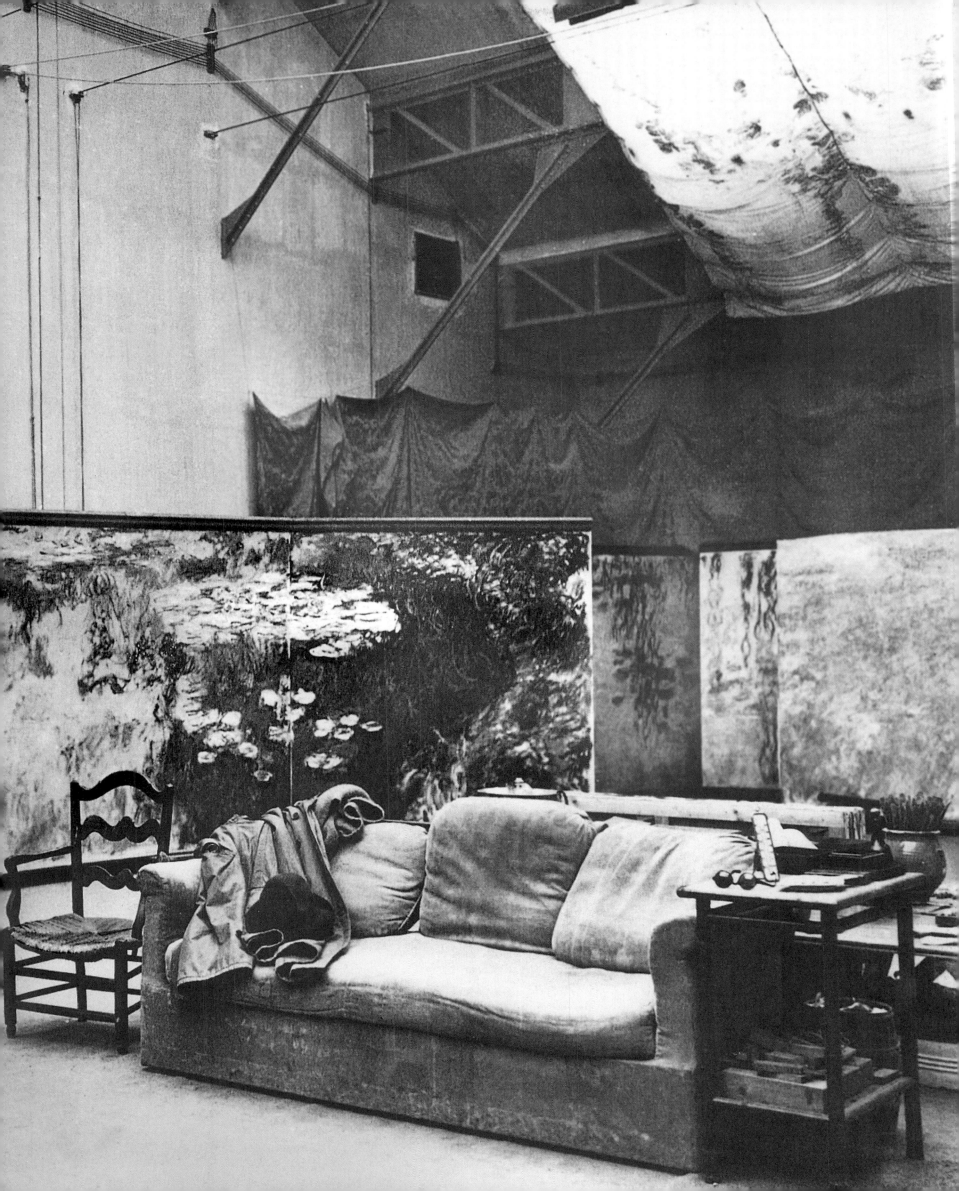

CONTENTS

LIVING LIKE MONET IN FRANCE

APPENDIX

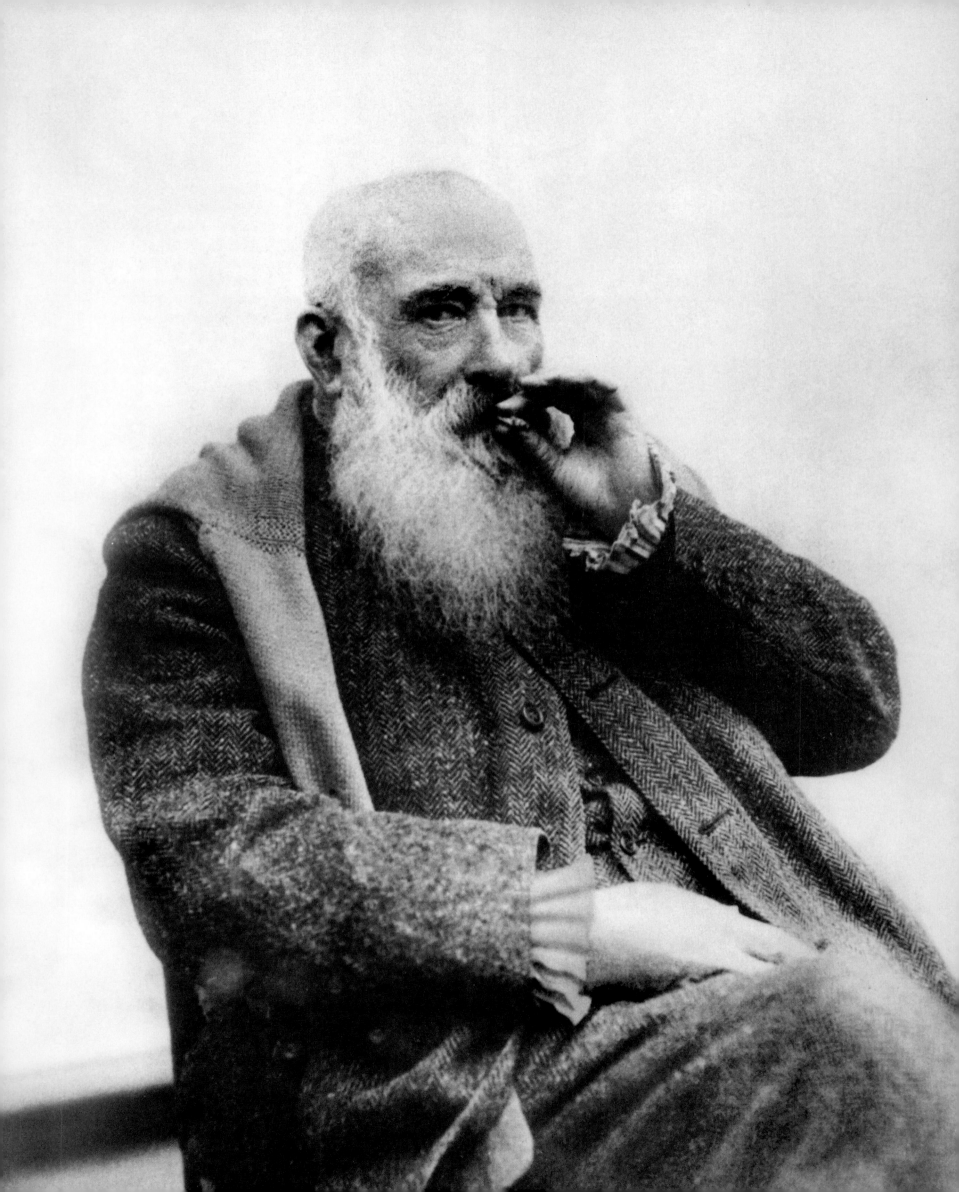

'WHAT COULD BE SAID ABOUT ME ... A MAN TO WHOM ONLY HIS PAINTING MATTERS? AND OF COURSE HIS GARDEN AND HIS FLOWERS AS WELL.'
Claude Monet

SUN-FILLED PAINTINGS OF GARDENS A sensuous delight in colour, flowers, shimmering reflections on water and, in picture after picture, water lilies: yellow, white, red and orange spots of colour on blue-green water—all this is what one associates with the name of the great Impressionist painter Claude Monet.

Countless visitors make the pilgrimage to France each year to see his paintings in the museums of Paris, while his famous garden in Giverny attracts half a million visitors annually. A village some forty-five miles north-west of Paris on the right bank of the Seine in Normandy, Giverny is the place where one can experience the life and work of the French painter most fully. However, Giverny was not the first place to awake Monet's love of gardens and plants. The gardens of the various houses he lived in appear time and again in his paintings—they had been his outdoor studio ever since he had begun to paint in the open air.

Monet spent over forty years of his life in Giverny. The house and garden there are inseparably bound up with his personality and his art.

The shaping of the garden was the artist's own labour of love over many years, which he made into a work of art like his paintings. The garden increasingly became the subject of his paintings until, eventually, it became the only subject.

The lifestyle of Monet and his wife Alice in Giverny was noted for the painter's delight in good food as much as for his love of nature and interest in art. All aspects of Monet's life, down to the exquisitely harmonised colour schemes of his house and even the matching crockery tell of a shaping mind and the painter's eye for beauty. Pictures, flowers, colours and shapes all came together in unity in the world of Claude Monet, to create a totality that is still much as he left it.

The painter in a typical pose—dressed in his comfortably tailored tweed suit with the inevitable cigarette in his mouth.

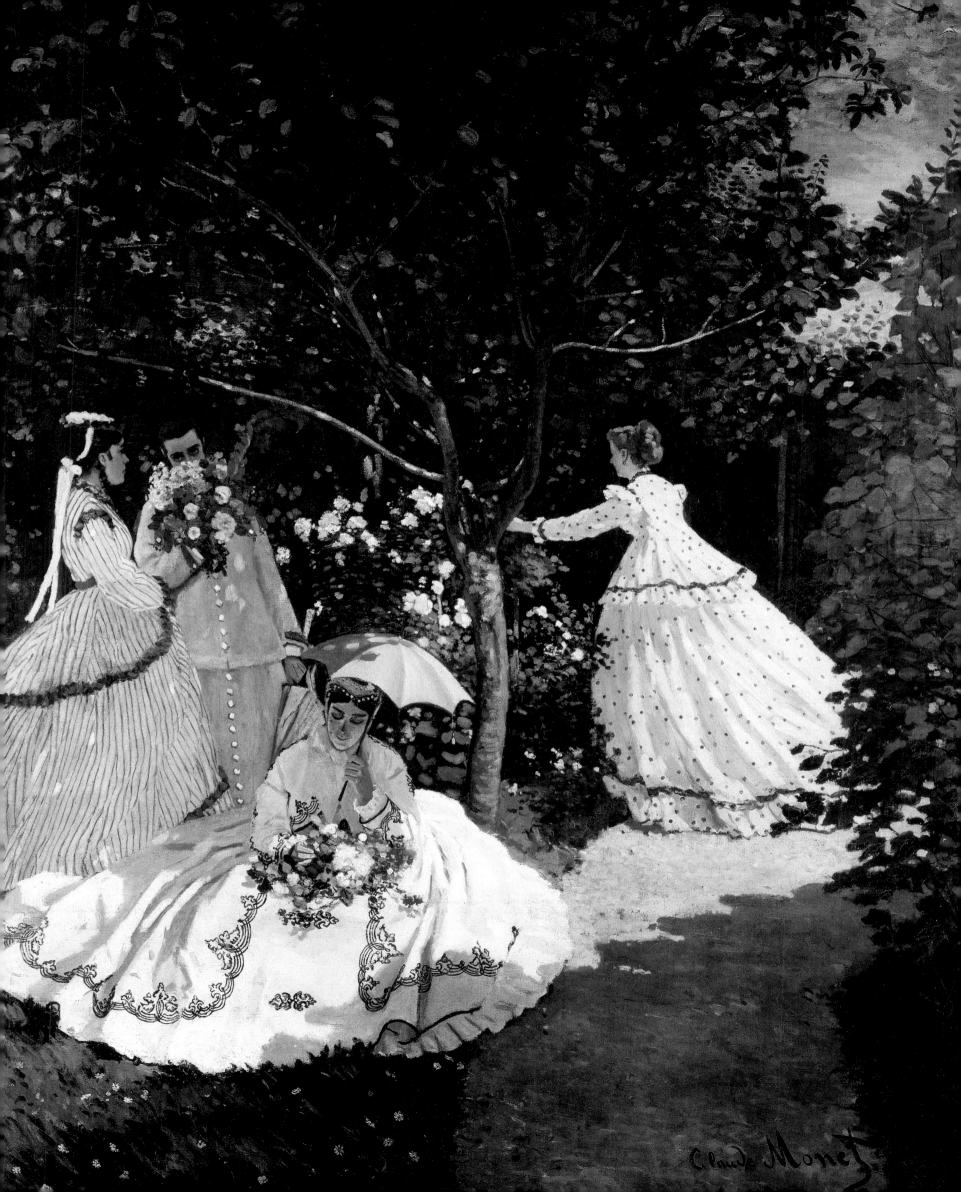

THE PAINTER'S GARDENS

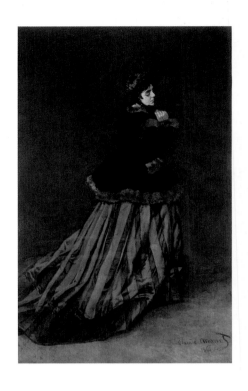

THE GARDEN AS A STUDIO
As a young painter, Monet lived from hand to mouth for many years, relying on the support of his family, as the few pictures he sold hardly provided him a living. In 1866, the young artist fled from Paris to escape his creditors, renting a house at Ville d'Avray, Sèvres, in April that year.

The garden of this house served as a setting for his early masterpiece *Women in the Garden*. This was where he first put into effect his form of *plein-air* (open-air) painting. He wanted pictures to be a direct record of the subject, thereby preserving the spontaneity of a sketch, which subsequent execution in the studio was incapable of.

Painting outdoors was by no means taken for granted in the mid-nineteenth century. It had only become possible at all since around 1840, with the invention of oil paints sold in tubes that could be easily carried around. The Barbizon School, a group of Parisian artists associated with Jean-Baptiste-Camille Corot, were the first to bring open-air painting into fashion. Previous to that, the normal practice had been to do sketches in nature and later work them up into a painting in the studio. Now, the young avant-garde artists could take their paints out into nature and record their impressions directly in oils on the canvas.

Monet began the painting of *Women in the Garden* in spring or summer 1866. With the aid of a special structure, the artist could sink the canvas in a trench in order to be able to reach the upper part of the canvas, which was over eight feet (2.5 m) high. The major parts of the painting were thus done in the garden of the house in Ville d'Avray, though the work was completed the following winter in the studio.

The two female figures to the left-hand side of the painting are recognisably Monet's favourite model of the time, nineteen-year-old Camille-Léonie Doncieux. It was a life-size portrait of her called *Camille* or *The Woman in a Green Dress*, which took him only a few days to paint in the studio in 1866, that had brought Monet his first success in the annual Salon in Paris. But when he submitted the *Women in the Garden* to the Salon committee the following year, they rejected it. It probably seemed too modern to the conservative jury members.

9

Above:
This life-size portrait of his 19-year-old mistress Camille
won Monet his first acclaim from the critics.
Camille or *The Woman in a Green Dress*, 1866. Kunsthalle, Bremen

Left:
This lovely picture comes alive from the contrast between the dark green foliage
and the brilliant white of the clothing worn by people enjoying the flowers of
summer. The white blooms of the roses infuse brightness into the shady background
like dappled sunlight. *Women in the Garden*, 1866–67. Musée d'Orsay, Paris

SUMMER IN SAINTE-ADRESSE

In summer, the young painter was a frequent and welcome visitor to the country home of the Lecadre family in Sainte-Adresse. Monet's aunt, Marie Jeanne Lecadre, played an important part in his career. She had been widowed young and had no children, so after the death of his mother she took her seventeen-year-old nephew in hand, supporting his artistic ambitions against the opposition of his father.

The model for this picture in the garden of Le Coteau,
the Lecadre family home, was a distant cousin of Monet's.
The flower bed (rear right) with the underplanted
standard roses in red and white appears in other pictures.
Jeanne-Marguerite Lecadre in the Garden, 1866.
The State Hermitage Museum, St Petersburg

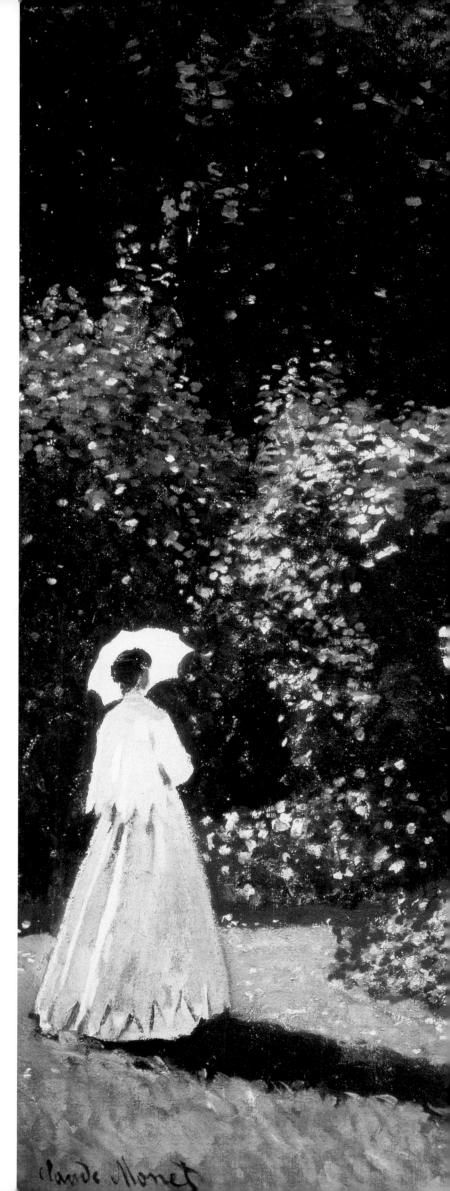

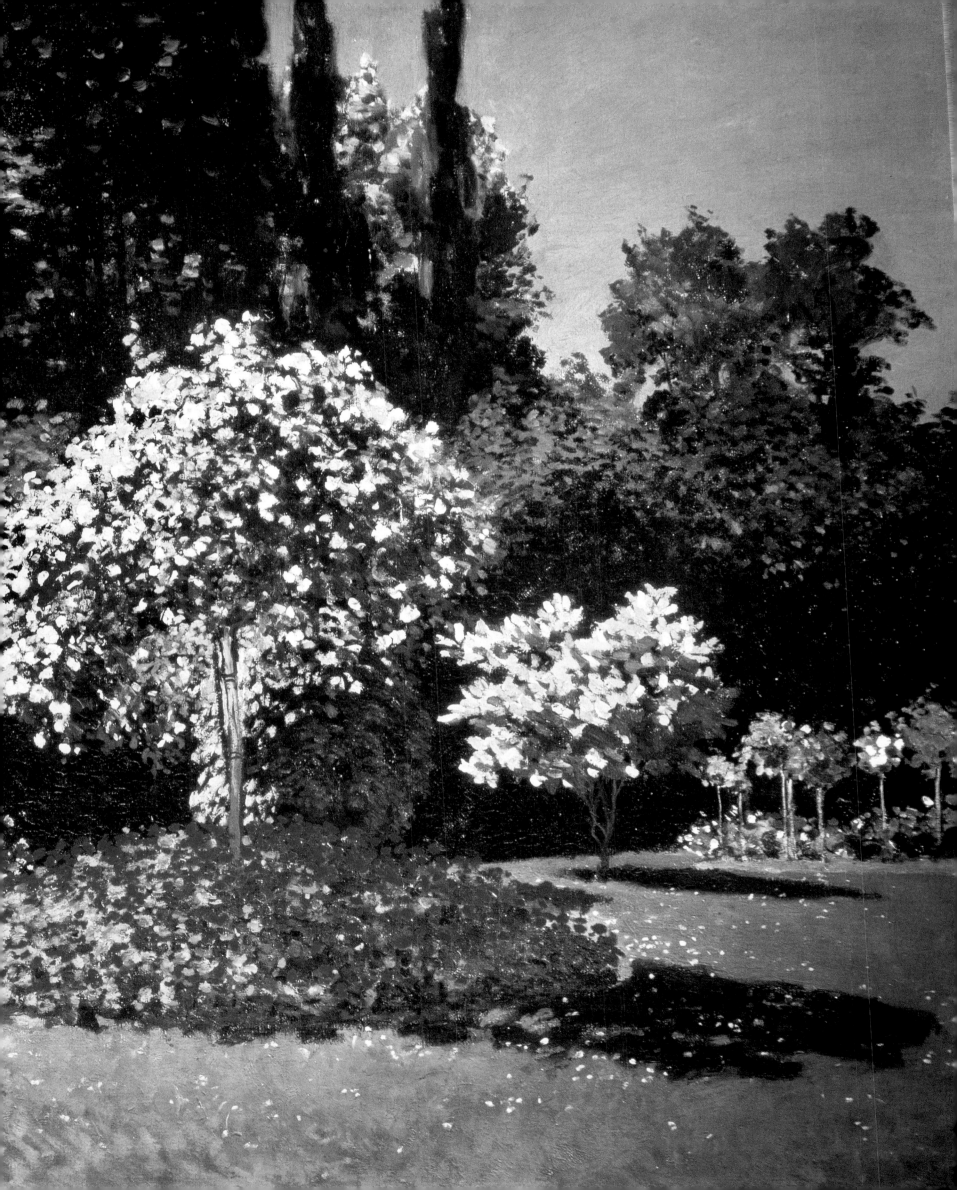

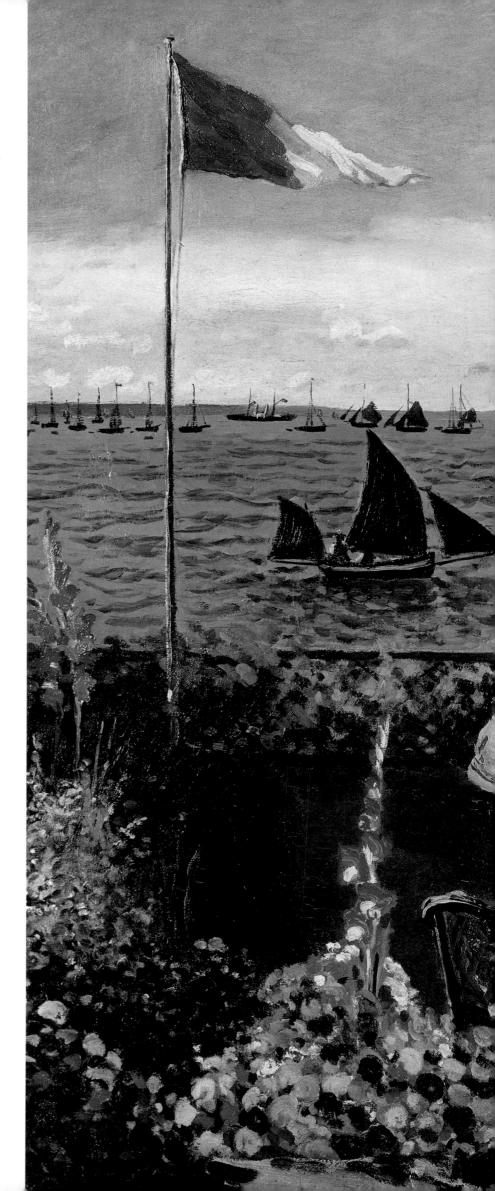

In 1866, the year the *Women in the Garden* was painted, Monet also painted the well-tended Lecadre garden. One of the pictures shows his father Adolphe Monet reading in the grass, while another features his cousin, Jeanne-Marguerite Lecadre, standing in front of a colourful flowerbed (see pp. 10–11).

Jeanne-Marguerite appears again as the young woman in front of the parapet in the painting of *Garden at Sainte-Adresse* from the following year. Monet's straitened circumstances are rarely reflected in the mood of his paintings. This picture for example is full of the cheerfulness of summer. Brightly coloured flags flutter in the wind over a gay array of red gladioli, geraniums and nasturtiums. On the terrace in the foreground of this delightful garden in Sainte-Adresse, the artist's father sits in his straw hat, peacefully gazing at the sea view. The woman in the chair beside him, hidden behind the parasol, is presumably Monet's aunt Lecadre.

Monet's family relationships, however, were not so harmonious at the time as it would seem from the picture. In April, Monet had told his father that Camille was expecting a child by him. His family was distinctly unenthusiastic about this 'immoral' connection and urged him to leave his 'mistress'. But as he was earning nowhere near enough even to support himself, let alone a wife and child, Monet had gone to Sainte-Adresse to see his aunt and seek financial help for Camille. On 8 August, while he was away, Camille gave birth to their son Jean. The rift between Camille and her son on the one side and the family on the other, on whose help he depended, would cause Monet a great deal of trouble in the years to come.

The complementary colour contrast between the fiery red of geraniums, nasturtiums and slender gladioli and the green of the plants in the foreground is a major element in the vividness and impact of this picture.
Garden at Sainte-Adresse, 1867. The Metropolitan Museum of Art, New York Purchase, special contributions and funds given or bequeathed by friends of the Museum, 1967

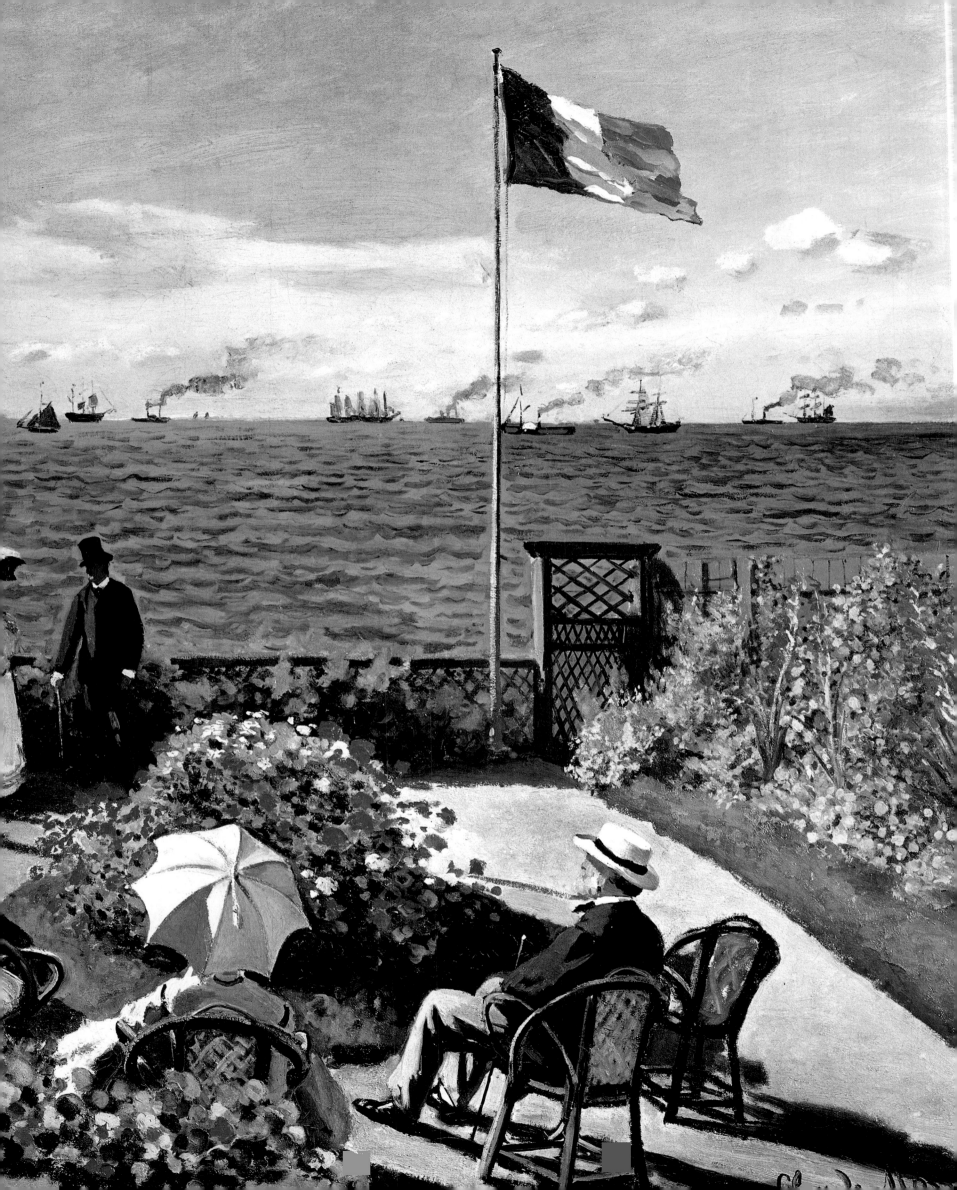

GOLDEN YEARS IN ARGENTEUIL

It took three years for Monet and Camille to get married. When they finally did, in June 1870, they did so without the approval of his family. Two tough years of poverty and artistic failure followed. To avoid being conscripted as a soldier in the Franco-Prussian War, the Monets fled to London, and later to The Netherlands. After the war was over, the young couple finally settled in the provincial town of Argenteuil, on the banks of the Seine six miles from Paris.

Monet's painted views of Argenteuil show the idyllic beauty of unspoilt nature and factory chimneys alike, an indication of nascent industrialisation, which Monet welcomed as a sign of progress. His studio in his first house in Argenteuil looked out over the Seine, which became a favourite subject. Once, when he had saved up enough money, Monet bought a small boat, which he converted into a floating studio and used to paint numerous pictures of the banks of the Seine.

In all, Claude Monet spent seven very happy years with Camille and Jean in Argenteuil, and some of his most magical garden scenes date from this period. He painted Camille and Jean in the garden, a view of Camille in a red hood through the doorway, Jean playing with a hoop between blooming flower beds and potted plants outside the house or sitting proudly on his little hobby horse—all loving snapshots by the paternal painter telling of peaceful, happy days and a harmonious family life.

A number of pictures sold well, giving Monet a break—at least for a while—from pressing existential worries, though in 1874, evidently because of financial problems, the family had to move to another house that had originally only been rented out as a studio. Overall though the life they led in Argenteuil was relatively carefree compared with earlier times. They could even afford a servant and a gardener. The paintings themselves betray no hint that they lived in impoverished circumstances—on the contrary, they give more an impression of a very comfortable middle-class life.

Camille at the window of the first house in Argenteuil, framed by summer flowers in pots and tubs. Geraniums and fuchsias pick up the red of the flowers of the climbing plants on the right, while white blooms provide highlights.
Camille at the Window, Argenteuil, 1873. Virginia Museum of Fine Arts, Richmond, Virginia

Under the influence of his garden-obsessed fellow artist Gustave Caillebotte, Monet himself developed a passion for gardening in Argenteuil that would remain with him all his life. That he himself was not above manual labour is clear from a painting by Edouard Manet, who was a good friend of Monet's. The latter is seen gardening while Camille and Jean can be seen relaxing on the grass nearby.

Several pictures by Monet in 1873 show the garden front of their first house in Argenteuil, with beds of red, blue and white flowers in front of the house. A creeper winds up the wall, while flowers bloom in the window boxes. The sand or gravel-covered area in front is decorated with potted plants in blue and white tubs. A green bench and a table in the shade are an indication of meals eaten outside. The round shapes of flower beds nestle in the bright gravel-like surface. As was the fashion then, they are densely planted with annuals such as geraniums and bordered with a strip of lawn. The shape suggests they were laid out as hillocks (see pp. 18–19). Other paintings show more beds, including some splendid dahlia plantings and lawns, lilac bushes and fruit trees in a very extensive plot of land.

The garden of the second house occupied by the painter and his family in Argenteuil was clearly smaller than the first. A winding path led here round a circular bed planted with flowers. Hollyhocks, gladioli and dahlias loomed over smaller flowers and provide a panoply of colour against the green of the trees in the background.

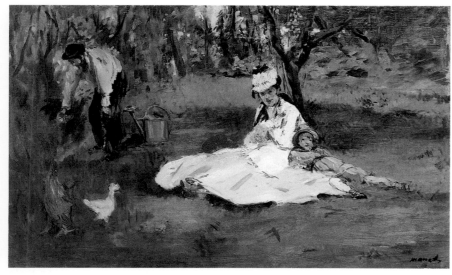

Above:
The painter working in the garden, with his wife and child. Edouard Manet recorded this idyllic scene of family life in the country at his fellow artist's house.
Edouard Manet, *The Monet Family in their Garden at Argenteuil*, 1874.
The Metropolitan Museum of Art, New York. Bequest of Joan Whitney Payson, 1975

16

Right:
A summer atmosphere—five-year-old Jean Monet and Camille in the garden of their first house in Argenteuil. At the foot of a climbing plant is a line of flowers in red and white running along the wall of the house, responding to the flowering beds in the garden. All the windows of the house have window boxes. The six large blue and white flower pots with daisies along with other flowers on the gravel area in front of the house recur quite frequently in Monet's pictures, though the plants in them vary. *The Artist's House at Argenteuil*, 1873. The Art Institute of Chicago Mr and Mrs Martin A. Ryerson Collection

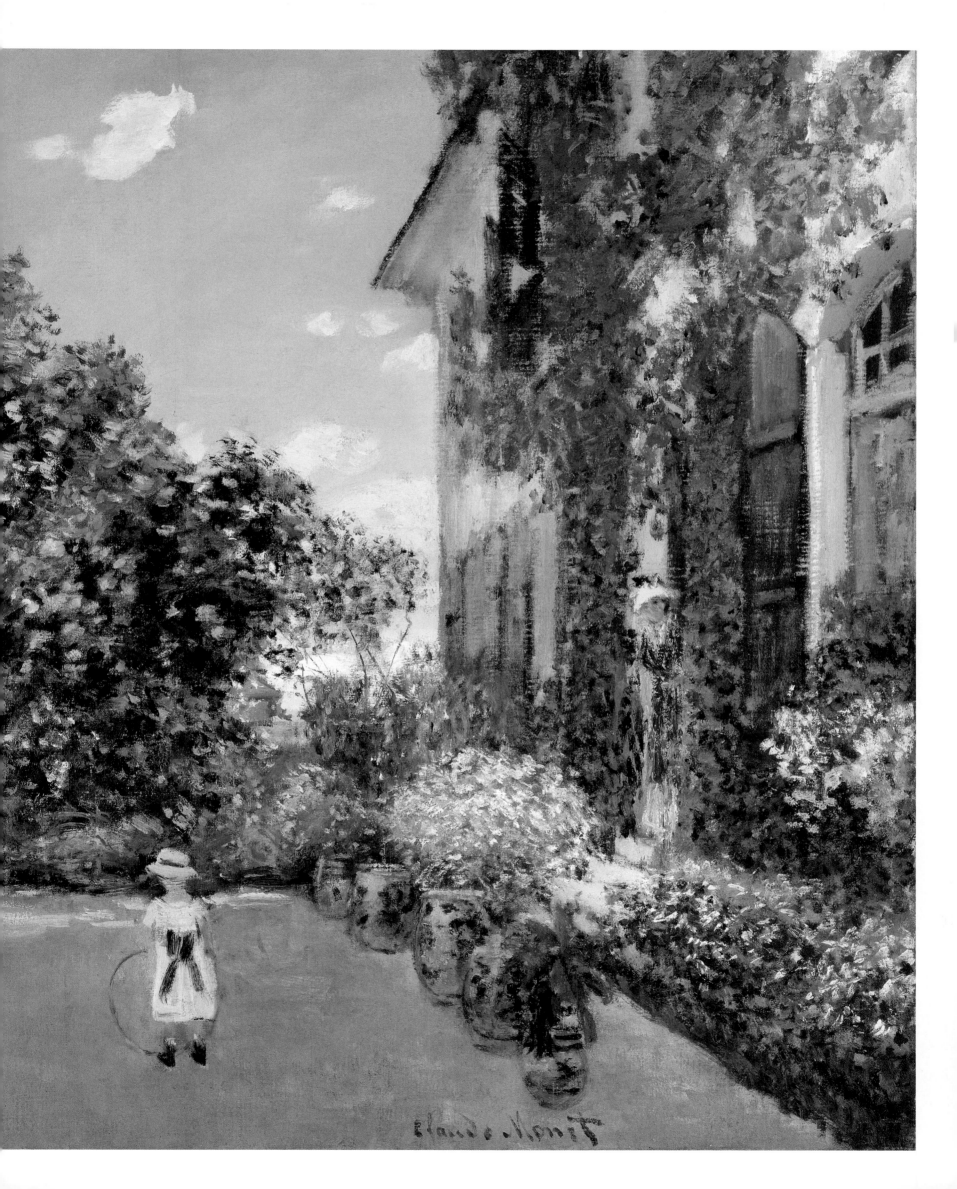

The *grand bourgeois* lifestyle—an elegantly dressed Camille in front of the well-tended bed in the first garden in Argenteuil.
The nanny looks after Jean. *Camille in the Garden with Jean and his Nanny*, 1873. Private collection, Switzerland

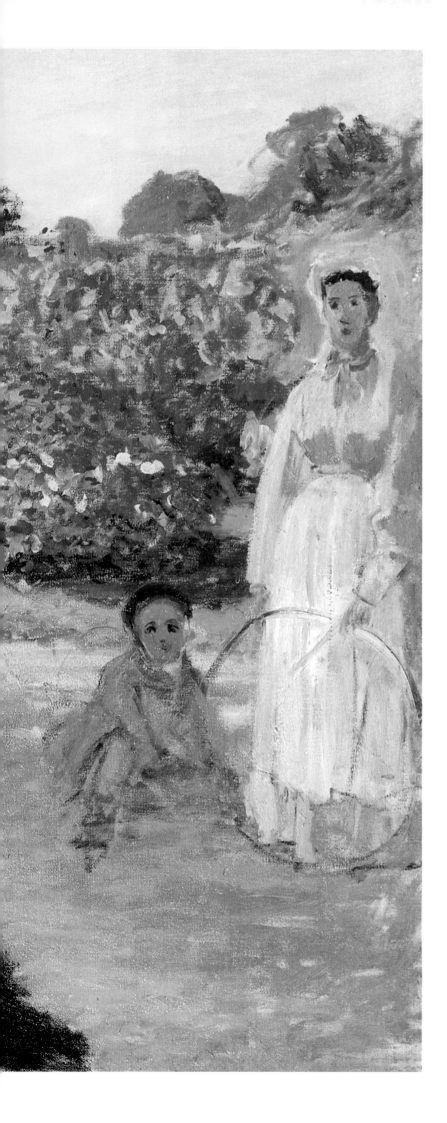

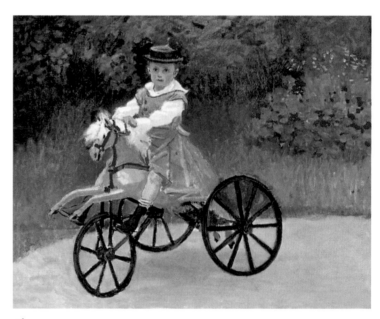

Above:
Five-year-old Jean posing in his Sunday best in the garden.
Jean Monet on His Hobby Horse, 1872.
The Metropolitan Museum of Art, New York
Gift of Sara Lee Corporation, 2000

Monet's biographer, Daniel Wildenstein, called the period in Argenteuil the 'golden age of Impressionist painting'. Impressions were what shaped Monet's art. Changing light conditions, the colours of the seasons, the various moods of different times of the day became his subject matter. The garden pictures he did in these years also show clearly what the artist was interested in—the play of patterns of light or dappled sunlight through foliage. One of the most stunning pictures of the time is *Luncheon*, which Monet painted in the flower-filled garden of the first house in Argenteuil. Jean plays peacefully in the shade beside the table where lunch has just finished. A hat is left unnoticed in a tree, a half-open handbag and a parasol lie on a bench—again, the painting records the atmosphere of a midday scene on a warm summer's day like a snapshot. The picture is imbued with an untroubled mood of summer relaxation, like the paintings his fellow artist and friend Pierre-Auguste Renoir painted of Monet, Camille and Jean in their own garden. Monet's friends Manet, Renoir and Alfred Sisley often visited Argenteuil with their families. Monet's garden also features in several of their pictures, while sometimes the artists painted each other in the garden.

Among the painters associated with Monet, Manet was the only one whose pictures were accepted at the Salon of the time. All the others encountered obdurate rejection by the official jury, particularly as they were unwilling to compromise in their art. In 1873, they therefore founded an 'anonymous artists association of painters, sculptors and draughtsmen' in order to organise a rival exhibition to the Salon, which opened at number 35 Boulevard des Capucines on 15 April 1874.

The painters who took part were labelled 'impressionists' by a mocking critic with a sharp tongue who took Monet's painting *Impression—Sunrise* (see p. 136) as his cue, thereby unwittingly giving a whole art movement a name. At the exhibition, Monet presented this key work of Impressionism along with the famous *Poppy Field near Argenteuil* (see pp. 76–77) plus seven other pictures. Even if many visitors only came to jeer and be amused—most of the positive responses were by friends of the artists—the exhibition became a milestone in art history.

Right:

20 After lunch, with the green bench in shadow and Jean playing.
Luncheon, 1873. Musée d'Orsay, Paris

Following double-page spread:
Giant dahlia blossoming in full colour in the garden of the first house in Argenteuil. The young couple look tiny in comparison. Auguste Renoir painted an almost identical view of these dahlias, with Monet at his easel instead of the couple.
The Artist's Garden in Argenteuil (A Corner of the Garden with Dahlias), 1873. National Gallery of Art, Washington, D. C. Gift of Janice H. Levin, in Honor of the 50th Anniversary of the National Gallery of Art

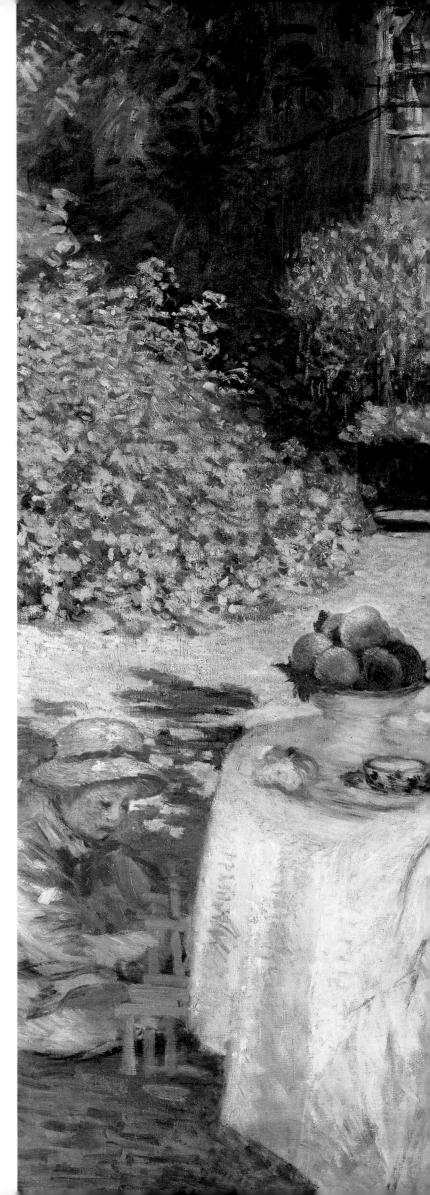

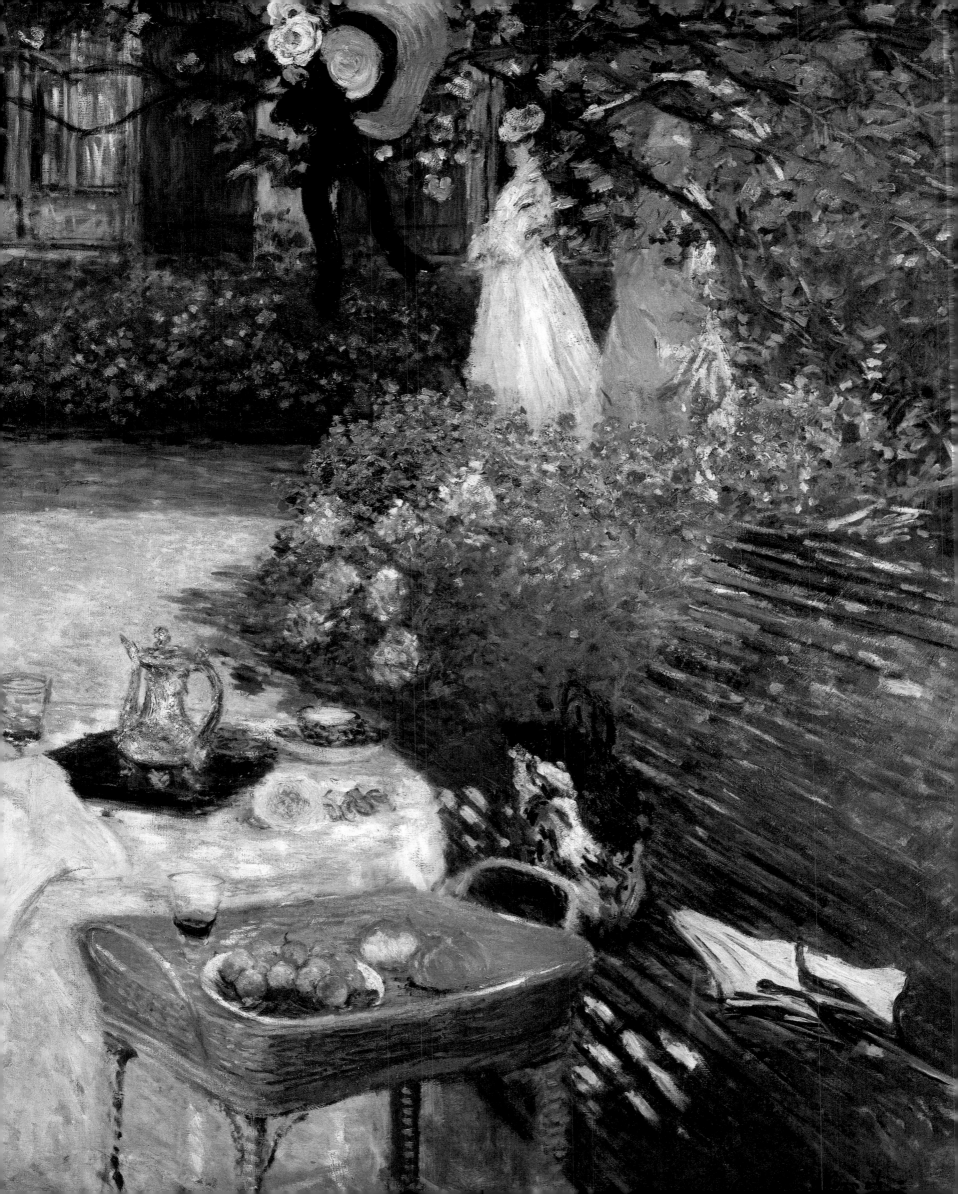

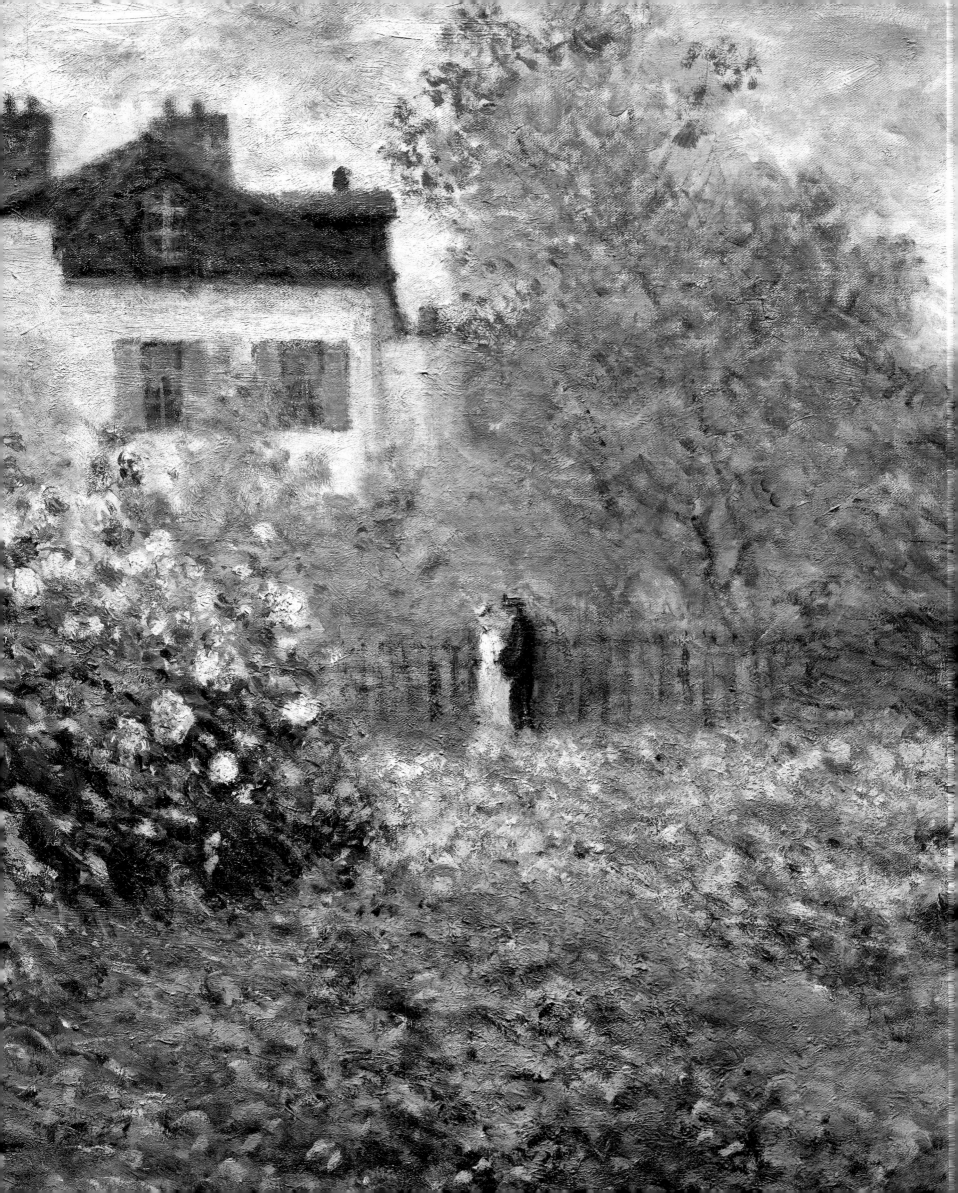

TIMES OF SORROW
Despite the recognition generated by the exhibition the general acceptance of Impressionism was still a thing of the future. The public still treated Impressionist work with contempt, and artists continued to live on the breadline. Few people were willing to put money into art of this kind.

Monet was paid preposterously low prices for his paintings, and his financial position became increasingly more difficult. Family problems and worries about his wife were added to the huge burden of debt. Camille was already in ill-health when she gave birth to their second son Michel in 1878. In that year, the family rented a house out in the country in Vétheuil, a place a little further north down the Seine. There they were joined by Alice Hoschedé and her six children Marthe, Blanche, Suzanne, Jacques, Germaine and the newborn Jean-Pierre

(1877). Alice and her husband Ernest Hoschedé were close friends of Monet and Camille, though Hoschedé, a businessman and former patron of Monet, was at the time staring financial ruin in the face and mostly spent his time elsewhere. Sharing a house was a way for two hard-pressed families to economise.

It is possible that there had at that time already been a long-standing relationship between Monet and Alice, but it only became official much later. Alice came from a very prosperous family. On the death of her

Left:
Blue shadows—Camille was recognizably ill when Monet painted her beside flowerbeds in the garden of the second house in Argenteuil. *Camille in the Garden at Argenteuil*, 1876. The Metropolitan Museum of Art, New York
The Walter H. and Leonore Annenberg Collection, Gift of Walter H. and Leonore Annenberg, 2000, Bequest of Walter H. Annenberg, 2002

The four Hoschedé girls: Suzanne, Blanche, Germaine and Marthe

25

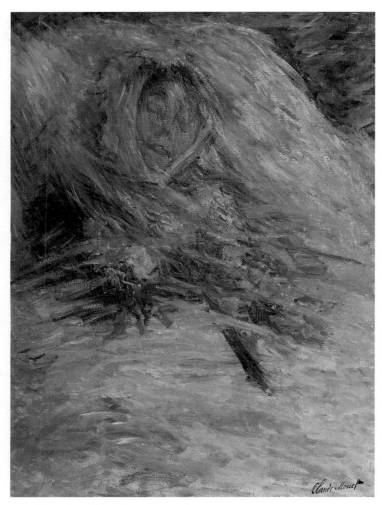

Camille died in Vétheuil on 5 September 1879 aged 32.
Camille Monet on her Deathbed, 1879. Musée d'Orsay, Paris

father she had inherited Château Rottenbourg, but later lost it when her husband's business failed. It was at the château that she had made Monet's acquaintance in 1876 and had probably been drawn to him even then, when her husband commissioned him to paint large decorative pictures with motifs from the château park in the round drawing room.

At Vétheuil, Alice threw herself unstintingly into looking after the gravely ill Camille, whose condition steadily deteriorated until, after long suffering, she died in September 1879 at the age of only thirty-two. Monet did a final portrait of her on her deathbed. He had loved Camille very much, and in his grief hid himself away at home for a long period of time. An idea of his state of mind can be gained from the still lifes he painted here, or the bleak wintry pictures of these years. And yet, despite the hard times the painter went through in Vétheuil, many of his paintings seem cheerful and carefree.

Two years after the death of Camille, Alice decided to separate from her husband. She remained with Monet and became a mother to his children, but it was not until Ernest Hoschedé died more than ten years later that Monet and Alice finally married (in 1892).

As a farewell to Vétheuil, in the summer of 1881, Monet painted several glowing pictures of the terraced garden on the slope on the other side of the road opposite the house, with its magnificent array of sunflowers and their children peacefully playing. A display of radiant yellow and blue dominates in the paintings. The figures of the children are conspicuously small amid the opulent vegetation. It is already noticeable that plant life is in the ascendant—human figures retreat more into the background of Monet's pictures as nature takes over.

In the same year, the Monet-Hoschedé household—an unusual patchwork family for the time, with eight children—moved to Poissy. After changing houses several more times and being forced to quit their last home, Monet went to Giverny in 1883 in search of somewhere more longterm to live.

Jean-Pierre Hoschedé
and Michel Monet, *c.* 1883.

Right:
Jean-Pierre Hoschedé and Michel Monet with an older girl between sunflowers and pots with gladioli. The house they lived in can be made out in the background.
The Artist's Garden at Vétheuil, 1880. National Gallery of Art, Washington, D.C.
Ailsa Mellon Bruce Collection

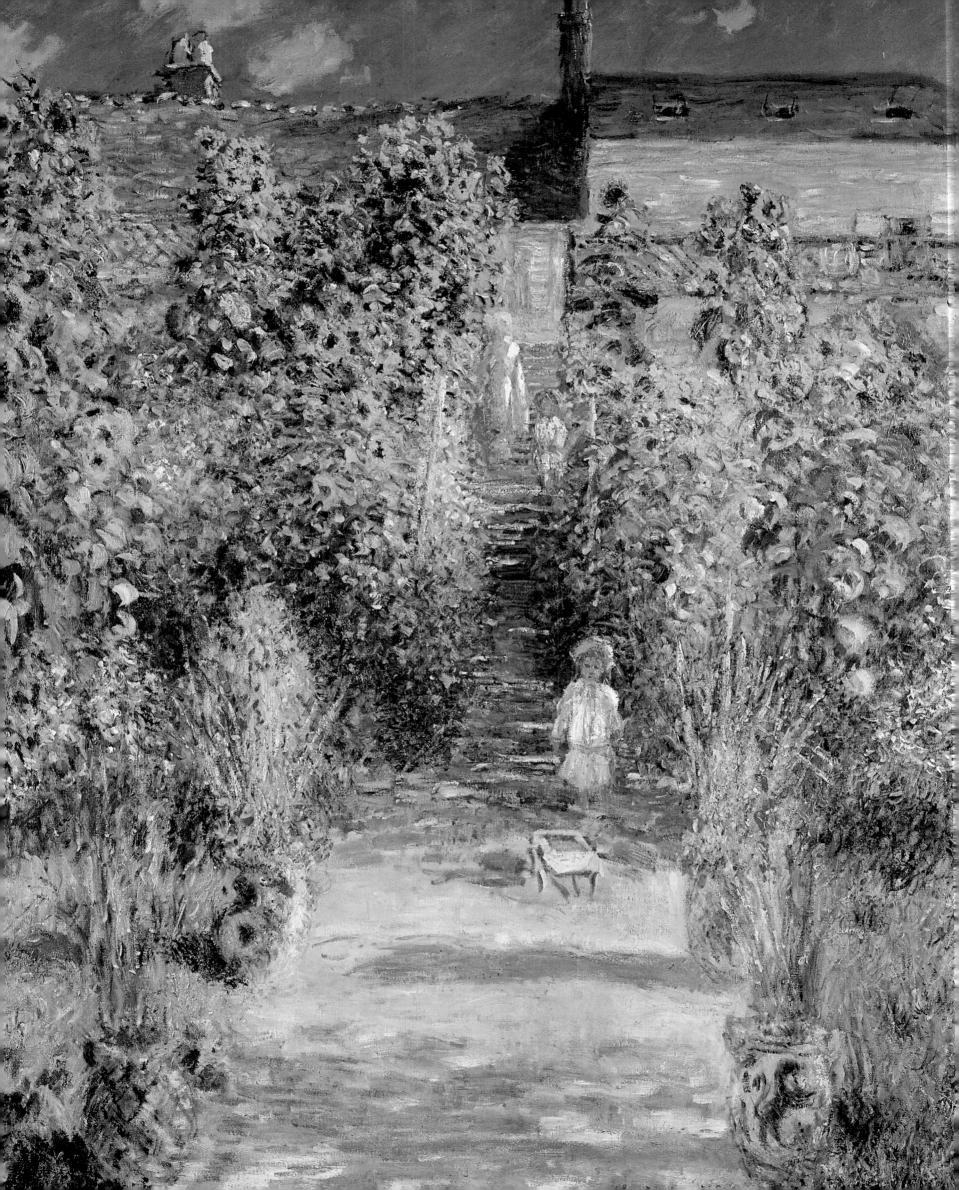

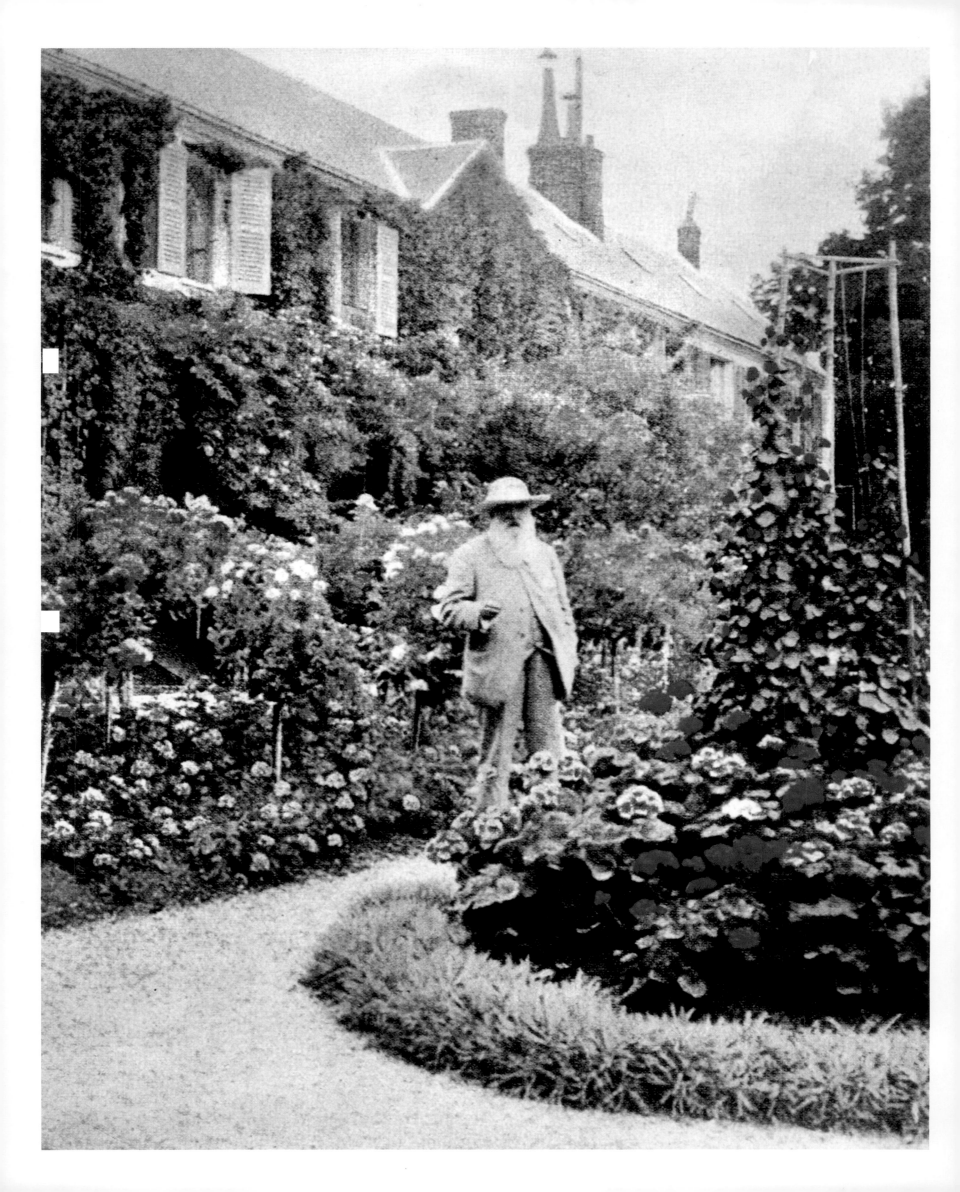

'I WORK AT MY GARDEN ALL THE TIME AND WITH LOVE. WHAT I NEED MOST ARE FLOWERS, ALWAYS. MY HEART IS FOREVER IN GIVERNY.'

Claude Monet

GIVERNY—THE MAGIC OF APPLE BLOSSOMS When he

discovered the picturesque village of Giverny on the banks of the Seine, Monet was immediately smitten. 'I'm delighted! I find Giverny a splendid area,' he wrote to his gallerist, Paul Durand-Ruel.

He soon found a large house for his ten-member household—the village's former cider press house, suitably named *Le Pressoir*. The first sight of the flourishing orchard behind the house so enchanted the painter that he took a lease on the spot, even though for the time being he did not know where the money for the move was to come from. Fortunately Durand-Ruel was on hand to help him out financially.

In the early years in Giverny, Monet explored the surrounding landscape in his paintings. The roadside poplars and haystacks in the fields were motifs he recorded at all times of the day and seasons of the year. Other paintings depicted the River Seine and poppy fields. His travels offered other subject matter—the Mediterranean landscape and sea at Antibes, the wild, craggy coast of northern France, Rouen Cathedral, the cities of London and Venice all featured in splendid series of pictures done in different lighting conditions.

Very few of the pictures from this period show his garden. In the picture *Springtime* dating from 1886 we see Suzanne, Monet's favourite model among the Hoschedé daughters, with Jean Monet under the blossoming apple trees in the garden (see pp. 30–1). Any closer link between the two remained wishful thinking. Suzanne later married the painter Theodore Earl Butler, who on her premature demise married her sister Marthe, while Jean married his stepsister Blanche Hoschedé.

The apple trees in the orchard on the western side Monet gradually replaced with Japanese flowering cherry and crab apple trees whose breathtaking display of blossoms far surpassed that of ordinary fruit-bearing trees. In spring, magnificent clumps of irises and oriental poppies transformed the meadow grass in the orchard into a see of flowers. Though times were hard at first Monet gradually began to prosper, though his first successes were in the USA. From 1886, Durand-Ruel took pictures by Monet and other French Impressionists to New York, where, unlike in France, they were greeted with enthusiasm and soon found a large clientele.

The commercial breakthrough in Europe was not until 1889, when Theo van Gogh organised solo shows for Monet in Paris and London, while Georges Petit put on a joint *Claude Monet—A. Rodin* exhibition in his gallery during the 1889 World Exhibition. In time, Monet became one of the best-known and most sought-after painters in France, and in his

Left:
The painter between the herbaceous borders outside his house, in Giverny, high summer in the 1920s. Coloured photograph

later years very rich. In 1890 he was able to buy the property in Giverny for 22,000 francs, payable in four annual instalments, and in 1893, ten years after first moving to Giverny, he bought an adjacent plot of land to construct his famous water gardens. Monet would remain in Giverny to the end of his life in 1926, spending a total of forty-three years there.

At Giverny, designing his garden became an ever-growing passion for Monet. Immediately after moving in, Monet and Alice had planted flowers and vegetables. Monet once said 'My drawing room was the barn. We all worked in the garden. I did the digging, planted, weeded and hoed, while in the evening the children did the watering. When my financial situation got better, I improved and expanded the garden.' Later, six gardeners and assistants helped to turn the huge orchard meadow into a paradise of flowers. Over the years Monet developed a passion for rare plants, swapping them with his friends Clemenceau and Caillebotte, and was constantly on the lookout for rarities, which he was ready to pay good money for. The garden would increasingly come to assume priority in his paintings as well. Towards the end of his life he became more and more of a recluse, never leaving his home and only painting his garden.

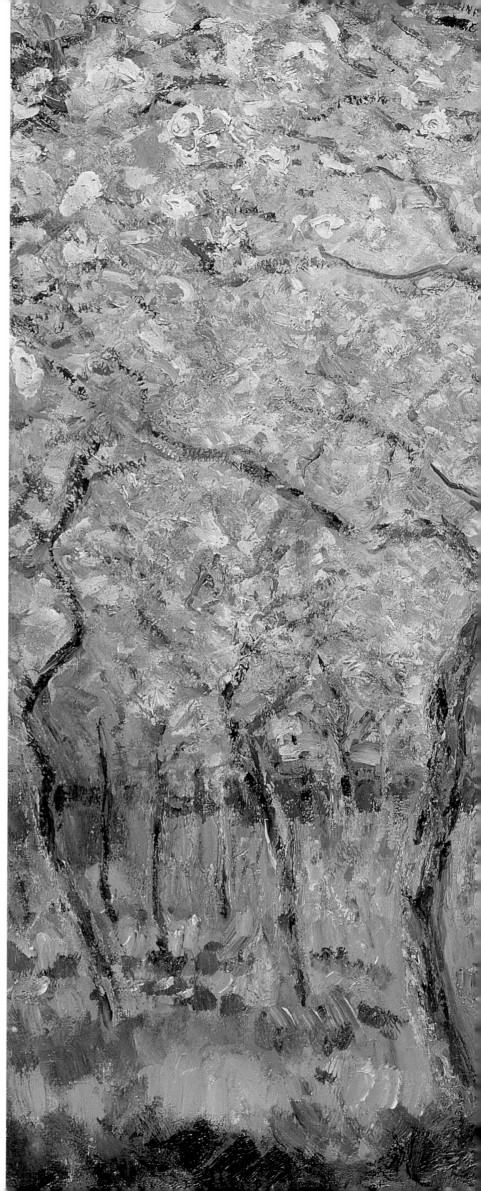

30 A sea of white flowers—the fruit trees are typical of the area around Giverny, and Monet's own garden was originally a purely fruit and vegetable garden full of apple trees. The dappled light shining through the foliage of the fruit trees has an Impressionist effect. *Springtime*, 1886. Fitzwilliam Museum, Cambridge

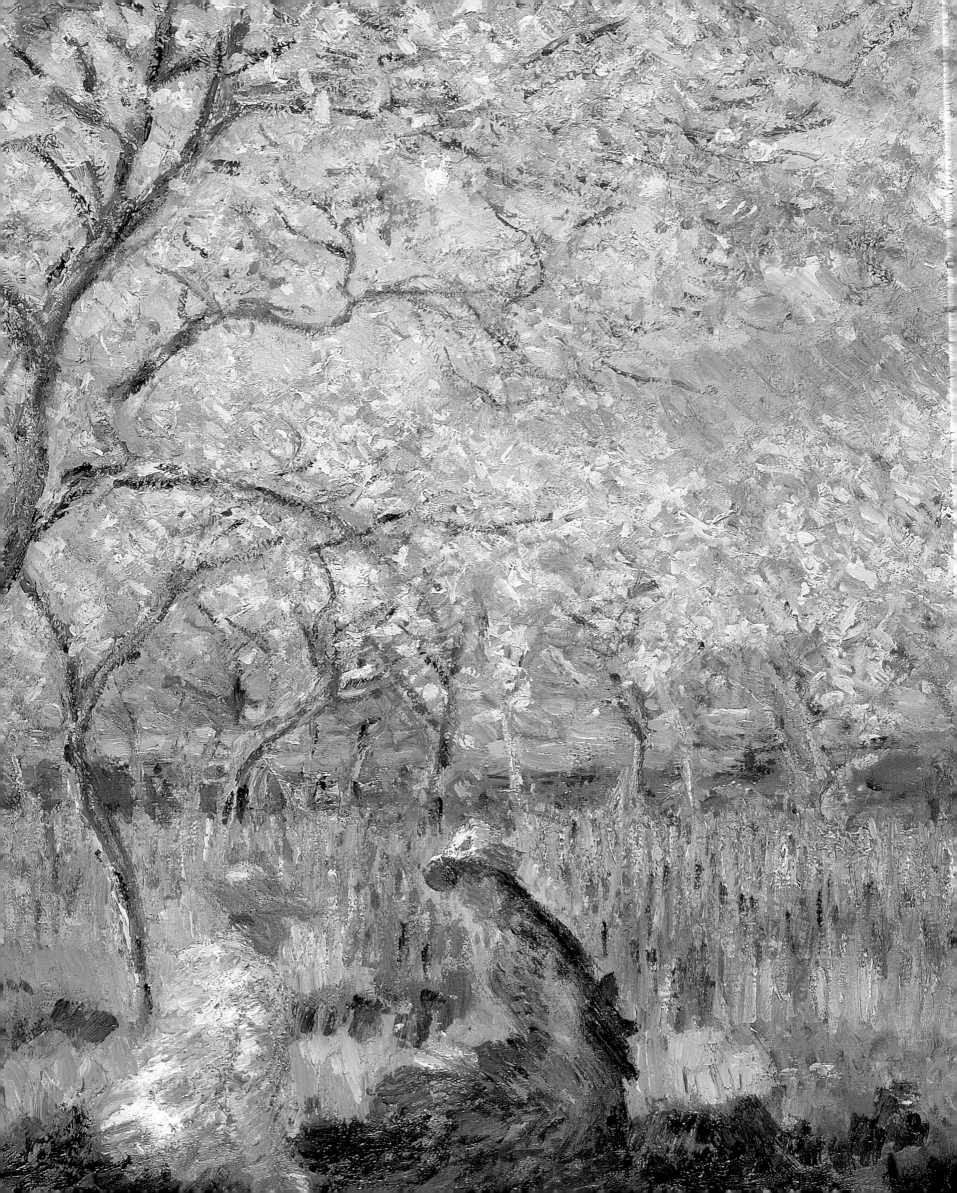

'THE LIGHT CONSTANTLY CHANGES, AND THAT ALTERS THE ATMOSPHERE AND BEAUTY OF THINGS EVERY MINUTE.'

Claude Monet

THE 'IMPRESSIONISTIC' GARDEN

Monet's paintings are not standard, closed compositions but look like picturesque slices of nature. Human figures formed the focal points of his pictures less and less, being pushed to the edges or into the background or disappearing into the landscape simply as colour highlights until, in the end, they were no longer in the paintings at all. His garden and its flowers were no longer a stage or setting but his most important and sole subject.

Above:
Blue blossoms in the Garden at Giverny.

Right:
Irises flowering beneath the trees that previously lined the Grande Allée.
Detail of *Irises in Monet's garden*, 1900. Musée d'Orsay, Paris

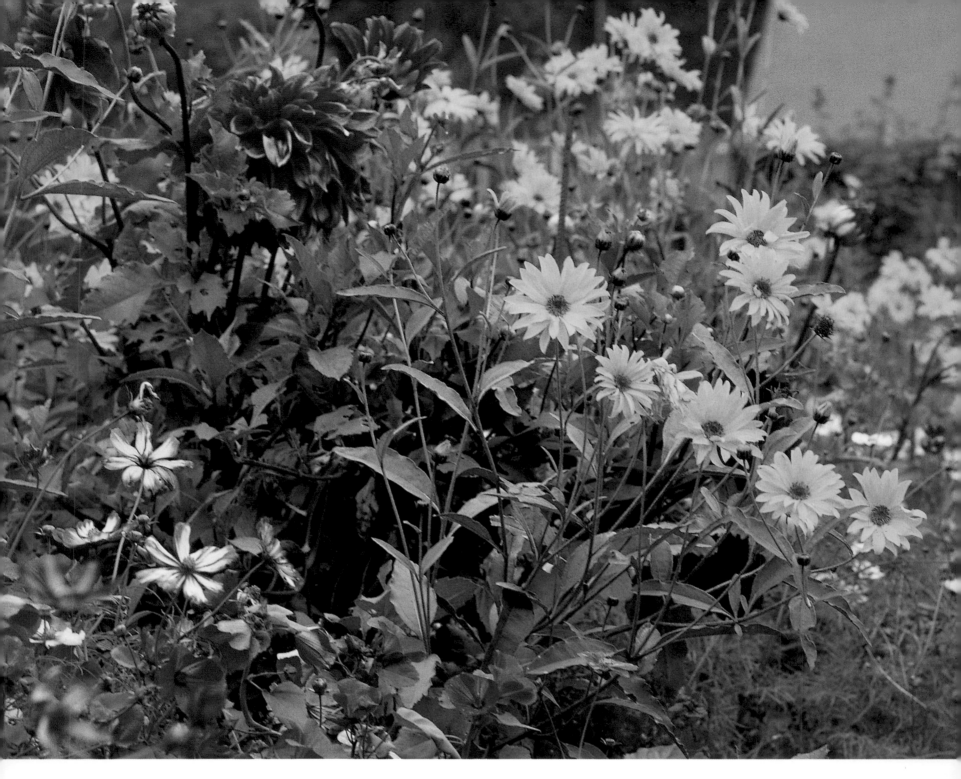

'MONET'S GARDEN MUST BE INCLUDED WITH HIS WORKS,
BECAUSE HE COMBINED THE MAGIC OF AN ADAPTATION
OF NATURE WITH THE WORK OF A PAINTER OF LIGHT.
AN EXTENSION OF THE STUDIO INTO THE OPEN AIR, WITH
COLOUR TONES LAVISHLY SPREAD OUT ON ALL SIDES TO
EXERCISE THE EYE WITH SEDUCTIVE VIBRATIONS,
FROM WHICH A FEVERISHLY AROUSED RETINA EXPECTS
UNQUENCHABLE JOY.'

Georges Clemenceau

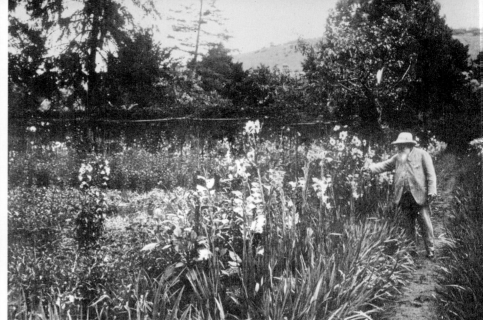

Modern varieties of large-blooming gladioli in Monet's summer garden, *c.* 1923.

In his paintings, Monet recorded the moods and colours of nature. He wanted to capture the light effects of the moment—the *instantanéité*, as he called it.

Monet's art is linked to his garden in a way that is perhaps unparalleled. Not only did his garden provide him with subjects to paint but they were mutually dependent, inseparably bound up with each other. In the same way as he painted, Monet set about creating his garden. Like his pictures, he set up a garden full of light effects, colours and changing views, arranging plants just as he arranged the colours on his palette. He planted various flowers together solely for their colour, inserting light-coloured flowers as light reflections and mixing very simple plants like poppies or daisies with rarities. In many beds, yellow, orange and red flowers glowed in the warm light of the evening sun, while elsewhere he combined only flowers with pink petals such as peonies, hollyhocks, roses, hydrangeas and cosmos. Other beds sported a wild riot of different colours.

The colour black is very rare in Impressionist painting. Monet himself rarely used tones of black or brown. He liked to render shadow in painting with shades of blue, and in his garden blue flowers grow in the shade. Monet hated rigidly geometrical gardens, for example the formal style of garden of the kind that Le Nôtre designed and which was still predominant at the end of the nineteenth century. He also did not like garden sculptures and similar artificial elements. Obviously influenced by the landscape architect Edouard André, whose book on *L'Art des Jardins* had come out in 1879, Monet favoured then the developing fashion for naturalness. He veiled formal design elements in waves of flowers. Often the flowers were left to grow and multiply by themselves.

The result was a garden full of colour and constantly changing impressions that he could record in his pictures—the garden acted as a planted, living model for his art. As the days and the seasons progressed and the plants grew, the appearance of the garden changed constantly. The painter was careful to ensure that the garden should be in flower from spring to late autumn, because in that way it became a never-ending source of subject matter for his paintings. Even in bad weather Monet often painted outside. In his greenhouses he cultivated begonias, exotic ferns, orchids and other delicate plants. Fresh bouquets of flowers decorated the house all the time, so that he had flowers to paint at most times of the year.

35

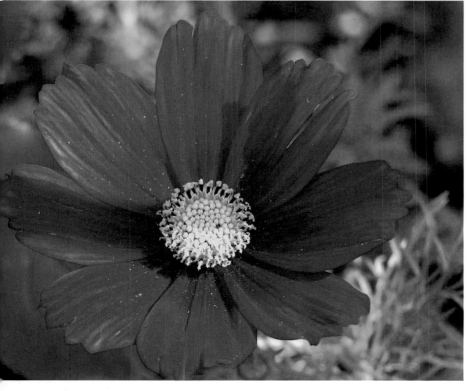

Above and left:
Impressions of summer in Giverny—sunflowers, dahlias and cosmos.

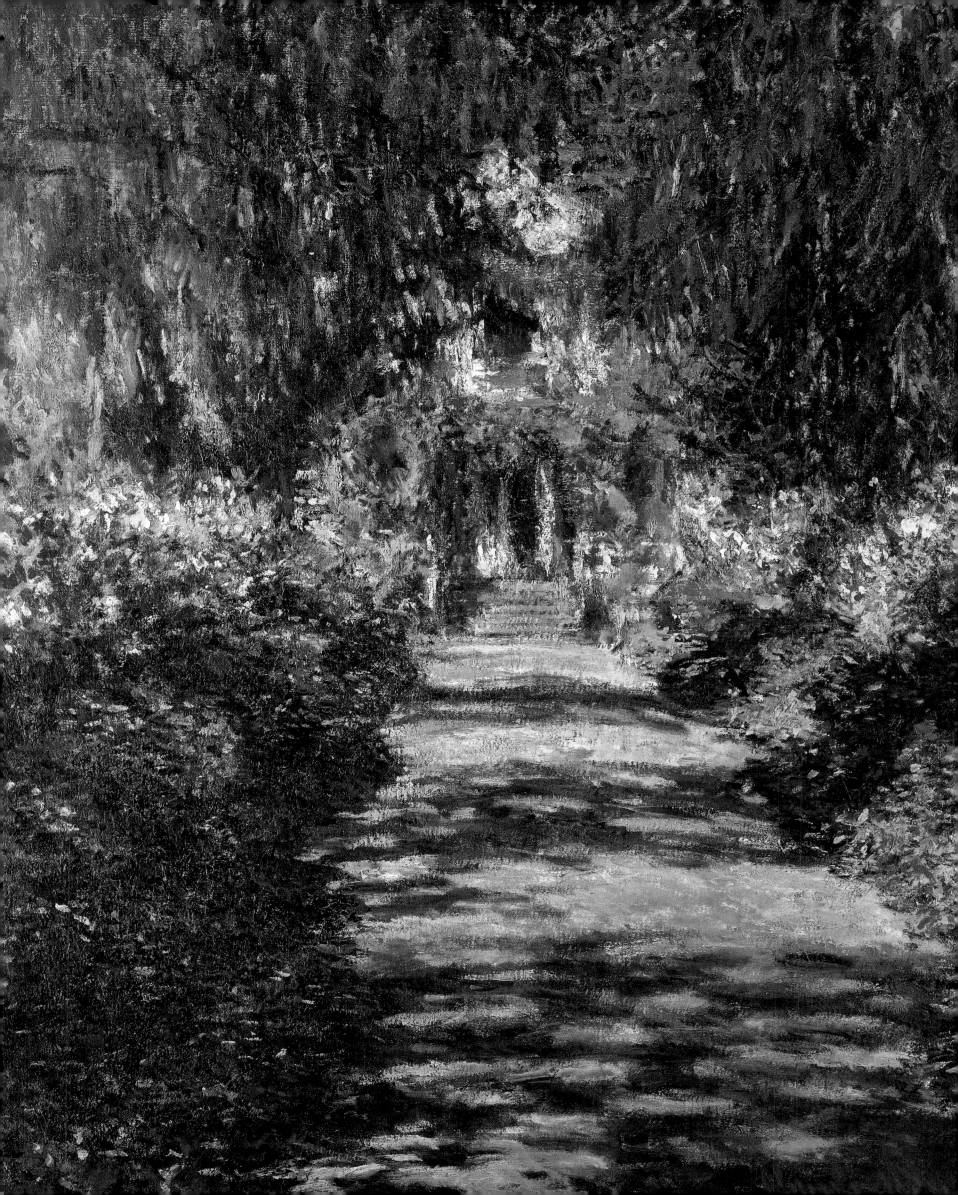

THE FLOWER GARDEN
When it came to designing the garden, Monet and Alice often had radically different ideas. One bone of contention was the Grande Allée. It formed a central axis of the garden, and led from the garden gate on the south side straight up to the house.

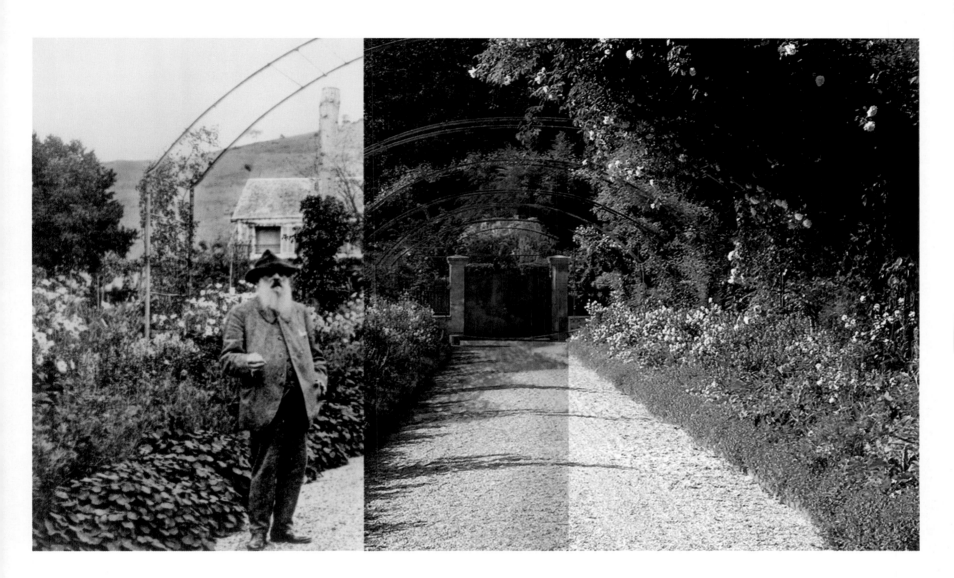

Originally it had been bordered by pines and cypresses, which Monet really disliked. However, Alice liked them, as she enjoyed sitting in their shade. As a compromise, Monet therefore had only the cypresses cut down at first, pruning the lower branches of the pines so climbing roses could grow on them. Paintings from around 1900 show pink climbing roses in bloom on the trunks of the dark pines. Between them shrub roses can be discerned, flowering in lighter colours. A wall of roses thus constituted the background for the seasonally changing flowers of the beds on each side of the main path.

Later, the tops of the conifers also fell victim to the saw. On old photographs, bare trunks can be made out between arches of roses, acting as supports for the roses. Long after Alice died, these also rotted away, and only the two huge yews closest to the house now survive. However, the floral tunnel formed of climbing roses on arched iron trellises is still a distinctive feature of the familiar image of the garden in Giverny today. Bulbous plants, perennial herbs and annuals line the path on both sides and creeping tendrils of nasturtiums overgrow it in summer so that hardly anything can be seen of the ground.

Above:
The Grande Allée with the bare stumps of the felled firs as they were and with flowering roses and dame's violets today. The wrought iron rose arches were put up by Monet around 1920.

Left:
The view from the garden gate towards the house—the central path was originally lined with large dark trees.
Main Path through the Garden at Giverny, 1902. Österreichische Galerie Belvedere, Vienna

'THE MAGICAL USE OF THE CLEMATIS MONTANA, WITH ITS WHITE FLOWERS AND ITS PINK-BLOSSOMING FORMS ON HIGH CLIMBING FRAMES . . . AT THE BEGINNING OF SPRING THAT IS ONE OF THE PRETTIEST CORNERS OF THE GARDEN . . .'

Georges Truffaut

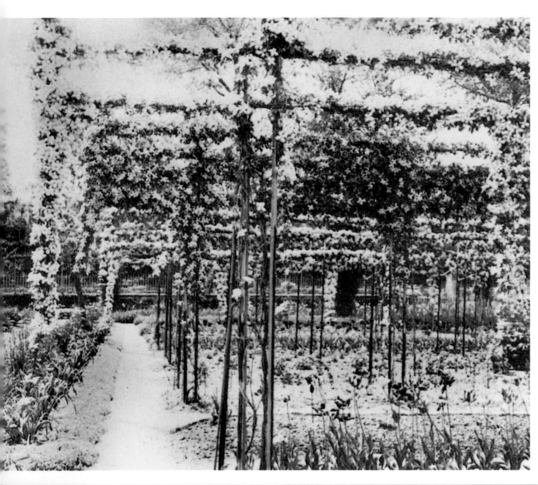

Left:
This historical photograph shows the clematis that flowered on long climbing frames over the paintbox beds east of the main path.

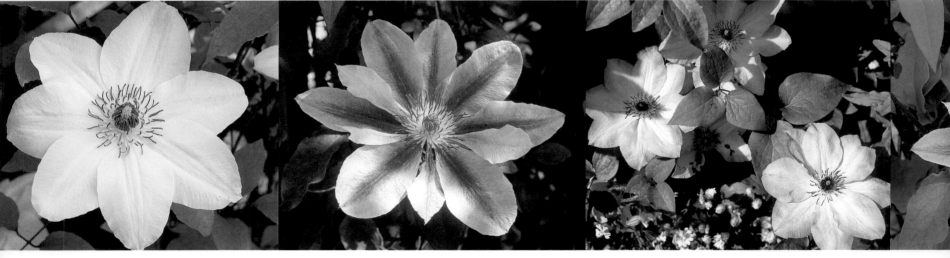

Above:
Modern clematis varieties make for a varied scene today. The large-flowered hybrids were planted only when the garden was reconstructed.

Right:
Monet painted the clematis in a couple variations.
White Clematis, 1887. Musée Marmottan, Paris

When one goes up the Grande Allée to the house, one reaches the large veranda that fronts the south side of the house. Virginia creeper covers the façade, while roses and other climbing plants overrun the veranda and the climbing trellises attached across the whole front of the façade. In the borders in front of the house a sea of tulips and forget-me-nots flower in spring, to be followed later by waves of red geraniums.

The numerous rectangular 'paintbox' beds east of the Grand Allée are planted with a wide range of flowers in a constantly changing display of fascinating colours, over which loom the typically blue-green painted climbing frames with roses and clematis, for which the painter had a particular partiality. Some of the earliest pictures in which the garden at Giverny appears feature clematis and peonies. Clearly visible in the painting on the right are the thatched roofs borne on wooden supports that protect the delicate blooms of the luxuriant tree peonies against sun and rain.

Among the flowers Monet loved especially were irises. They were found everywhere. In the Clos Normand, the orchard west of the Grand Allée, a sea of irises danced beneath the apple trees. In Monet's paintings, the blue flowers dominate the meadow in dense clumps. The Grande Allée itself along with its offshoot paths were lined with long beds of irises. They can be seen in his pictures as broad strips of bright blue (see p. 74).

Roses were likewise among Monet's favourite flowers. They blossom everywhere in his garden. Rambling roses clamber up the veranda and rose archways, standard and small roses fill the beds west of the house, while between the apple trees there are imposing cascades of weeping standards. Monet painted them several times. The picture with the blooming rosebush with its charmingly curved branches like a filigree pattern against the blue of the sky, is particularly magical (see p. 44–45).

Right:
The peonies are among the first motifs that Monet painted in his new garden in Giverny. *Peonies*, 1887. National Museum of Western Art, Tokyo

Below:
From the bud to the fragrant bloom—in Giverny, various peony varieties flower in May and June.

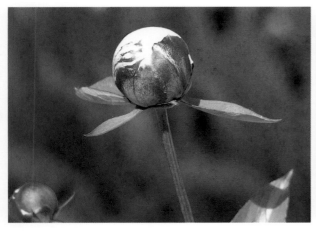

'YOU ARE CONFRONTED WITH A SOFT, FLAT LAWN. THE LIGHT SHADOW OF THE APPLE TREES CONCEALS DENSE CLUMPS OF IRISES, WHOSE VIOLET FLECKS FOLLOW THE GLEAM OF LIGHT DARTING QUICKLY TO THE FLOWERS.'

J. C. N. Forestier

Above: Irises flowening amongst the apple trees. *The Artist's Garden at Giverny,* 1900.
Yale University Art Gallery, New Haven, CT Collection of Mr and Mrs Paul Mellon, 1929
Left: Densely planted rows of blue irises and dame's violets line the sides of the western path of the garden in Giverny.
Following double-page spread: Roses, 1925–26. Musée Marmottan, Paris

THE WATER GARDEN

Whereas the flower garden has the charm of a rustic garden paradise in the country, the water garden Monet began in 1893 exudes Asiatic flair. This was constructed on a plot adjacent to his garden on the south side, but separated by the road to Vernon and the railway line that ran there at the time. The Ru, a branch of the Epte river, which is itself a branch of the Seine, flowed through the whole length of the garden, feeding an overgrown pond that Monet converted into his water garden.

The painter needed all his powers of eloquence to convince the suspicious villagers of Giverny that his rare, exotic water plants would not contaminate the river where they watered their cattle and washed their laundry. However, in the end he was allowed to install two sluices to dam the Ru and construct his first water lily pond.

In that same year he also had the famous Japanese bridge built, which was refashioned around ten years later with a metal frame now overgrown with blue and white wisteria. Unlike traditional Japanese examples, which are painted red, Monet had the bridge painted in his favourite green, the same bluish-green as the climbing frames. In this colour, the bridge blends harmoniously with the colours of the water and the plants around it. Together with the plants he used—weeping willows and bamboo, rhododendrons, azaleas, peonies, calla, lilies and irises—it forms a marvellous, Far Eastern-looking backdrop for the famous water lilies. The latter form countless islands of round, dark green leaves that transform the water into a sea of flowers throughout the summer. When you enter this garden, you enter the green stillness of an exotic waterscape that is like another world.

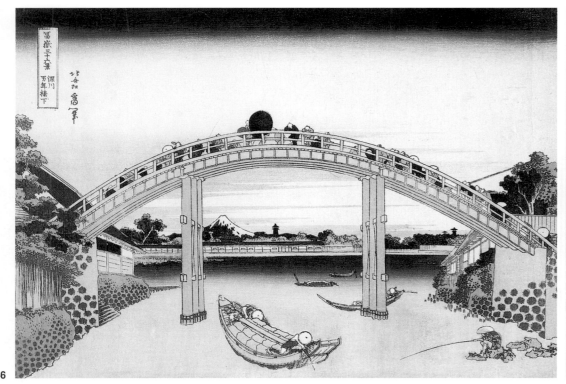 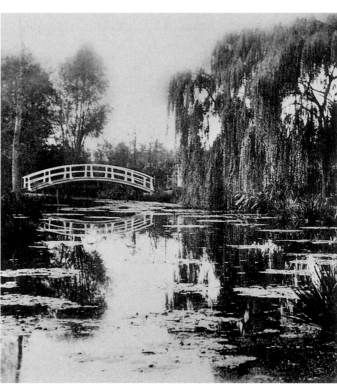

46

Above: Mount Fuji seen through the Piers of Mannenbashi Bridge
Katsushika Hokusai, *c.* 1831. From the *Thirty-six Views of Mount Fuji*

Above right: The Japanese bridge still lacking a superstructure, *c.* 1900.

Right: The bridge is in shadow in this balanced but very atmospheric composition, while in the background golden light filters through the trees on to the lily pond.
The Japanese Footbridge and the Water Lily Pool, 1899. Philadelphia Museum of Art, PA

Below right: The historical photograph shows the water lilies in Monet's time.

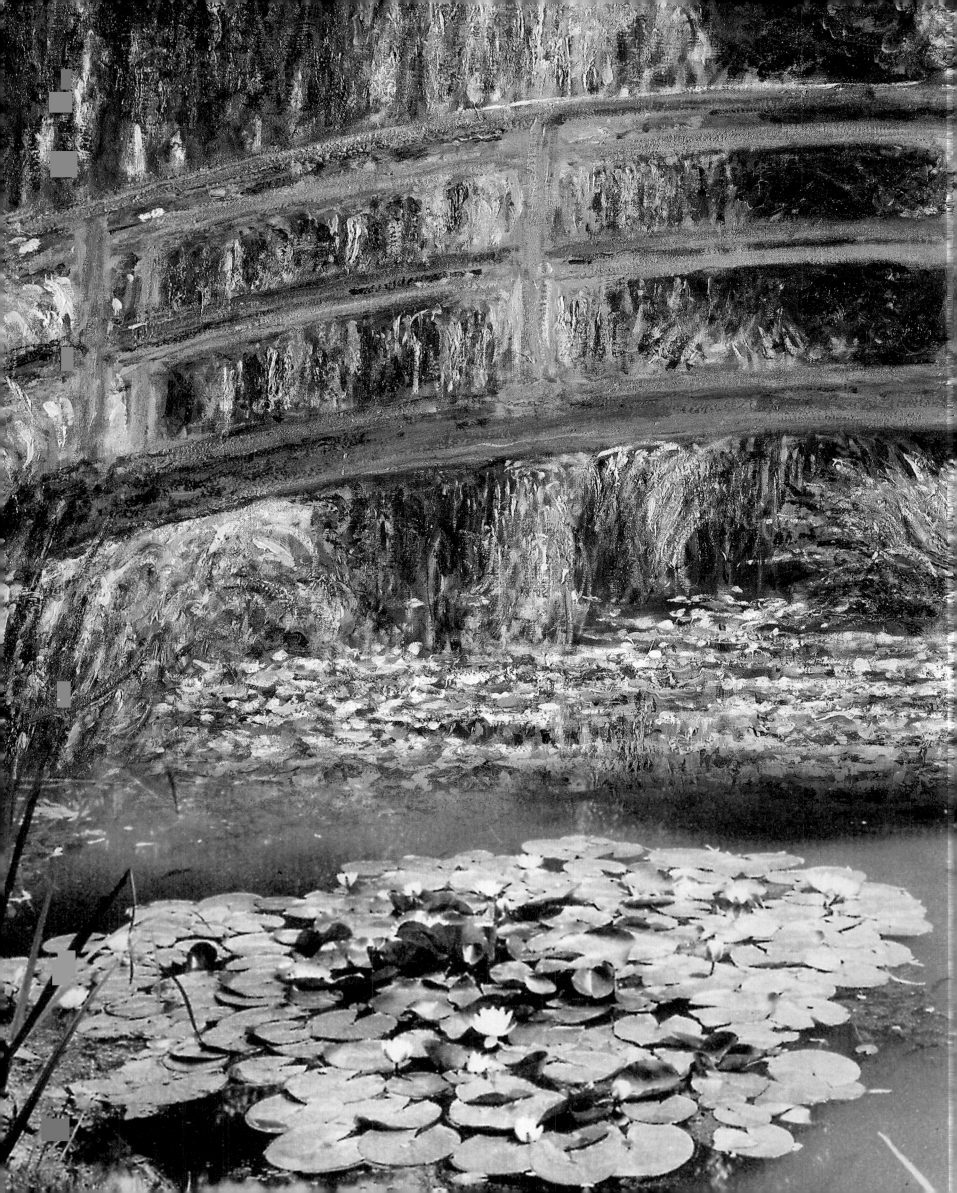

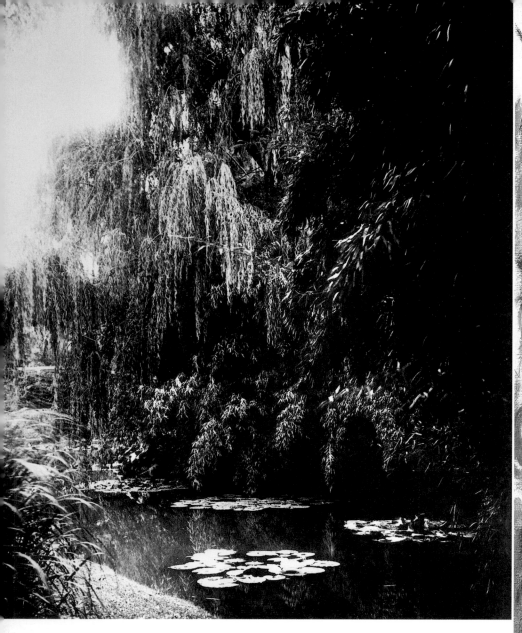

Above:
The water garden at Giverny

Right:
48 One of several weeping willows (*Salix babylonica*) on the bank of the lily pond,
which Monet painted in a series of paintings in various light conditions.
Weeping Willow, 1918–19. Musée Marmottan, Paris

Page 50:
A picture taken from the Japanese bridge looking over the water lily pond

Page 51:
On the north-east bank of the pond, climbing roses bloom behind water lilies
and tall grasses against a dark wall of trees.
The Water Lily Pond at Giverny, 1917. Musée de Grenoble

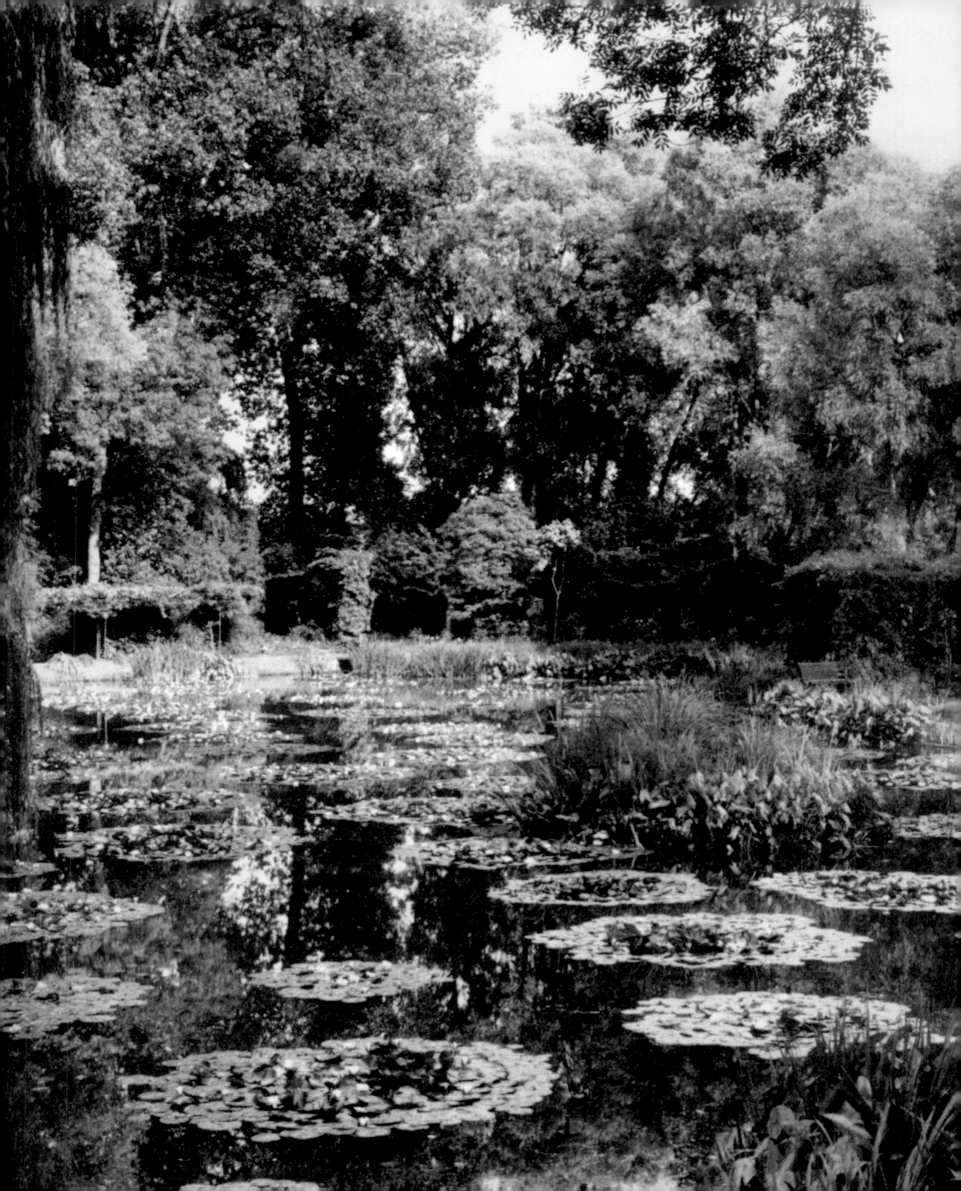

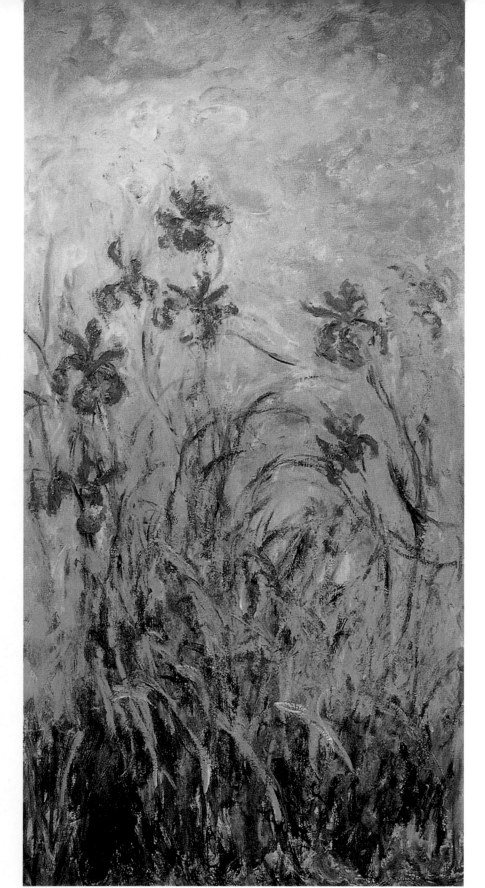

For more than twenty years Monet found inspiration for a multitude of images in his water garden—the Japanese bridge, the water lilies and reflections on the surface are recorded over and again in paintings. He did his first pictures of the Japanese bridge in 1895, two years after he had constructed the water lily pond. A series of very symmetrically organised and harmonious compositions show the bridge still without the wisteria and always from the same viewpoint in the middle of the picture. Another series shows them at an angle. The bridge is cut short here on the right, allowing the grass and irises on the left bank to be brought further into the picture (see p. 47), and in two pictures a section of path can also been seen in the foreground.

Monet often painted the large weeping willow on the north bank of the pond, while often only the hanging branches reflected in the water can be seen in the pictures. Other motifs are a certain corner of the pond and the plants on the bank. A whole series of paintings is devoted to the irises in the water garden—against the background of the water lily pond, as proliferating borders along the paths, which meander, unlike those in the upper garden, or are reproduced against the blue of the sky.

Following the World Exhibitions in London in 1862 and Paris in 1867 a veritable fever of *japonisme* had broken out. Monet himself was not immune to the fascination, as is borne out by his large collection of Japanese coloured woodcuts by Hokusai, Hiroshige, Utamaro among others, which are still in Giverny. In 1893, shortly before he bought the land for his water garden, he visited an exhibition of Japanese art organised by Paul Durand-Ruel. Although Monet himself is supposed to have disputed it in reference to the Japanese bridge, his water garden was strongly influenced by the craze for things Japanese of the time. Many of the plants that grow there, such as the tree peonies or special species of iris, were introduced to Europe as novelties at that time, and regardless of their actual origin were considered generally to be Japanese.

Though the garden in Giverny is not Japanese in style, the influence of Japanese pictures is clearly evident in Monet's pictures—for example in the flat clarity and composition of a number of water lily pictures or the irises flowering like ornamentation against the background. Possibly this similarity of compositional style was what induced Japanese collectors to take an interest in Monet even then, and led to personal contacts of friendship with Japanese collectors and dealers. Among the Japanese visitors who came to Giverny was Kojiro Matsukata, whose collection forms the basis of the National Museum of Western Art in Tokyo.

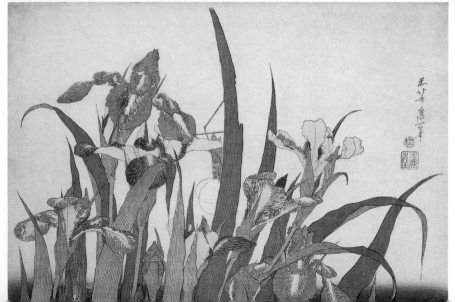

Above:
Lilac Irises, 1914–17. Private collection

Left:
Iris, c. 1832. Katsushika Hokusai. From an untitled series published by Nishimuraya Yohachi

Right:
The interaction of the lancet-shaped leaves of the irises with the round shape of the water lilies gives this composition its vitality.
Irises and Water Lilies, 1914–17.
Former collection of Michel Monet, Giverny

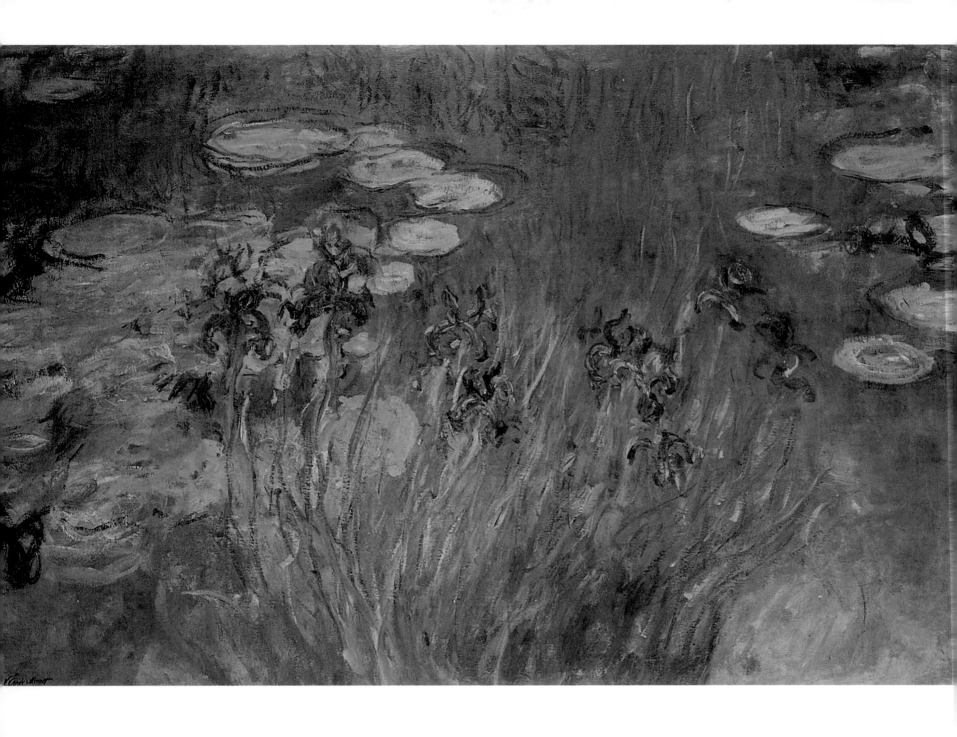

'THE BANKS OF THE POND ARE STREWN
WITH IRISES OF ALL KINDS. IN SPRING YOU
SEE SIBERIAN IRISES AND VIRGINIA IRISES
WITH SILKY, GLEAMING LEAVES.
LATER THERE ARE JAPANESE IRISES AND AN
ABUNDANCE OF IRIS KAEMPFERI.'

Georges Truffaut

'WATER EXERCISED A PARTICULAR ATTRACTION ON MONET'S BRUSH.'

Georges Clemenceau

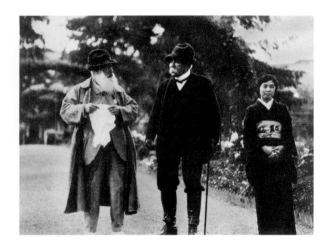

Above:
Madame Kuroki, the niece of Japanese collector Kojiro Matsukata,
accompanied by Monet (left) and Georges Clemenceau (centre)
in the garden in Giverny, *c.* 1920.

Right:
In their ornamental clarity, these yellow irises against an
unnatural violet sky are very reminiscent of Japanese prints.
Yellow Irises with Pink Cloud. Private Collection

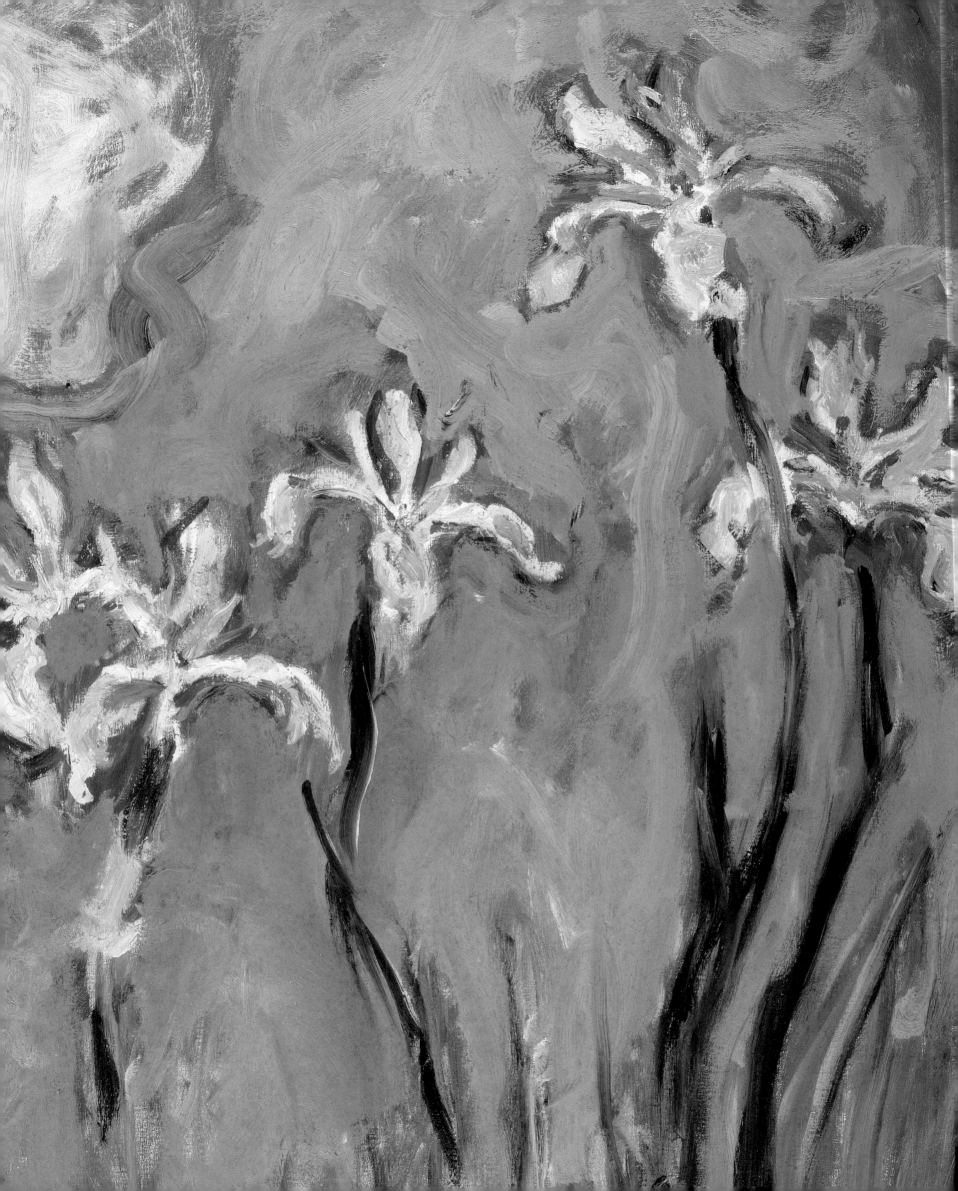

THE WATER LILIES

In the year 1903, Monet had the pond renovated and enlarged. Henceforth the blue water with its islands of gaily flowering water lilies would become his favourite subject. He had a gardener whose sole responsibility was to look after the lilies and ensure that nothing disturbed the view of the lake even in the early morning.

Monet was an obsessive collector of exotic water lilies, and spared no expense to obtain rare varieties. He obtained them from the nursery of Joseph Bory Latour-Marliac, who managed to grow prize-winning plants in Temple-sur-Lot, in the warm south-western part of France. Monet bought from him not only exclusive water lilies but also other rare aquatic plants. Some of the lists of his orders still survive.

The painter in him was fascinated above all by the reflections of the sky, clouds and plants on the surface of the water in his pond. Many pictures present a confusing, shimmering medley of water lily flowers and leaves, reflected clouds and willow branches. The world is turned upside down in these pictures of reflections.

His work focused increasingly on his water garden. Countless paintings are devoted almost exclusively to water lilies. In these, the flower-filled surface of the water occupies almost the entire canvas. Often, strands of weeping willow hang down into the picture from above, or a strip of bank can be seen at the top of the picture, but many works are devoted solely to the water lilies and reflections on the water. Many of Monet's water lily pictures are round, but most of them are rectangular or approximately square in format. The paintings have a wealth of colours in them—along with countless shades of blue and green we find soft pink reflections of the sky and golden yellow light reflections.

Monet set to work on these 'waterscapes' like a man possessed—they had become an absolute obsession. In 1909 he presented 48 water lily pictures at an exhibition at Durand-Ruel's, and despite the initial scepticism of the dealer the exhibition was a fantastic success, and even had to be extended.

A delightful composition of water lilies, dangling willow branches and reflections of the sky in the water.
Water Lilies, 1916–19. Musée Marmottan, Paris

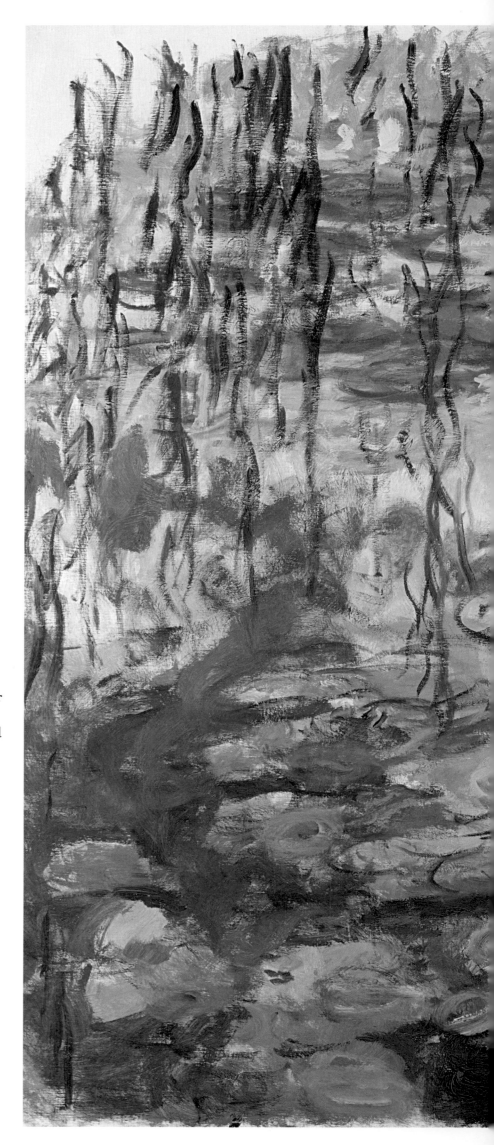

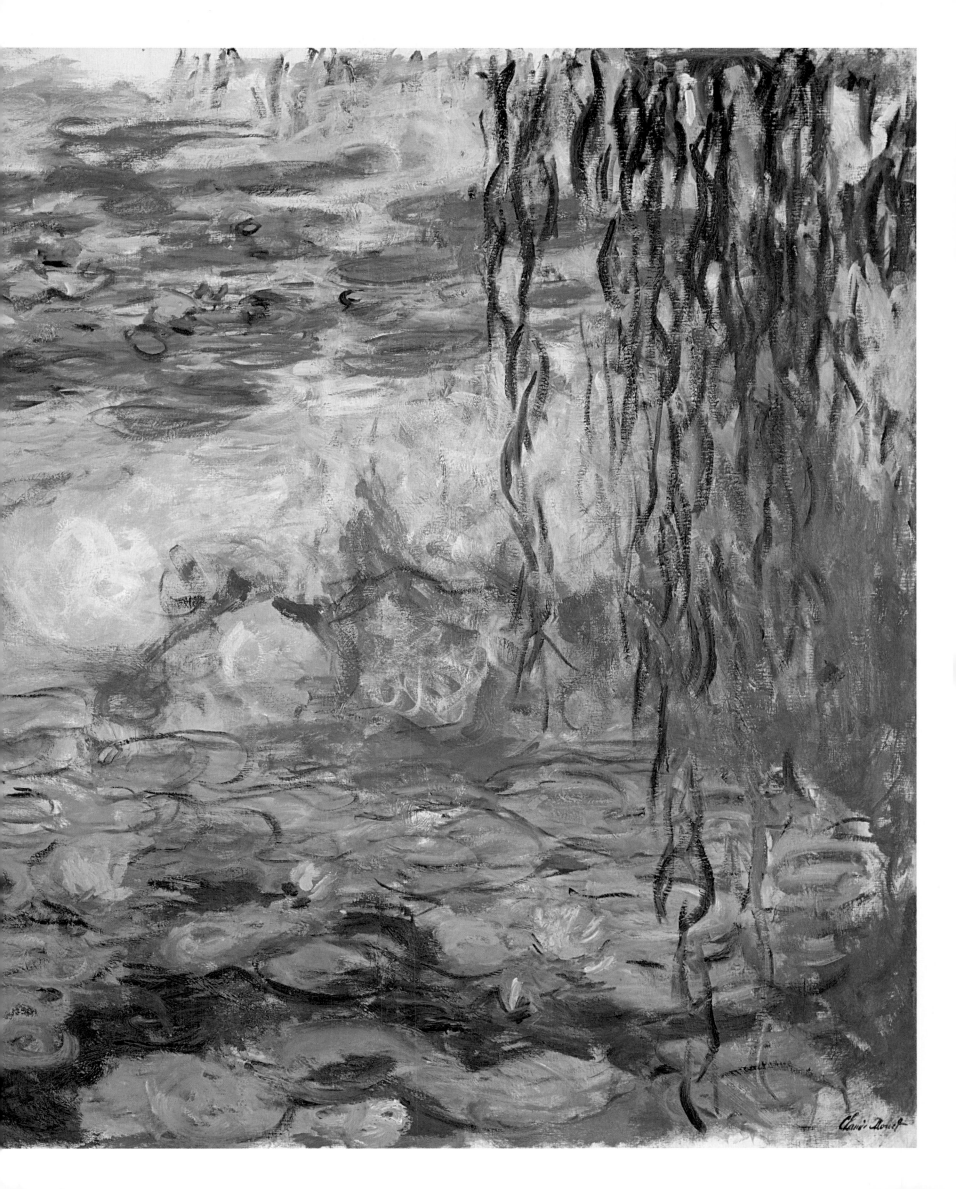

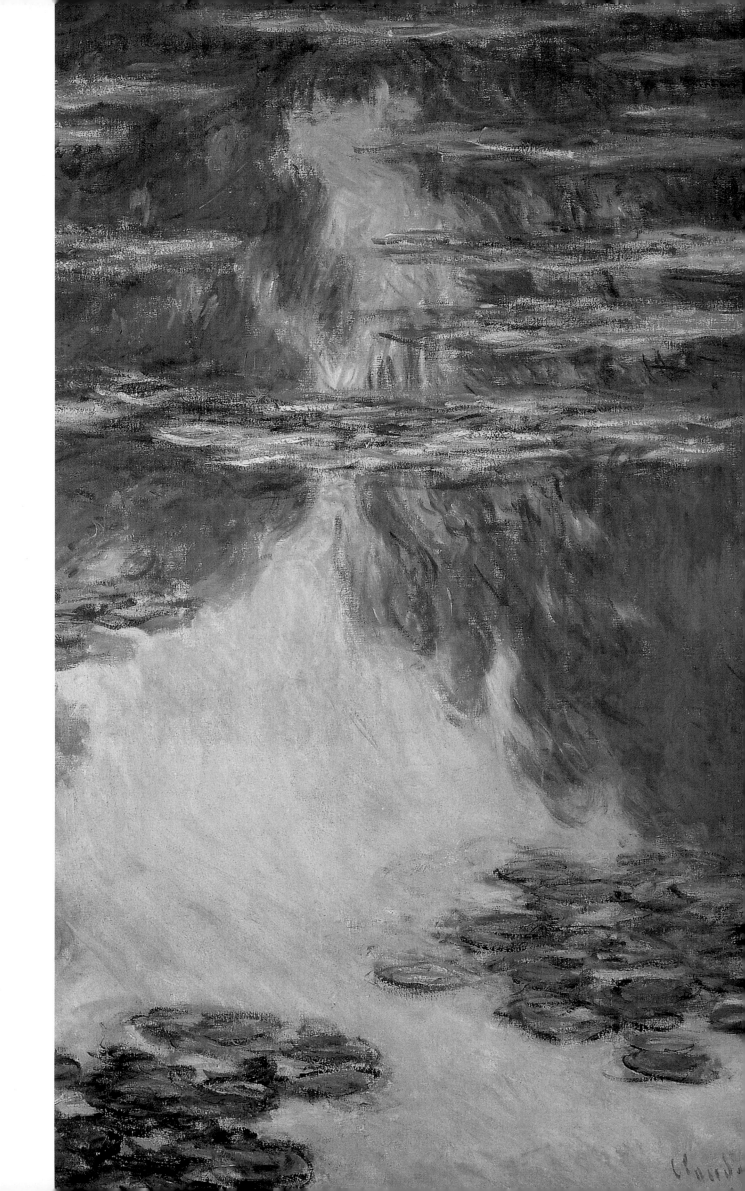

58 Two pictures from a major series from 1907 that present the identical view in varying light conditions. *Water Lilies*, 1907. Musée Marmottan, Paris and Bridgestone Museum of Art (Ishibashi Foundation), Tokyo

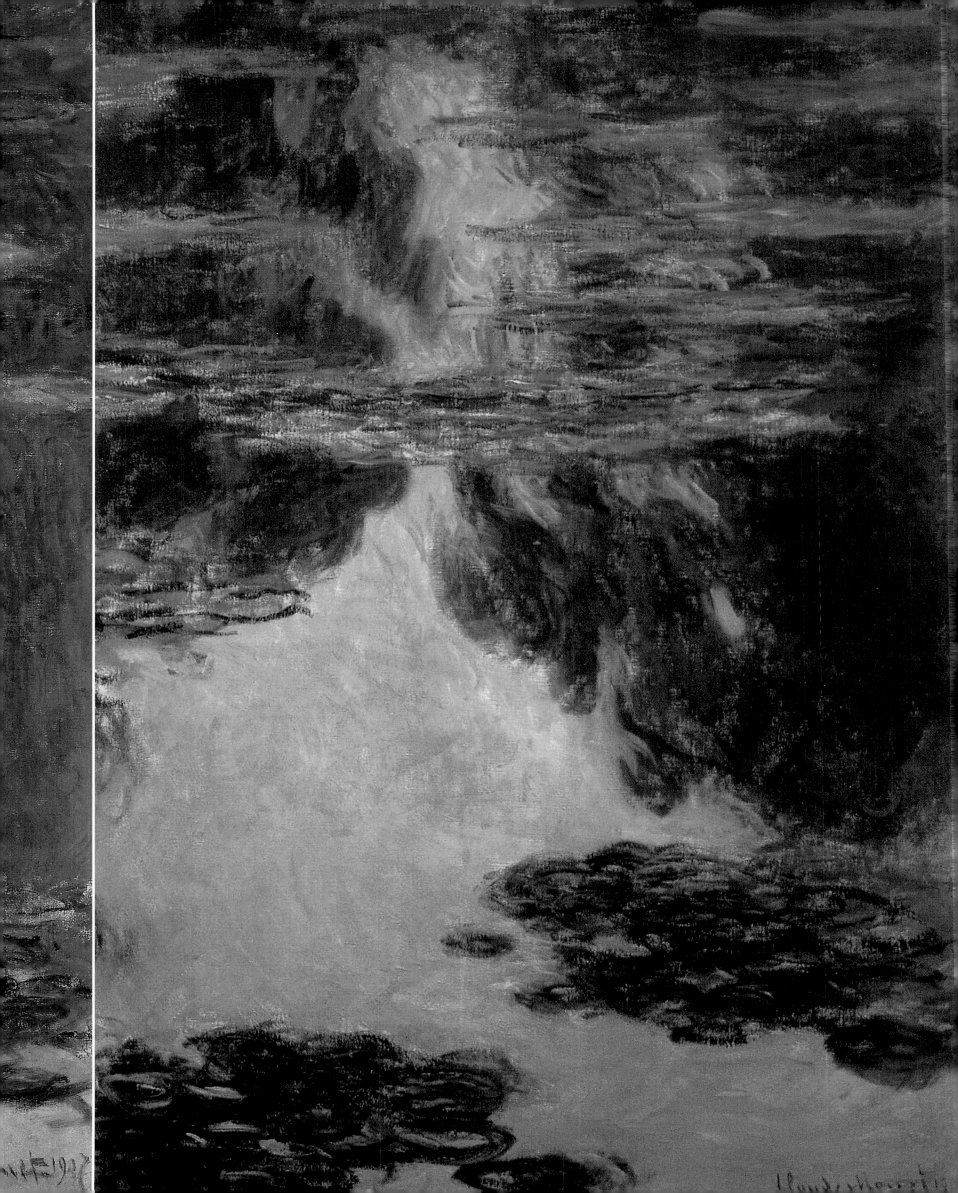

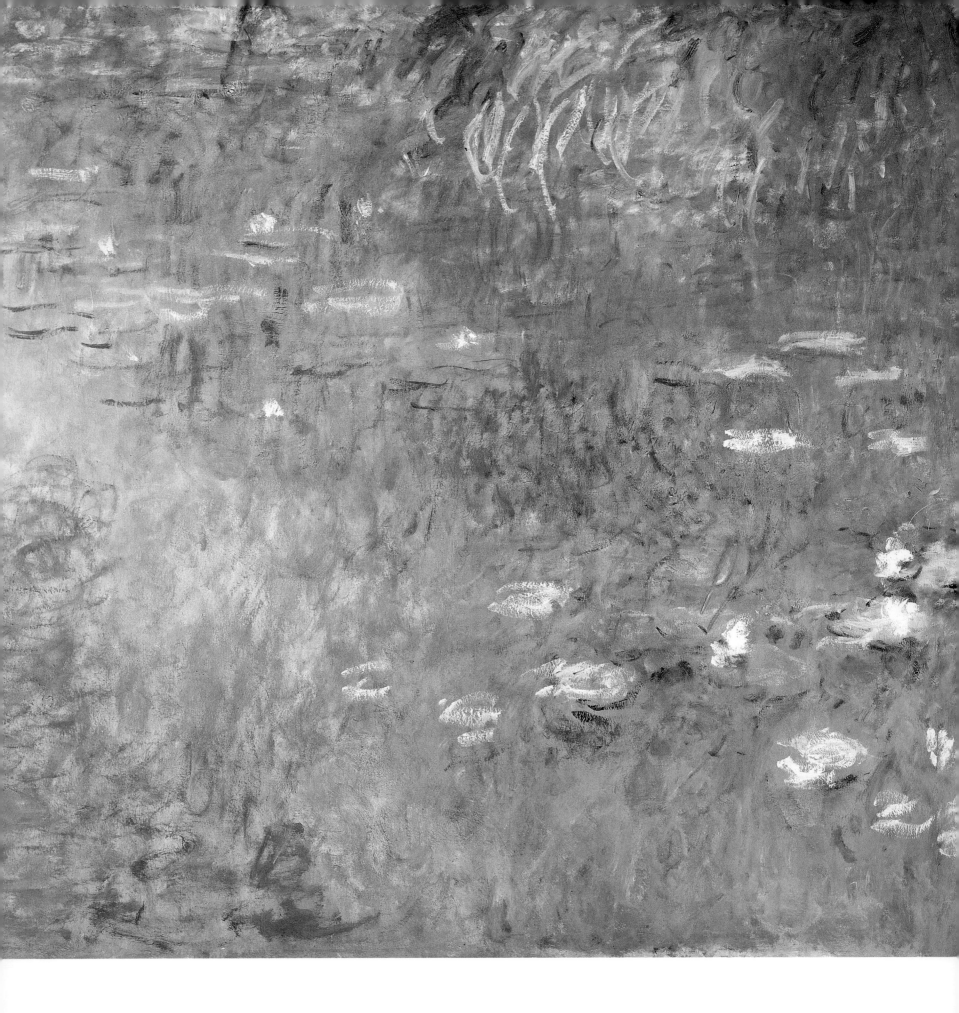

Impressions from the water garden.
Water Lilies, 1907.
Kawamura Memorial Museum of Art, Chiba-shi, Japan

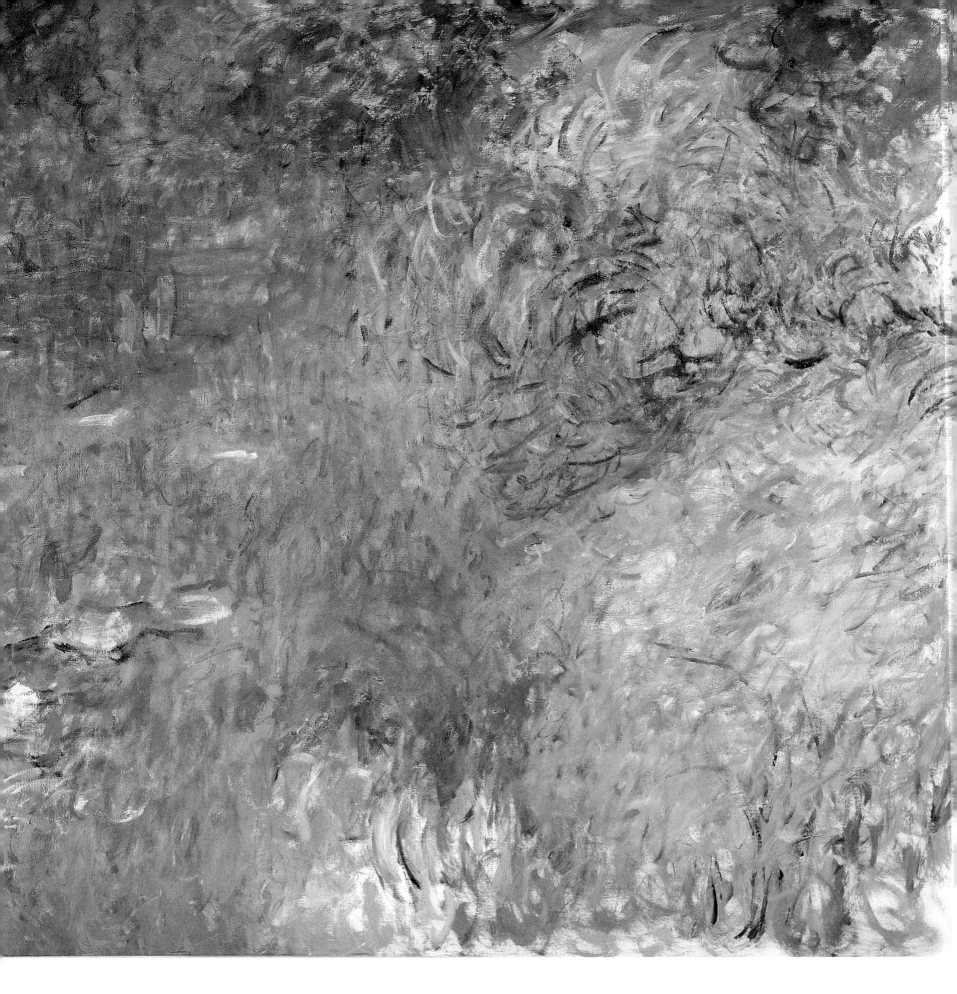

'A PANORAMA OF WATER AND WATER LILIES,
LIGHT AND SKY. IN THIS INFINITY,
NEITHER WATER NOR SKY HAVE A BEGINNING OR END.'

René Gimpel

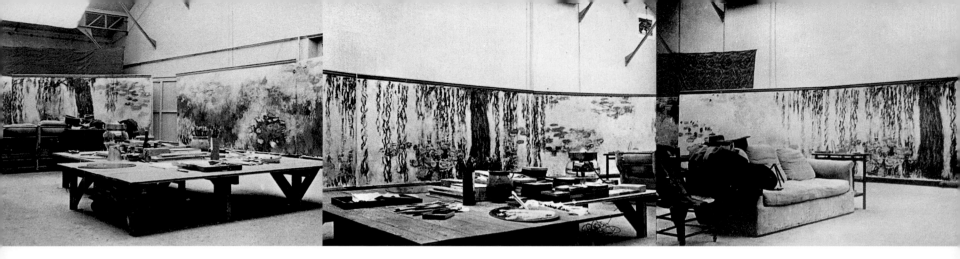

THE 'GRANDES DÉCORATIONS'

In 1897 Monet was working on a series of wall paintings of water lilies over three feet (1 m) high, intended to run round the walls of a room as a frieze. After he had painted eight pictures, he lost interest in a connected scheme of paintings. The idea was resuscitated by the successful exhibition of his water lily paintings in the year 1909, but the following year a flood wreaked havoc on his garden, and it took years to restore it to its former glory.

It was not until 1914 that Monet was ready to pick up where he had left off, and set about creating a series of vast wall paintings. In 1915, he had a third studio built on the eastern side of his house that was big enough to accommodate the huge canvases, which measured six foot six (2 m) high and up to thirty-nine feet (6 m) long. The third studio was solely for the purpose of painting his waterscapes. In the very last years of his life he worked only on these wall panels, which were intended to give a gigantic panorama of his water garden with its water lilies and the dangling strands of weeping willow. Photos from 1917 (see above) show twelve painted canvases already complete, which could be pushed backwards and forwards on rollers. Although in these late years he spent time in his garden every day, his pictures were now painted in the studio. The watery world of his imagination had become detached from its real-life source. What he had been observing for years now came together in his mind like a vision.

Originally, Monet had toyed with the idea of donating two large water lily pictures to the French state as a memorial to the dead of World War I. However, in 1918, his friend Clemenceau persuaded him to give the nation the *Grandes Décorations*. The first plan was to build a special circular building in the garden of the Hôtel Biron, but this fell through, and it was finally decided to house them in two oval rooms at the Orangery in the Tuileries in Paris. In 1922, Monet signed a gift of donation for an initial nineteen pictures, under the stipulation that the premises and the ensemble should not be changed. He also insisted that the pictures should not be varnished, and set down the subjects that made up groups of canvases: *Sunset*, *Morning*, *Clouds* and *Green Reflections* would fill the first room, while *Tree Reflections*, *Morning with Willow*, *Clear Morning* and *Two Willows* should make up the second. The painter worked on this grandiose work, which finally spanned a total width of nearly 300 feet (90 m), to the end of his life, but he never lived to see it installed.

It was only after his death in 1926 that the huge canvases of the *Grandes Décorations* (now numbering twenty-two) were taken to Paris and opened to the public in the Orangery. The public was initially baffled by the works, which did not fit in with a current art fashion. Monet had anticipated this: 'Perhaps they will get used to them, but I was before my time.' The Orangery is now celebrated as the 'Sistine Chapel' of Impressionism.

62

Above:
The water lily *Décorations* in Monet's studio, 1917.

Right:
A close-up view shows how the large water lily pictures became more and more abstract, moving in the direction of pure painting.
Detail from the *Water Lily Pond*, 1917–19. Museum Folkwang, Essen

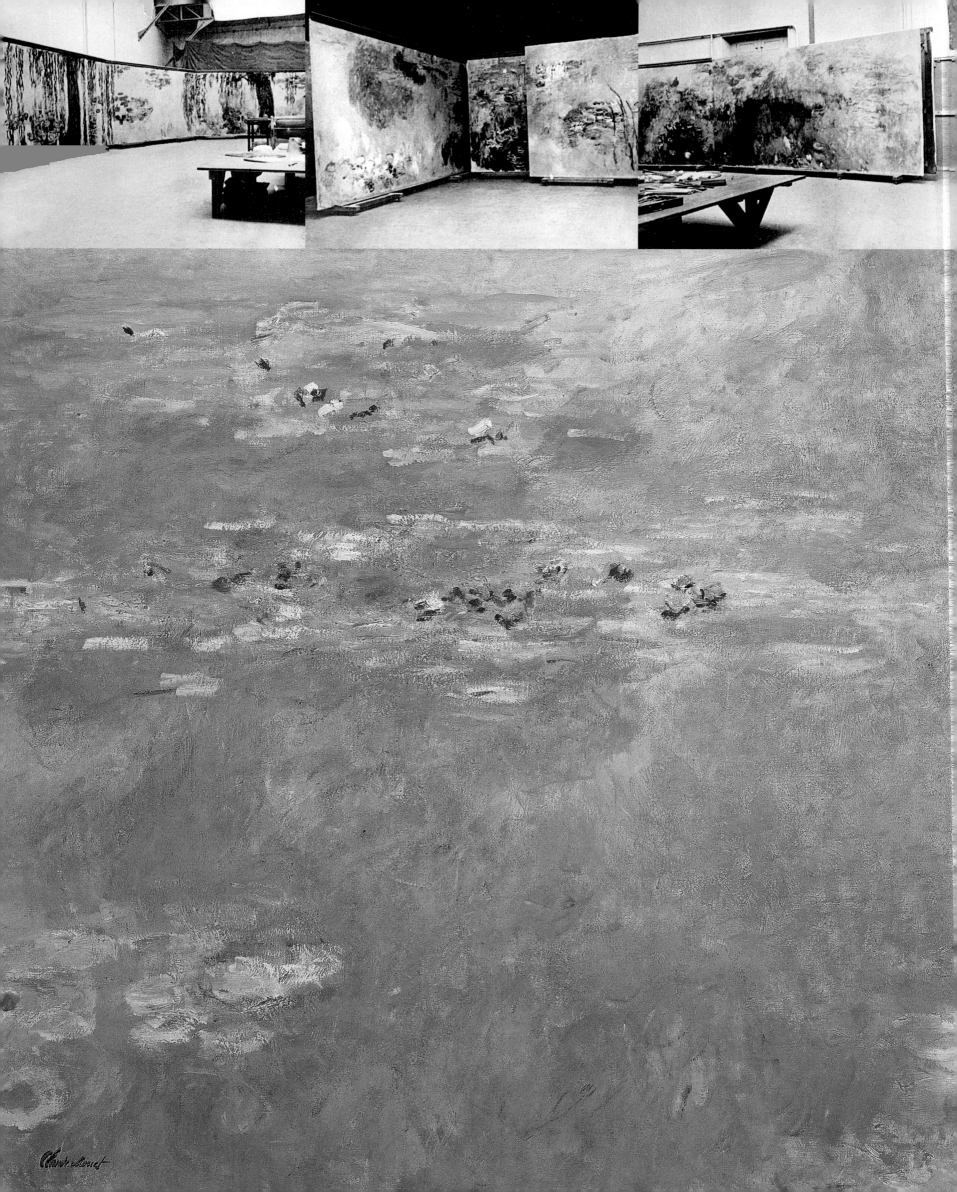

'THE DISTORTION AND EXAGGERATION OF THE COLOURS I NOW EXPERIENCE IS FRIGHTENING. IF I WERE CONDEMNED TO SEE NATURE ONLY LIKE THIS, I WOULD PREFER TO BE BLIND AND SEE THE BEAUTIES OF NATURE ONLY IN MY MIND'S EYE.'

Claude Monet

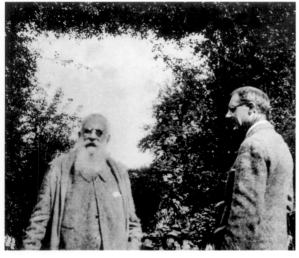

Monet and Pierre Bonnard, *c.* 1926

64 'He has painted very many paintings in his garden; with minor variations, they are the same as those we already know; here, everything is less brutal than in his wall paintings, but rather black and sad.' (Paul Durand-Ruel in a letter to his son, 1 October 1922)
The Japanese Bridge, *c.* 1920–24. Musée Marmottan, Paris

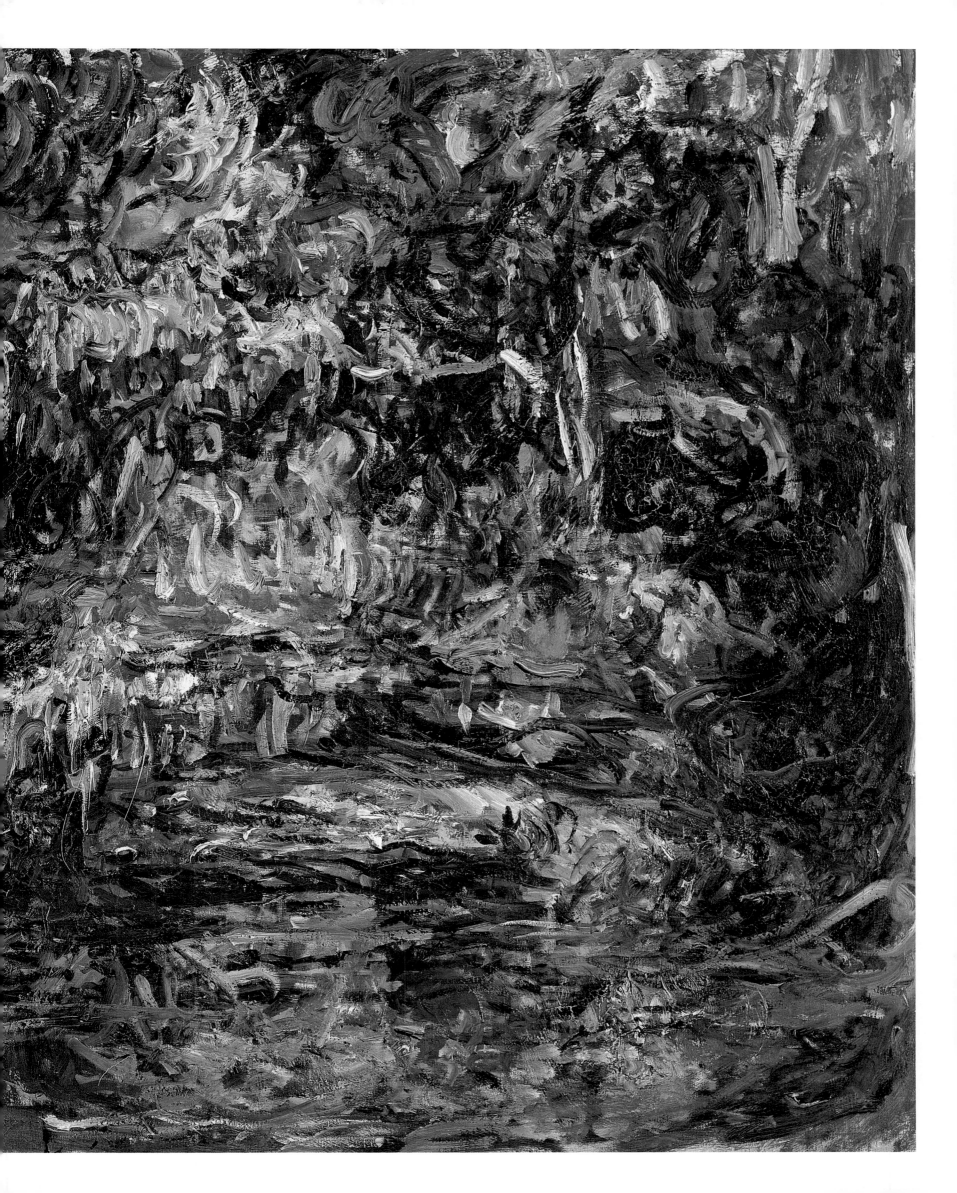

THE LAST YEARS
The second decade of the twentieth century dealt Monet a series of severe personal blows. His wife Alice passed away in 1911, and only three years later his son Jean died as well.

Once World War I broke out, the painter no longer left Giverny. He had leased another plot of land in the Rue du Chêne at the west end of Giverny, the Maison Bleue, and constructed a vegetable garden there. Most of the yield he delivered to the nearby field hospital.

A further blow was that his sight steadily deteriorated as he grew older, a catastrophe for a painter. In 1912 a cataract was diagnosed, and in subsequent years his eye disease was an ever-increasing cause of mental suffering associated with bouts of profound depression. During these years he produced a series of impressive paintings markedly influenced by his ailment, and in their wild, energetic brushstrokes they look almost abstract. Particularly in their colour, which are dominated either by strong tones of red or deep blue and green, it is obvious how difficult the cataract made his work and impaired his perception of colour.

The Grande Allée overgrown with rose arches, the weeping willows, various views of his house with roses and above all the Japanese bridge were the subjects he now painted in vigorous, exaggerated colours. If we compare these pictures with works depicting the same subjects from earlier times, the changes become even more palpable. Shapes were now more or less diagrammatic and seemed to dissolve in colour, so that the pictures almost looked abstract.

In May 1922, Monet more or less went blind, but a series of operations and the aid of tinted glasses brought some improvements to his sight for a period so that he could continue work on the *Décorations*, which held him in thrall to the end.

Monet died on 6 December 1926 in Giverny, and was buried in the family grave in the village cemetery. The house and garden in Giverny were inherited by his son Michel, but it was Monet's stepdaughter Blanche who lived there and looked after the garden to her death. After World War II the gardens became overgrown until, on the death of Michel Monet, ownership passed to the French state and the Academy of Fine Arts. From the 1970s, years of work went into reconstructing and restoring it, thanks primarily to liberal sponsorship mainly by American benefactors, and since 1980 it has been open to the general public.

This painting has been associated with Monet's eye condition.
After his cataract was operated on he suffered initially from xanthopsia (seeing yellow), then cyanopsia (seeing blue). To counteract incorrect colour perception he later wore glasses with tinted lenses.
The House Seen from the Rose Garden, c. 1922–24. Musée Marmottan, Paris

THE FLOWERS OF THE PAINTER

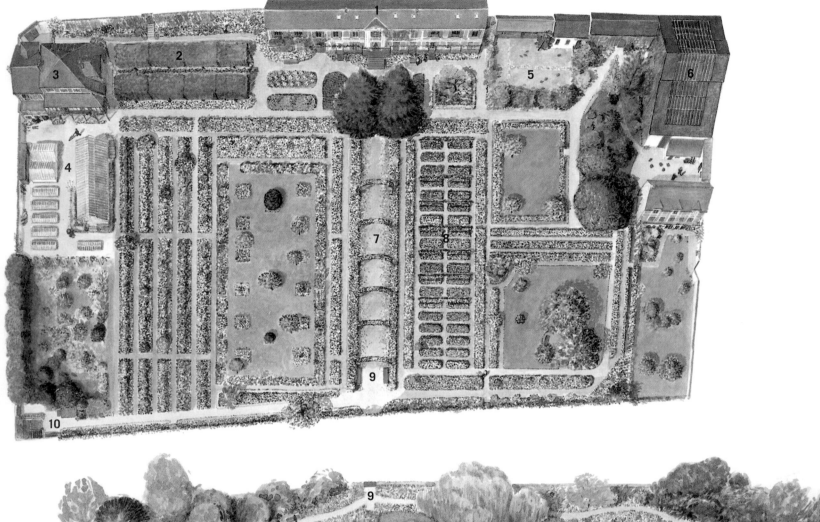

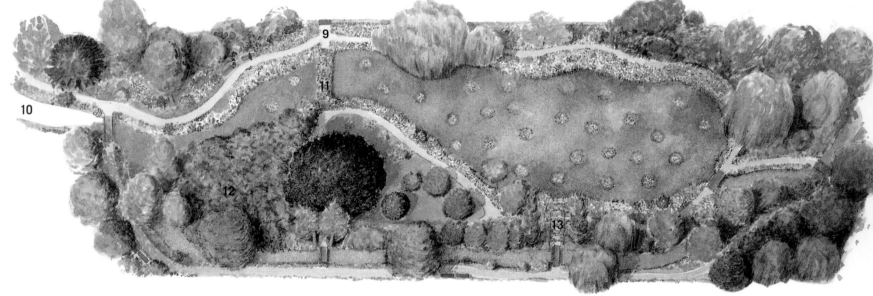

1 Monet's house, with the first studio in the left wing
2 Avenue of limes
3 The second studio
4 Greenhouses
5 Poultry yard
6 The water lily studio
7 The Grande Allée
8 Paintbox beds
9 The former main gates
10 The present-day entrance to the water garden through the pedestrian tunnel beneath the road
11 The Japanese bridge
12 The bamboo thicket
13 The rose arches beside the water lily pond

'PERHAPS I OWE IT TO THE FLOWERS THAT I BECAME A PAINTER.'

Claude Monet

THE GARDEN OF GIVERNY

The reconstruction of Monet's garden is now a place of pilgrimage for garden lovers. Every season, around half a million visitors stream into Giverny to admire the painter's garden and gain inspiration for their own gardens and paintings.

The wide variety of plants available these days at nurseries and garden centres was not available in Monet's time. The same applies to many flowers that now flourish in Monet's garden in Giverny. When the garden was resurrected, a flower paradise was created to reflect the spirit and concept of Monet's creation. An exact reconstruction was not possible, however, and not only because no precise plans or drawings exist. Over the years, Monet himself had kept changing things bit by bit, trying out many new ideas. He not only had a large botanical library but also kept in touch with developments by subscribing to gardening periodicals such as *Jardinage*, ordering nursery catalogues and going to exhibitions, constantly on the lookout for botanical novelties. He frequently ordered them by post or brought them back with him from his travels. He was also given cuttings by friends such as Emile Varenne, head of the Botanical Gardens in Rouen. Monet's garden was a living organism in constant change. In his pictures, he recorded a great variety of impressions, and it is only through them that we get a closer idea of what was there during Monet's lifetime.

A typical feature of Monet's garden is the Impressionist wealth of colour, displaying a mastery of colour combinations and fine gradations as well as the impression of opulence. Not an inch of soil is left unused in Giverny. There are climbing plants on trellises, woody plants, perennials, bulb and tuberous plants, annuals and biennials that grow to varying heights in several rows as freely growing counterparts to the orderliness of the formal gardens. Monet mixed wild flowers with exquisite nursery products and ordinary domestic flowers with exotica.

In the course of a year, the garden goes through a succession of phases. In the early part of the year the structure is still easily recognisable, but the formal arrangement increasingly gives way to an extravagant abundance as one colour explosion follows another. A secret of beautiful gardens is that they reveal their treasures at every season of the year. Monet always made sure that his gardens provided new aspects and subject matter for his pictures throughout the year.

The flower garden slopes slightly to the south in front of the house. The sunny position offers good conditions for flowering plants throughout the season. Three colour schemes constantly recur. On one side there are monochrome beds in which a large number of similar flowers have an intoxicating effect. In other places, graded colour tones on a colour theme unfold into a subtle orchestra of colour. In yet other beds, Monet worked with the strong effects of contrasting colours.

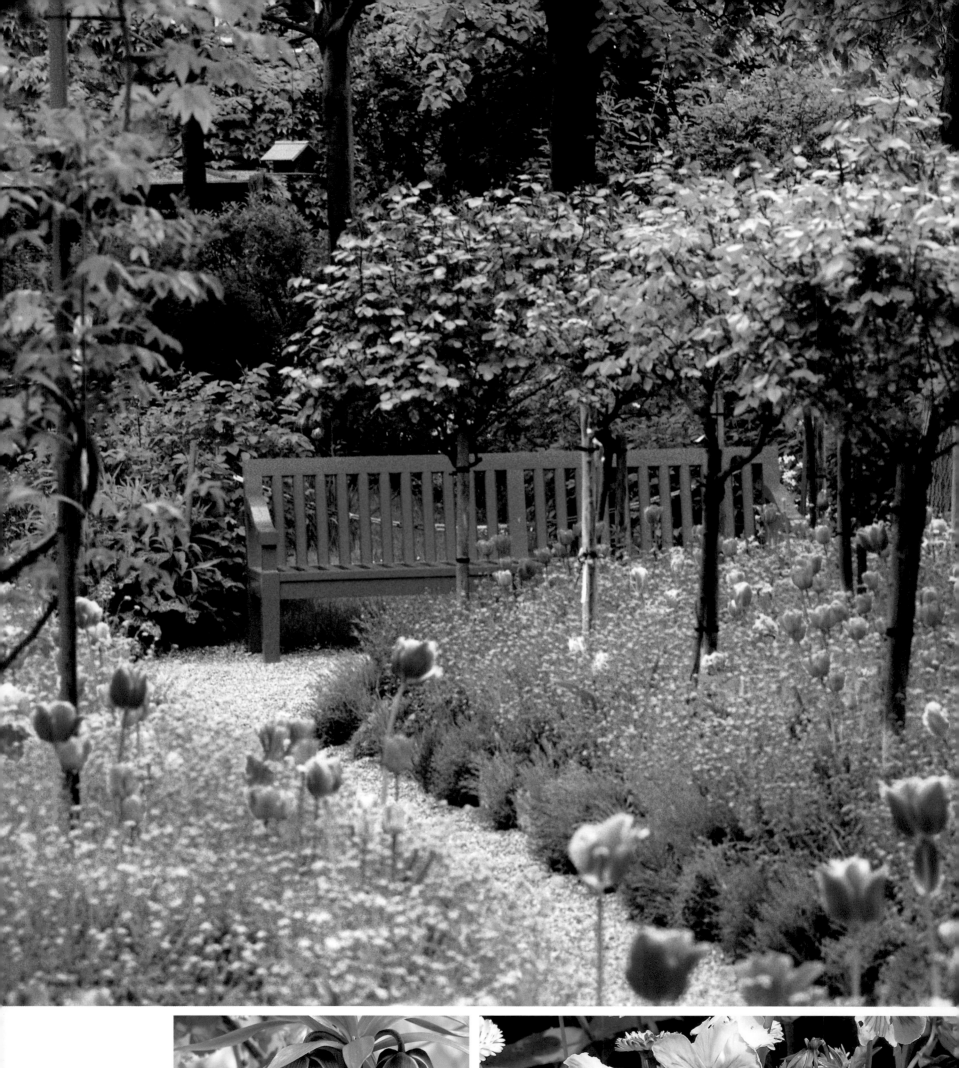

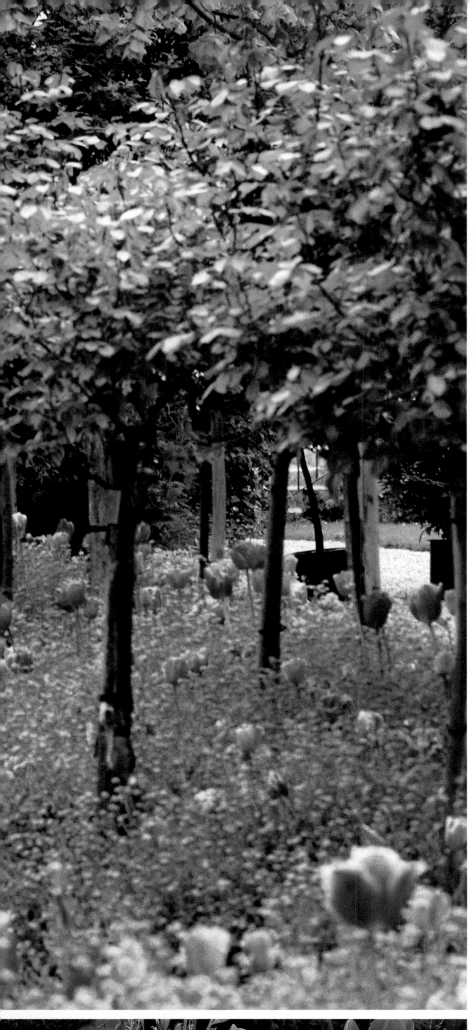

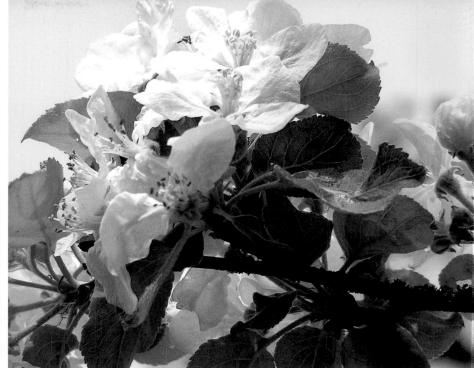

SPRING—THE GARDEN AWAKENS

In spring, the shapes and structures of the garden can still be clearly recognised. It comes to life with tulips—clouds of brilliant colour float over the bright green of spring.

Rose-coloured tulips are underplanted with bright blue forget-me-nots (*Myosotis*) in the beds in front of the house (left). Strong colour highlights are provided by red and yellow tulips together with yellow and orange wallflowers (*Erysimum cheiri*) or combinations of complementary colours such as orange with blue or yellow with violet. Inspired by the impressive colour surfaces of the tulip fields in Holland, which he saw and painted in 1886, Monet often laid out beds with flowers of the same colour in harmonious gradations—a feature that is taken up again and again in variations throughout the year.

Above:
The month of April is the time of the apple blossom.

Spring flowers: Tulips with forget-me-nots or wallflowers in red and orange, pastel hued horned pansies (*Viola cornuta*) and impressive crown imperials (*Frittillaria imperialis*).

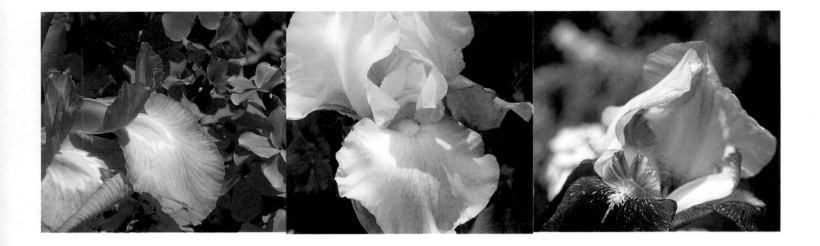

THE BLUE MONTH OF MAY Irises—the *fleur-de-lys* in the

Bourbon coat-of-arms—are a symbol of France. In May, when the irises flower, is possibly the best time to visit Monet's garden. They were one of the flowers he painted quite often.

Although bearded irises (*Iris germanica*) love sun and dry soil, they also flourished marvellously in the shade beneath the trees in Monet's orchard. Arranged in loose clumps, they form islands of flowers in among the fruit trees. Monet planted a wide variety of them in both the flower garden and the water gardens, where there are moisture-favouring varieties such as Japanese water irises (*Iris ensata*), *Iris sibirica* or yellow flag irises (*Iris pseudacorus*).

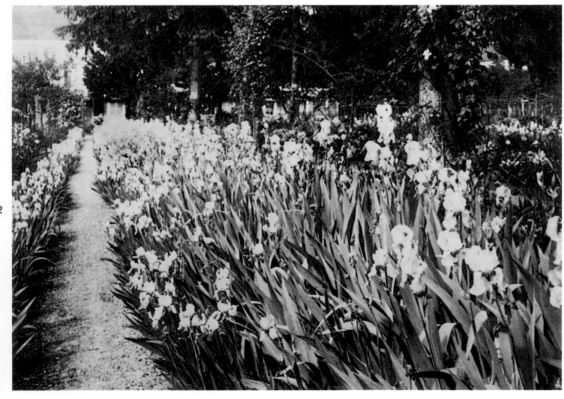

Above and right:
Countless varieties of irises can be discovered today in Giverny.

Left:
Irises in various tones of blue bloom in May besides the paths west of the Grande Allée.

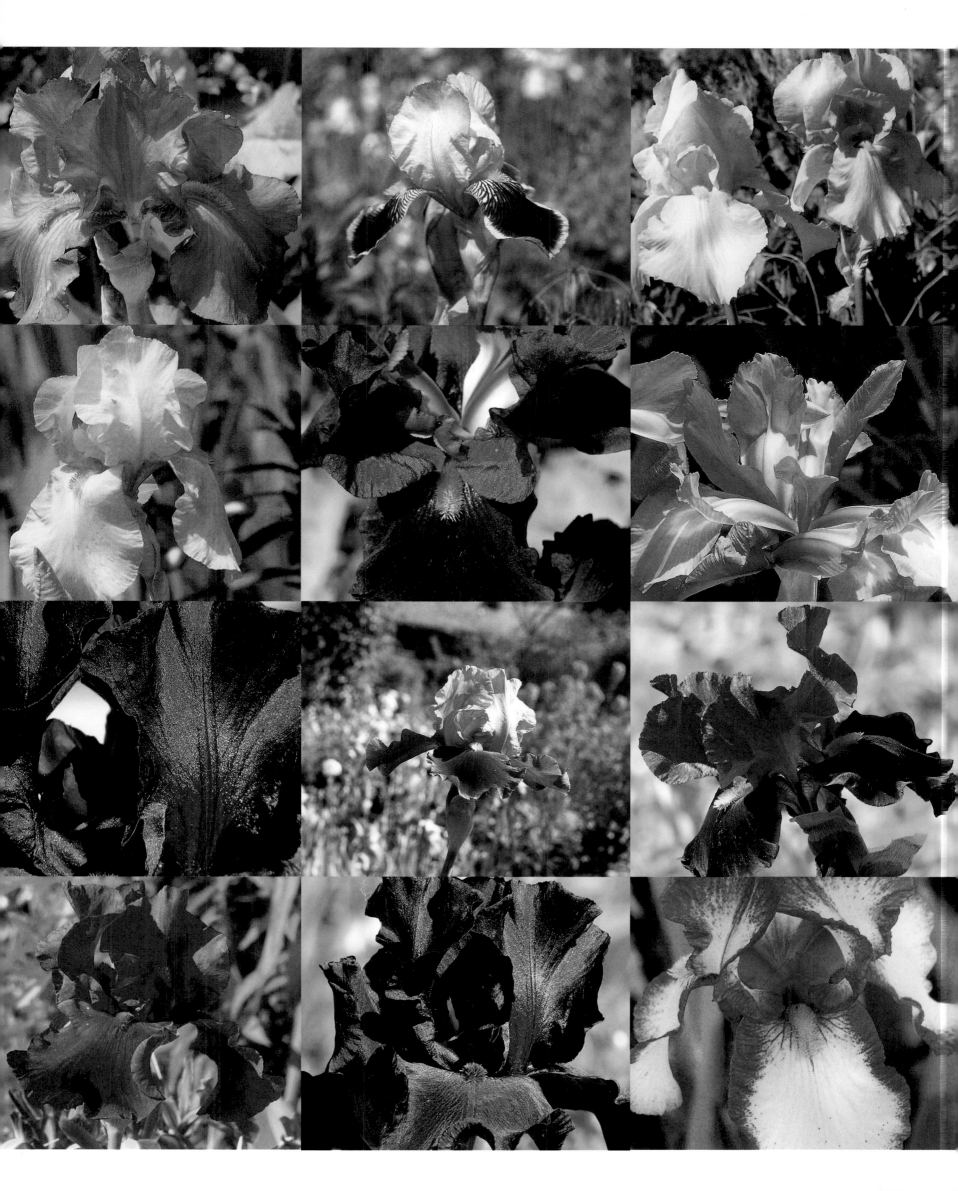

'THIS MAN DID NOT LIKE FUSS. HE WOULD HAVE NOTHING TO DO WITH THE ARTIFICIAL JOYS OF CELEBRITY. INTOXICATED BY LIGHT, HE DEVOTED HIMSELF ENTIRELY TO THE PLEASURE OF OPENING HIS WINDOW AND LOOKING, IN ORDER TO TRANSLATE THE SENSATIONS HE ABSORBED WITH EVERY NERVE END FROM THE WORLD OUTSIDE, AND IF POSSIBLE GET SOMETHING OF THE UTTER DELIGHT IN COLOUR DOWN ON CANVAS.'

Georges Clemenceau

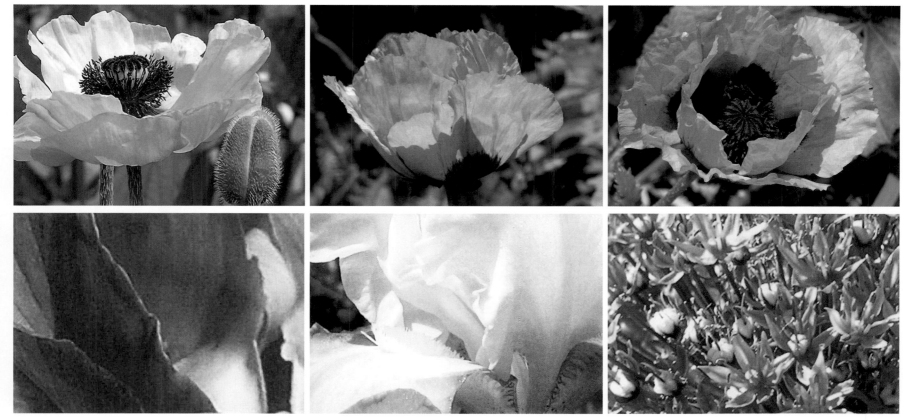

In beds with pastel colours there are oriental poppies (*Papaver orientale*) in delicate pink shades as well. Monet had a particular affection for the translucent fragility of their petals. The large violet blooms of ornamental allium (*Allium aflatunese*, *Allium christophii* or *Allium giganteum*) likewise go perfectly with the iris varieties.

In the mixed flower beds of the Giverny flower garden there are fascinating groupings of irises in various colours with a wide variety of accompanying plants. Sometimes the colours of the blooms are co-ordinated in delicate graded tones, while in other places they are bright with strong colours. A typical combination for Monet is blue, or rather violet with yellow. Sometimes, on both sides of a path, flowerbeds are planted in modified colour tones. For example, gradations of blue tones on one side of the path correspond with various red tones on the other side.

Left:
The paths running parallel to the Grande Allée are densely planted with bearded irises (*Iris germanica*) in various shades of blue and lilac. In the painting, they run through the flower garden like bright blue strips. *Iris Bed in Monet's Garden*, 1900. Musée d'Orsay, Paris.

Below:
Harmonious colour gradations form rows of deep blue bearded irises (*Iris germanica*), light blue *Iris spuria* and dame's violets (*Hesperis matronalis*).

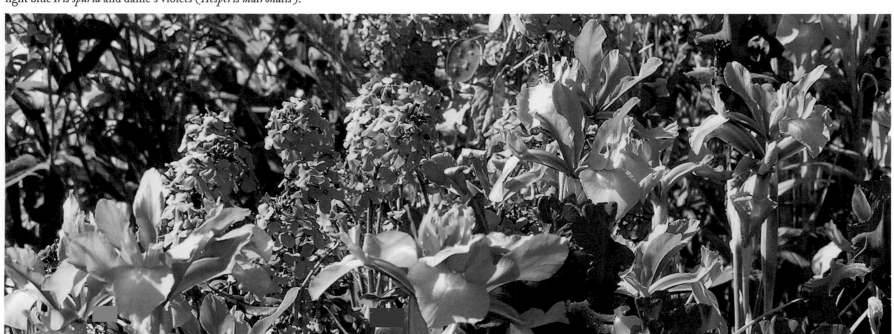

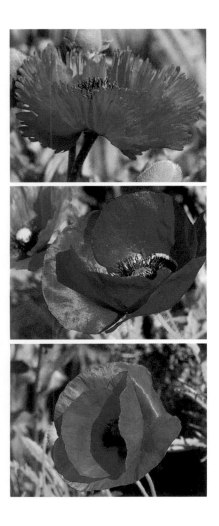

POPPIES Monet was always painting meadows full of corn poppies (*Papaver rhoeas*) around Argenteuil, Giverny and elsewhere—fascinated by the vivid signalling effect of the orange-red flowers. He placed spots of red in his garden with large-bloom oriental poppies (*Papaver orientale*) or red field poppies (*Papaver rhoeas*), which are almost his trademark, and the likewise annual opium poppies (*Papaver somniferum*).

Above:
Unique varieties of poppy can be found in Giverny—even sorts with enchanting frilly leaves.

Right:
One of Monet's most famous paintings comes alive from the brightness of red dabs of poppy colour.
Poppy Field near Argenteuil, 1873. Musée d'Orsay, Paris

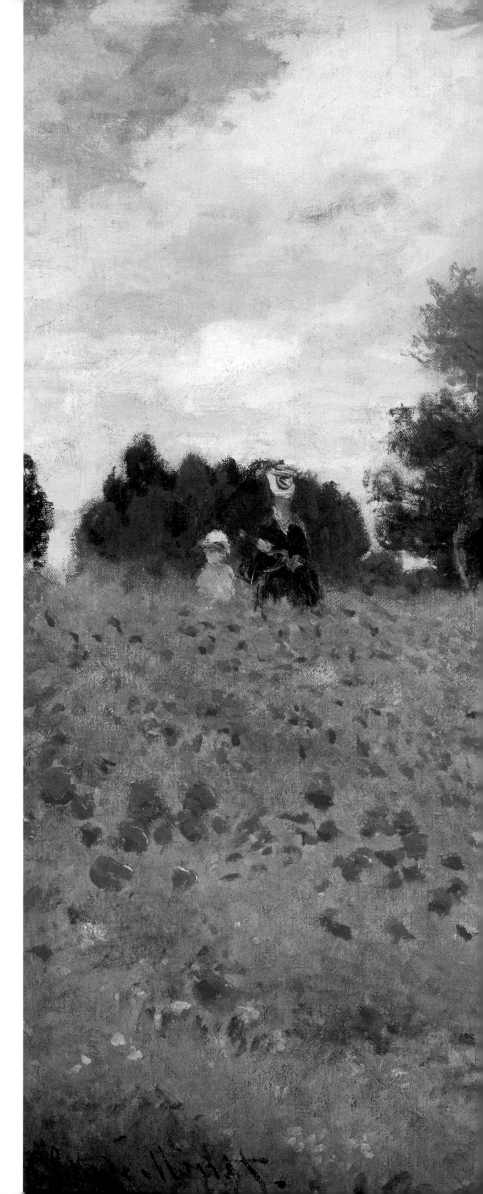

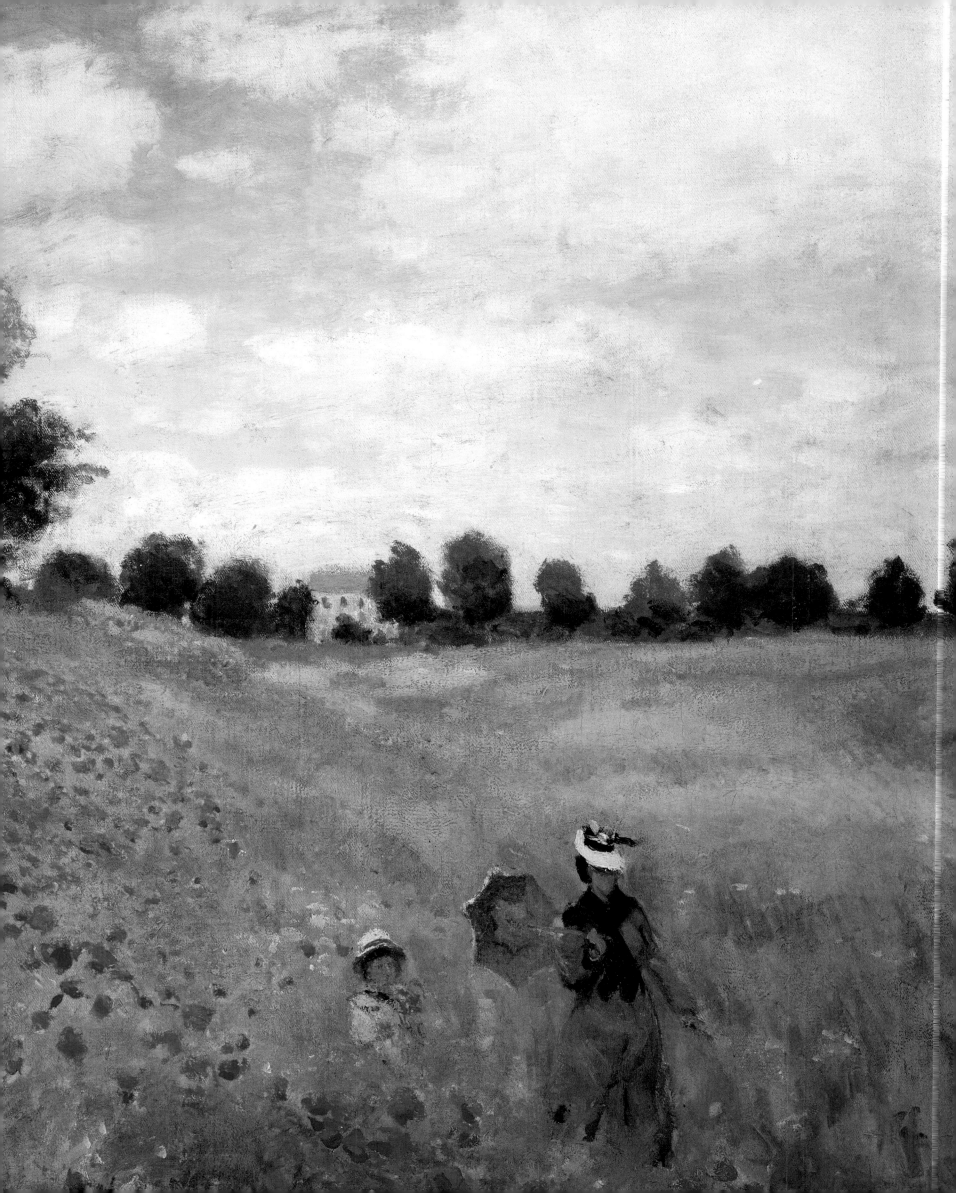

ROSE MAGIC The most notable feature of the famous image of Giverny is the rose tunnel, which still overarches the main path to Monet's house. A blooming canopy of climbing roses in various colours grows over the iron-arched flower tunnel, while in summer the ground vanishes beneath a carpet of nasturtiums (see pp. 88–89).

But Monet also planted roses in all other conceivable places in the garden. Along the garden wall west of the house and in the long bed between the paths tree roses, shrub roses and small roses bloom forming several layers. In the Clos Normand, roses tumble in luxuriant cascades over bell- or mushroom-shaped trellises made of iron, which Monet is supposed to have invented specially for his weeping standard roses. Monet's love of roses was very uncommon for the time. In his day, shrub roses were considered to be commonplace vegetable-garden flowers, and were not quite the thing for showpiece gardens.

However the so-called 'pillar rose', that wound round trellises, was the latest fashion in Monet's day. Roses also climbed up the trellis along the front of the house, so that the painter could smell the delicate scent of the light yellow 'Mermaid' ramblers through the windows of his bedroom.

Varieties from Monet's time that are still in his garden today include the 'Gruss an Aachen' floribunda, the hybrid perpetual 'Baronne Adolphe de Rothschild' (Baroness Rothschild) and centifolia moss rose 'Blanche Moreau'. The 'Claude Monet painter' rose by the grower Delbard is a modern cultivar and has nothing to do with Monet himself other than the name.

78

Above:
Rose blossoms in Giverny

Right:
View into the rose tunnel (left picture).
One of the painter's favourite places was the
rose bower beside the water lily pond.
He often sat here looking at the water lilies.

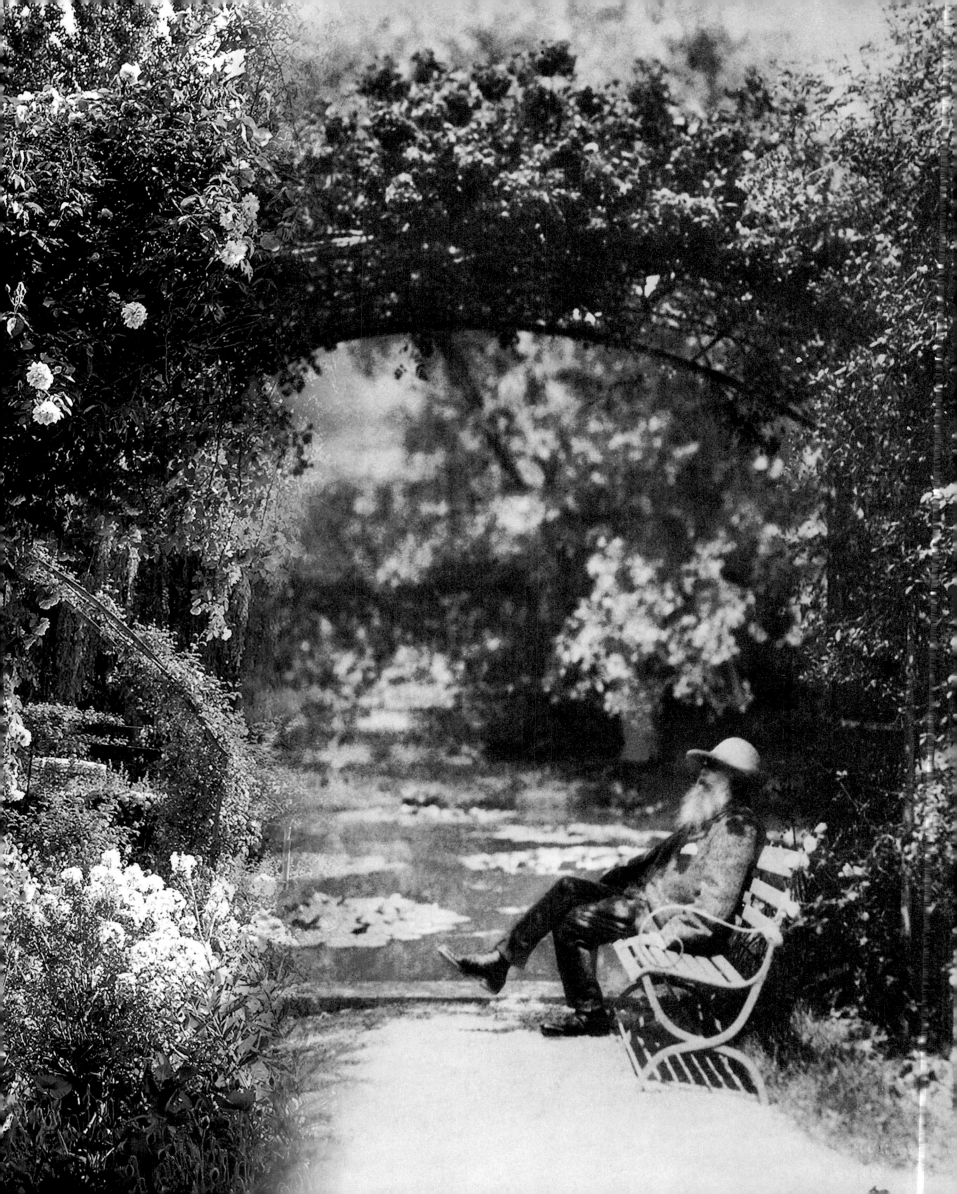

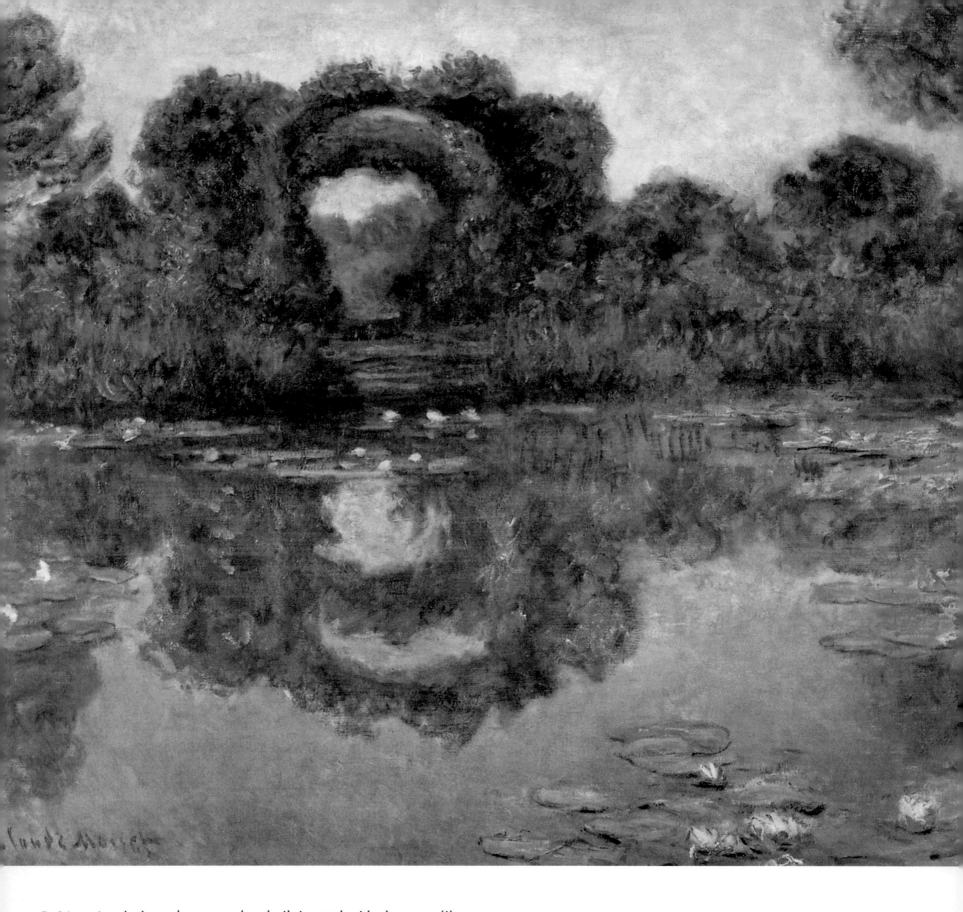

In Monet's paintings, the rose arches, built in 1913 beside the water lily
pond rise majestically in imposing, larger-than-life dimensions like
flowering crowns, reflected in the water in pastel, almost Rococo colours.
80 They form a kind of rose bower directly on the banks of the pond. Monet
liked to sit in it in order to study his water lilies and paint.

Above:
Monet painted this view of the rose arches by the pool in full bloom several times.
Flowering Arches, Giverny, 1913. Phoenix Art Museum, Phoenix, Arizona
Gift of Mr and Mrs Donald D. Harrington

Right:
This photo from 1913 shows the painter in his studio revising one of these pictures.

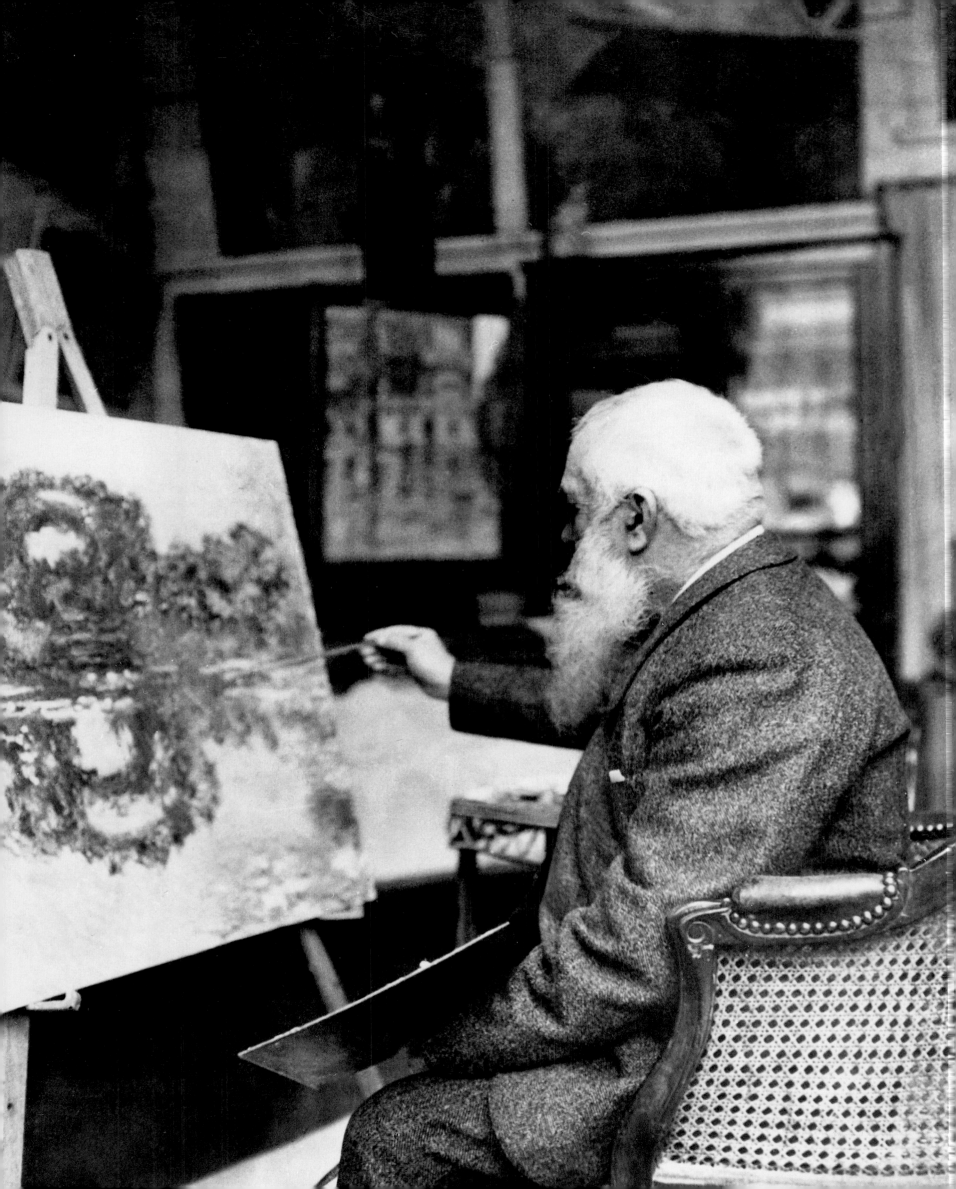

PAINTBOX BEDS

The rectangular beds east of the Grande Allée—thirty-eight in all—are called 'paintbox' beds, because Monet planted flowers in them according to colour. They run in two rows parallel to the main path, and are spanned at right angles by seven trellises.

Here, Monet experimented with colour effects of various colours of flower. He himself planted many flowers of one variety per bed, which produced a splendid effect when they were flowering, but did not last very long. Afterwards, the beds looked rather meagre, as old photos bear out. Later, more opulent plantings were adopted. Nowadays the beds are planted mixed, for a longer blooming period, with Monet's flowers being planted in combination with others.

Here in the 'sunrise beds' there are mainly pastel colours. The flowers form romantic colour combinations in pink, blue, lilac, mauve and white. Colour perspective lent the plantings sophisticated depth effects—strong colours in the foreground are picked up again further back in paler varieties. From north to south there are graded colour shades from cool blue and lilac via red and pink tones to sunny yellow and orange in the southernmost beds.

Right:
Shades of blue and white run through the beds on the northern side: foxglove (*Digitalis purpurea*, below left); *Allium aflatunense* and dame's violets (*Hesperis matronalis*), English daisies (*Bellis perennis*), 'Miss Bateman' clematis, blue *Anemone coronaria*, 'Nevada' shrub rose, horned pansies (*Viola cornuta*) in pastel colours and columbine meadow rue (*Thalictrum aquilegifolium*).

Below right:
This historic photo shows the paintbox beds as originally planted out, with only one kind of flower per bed.

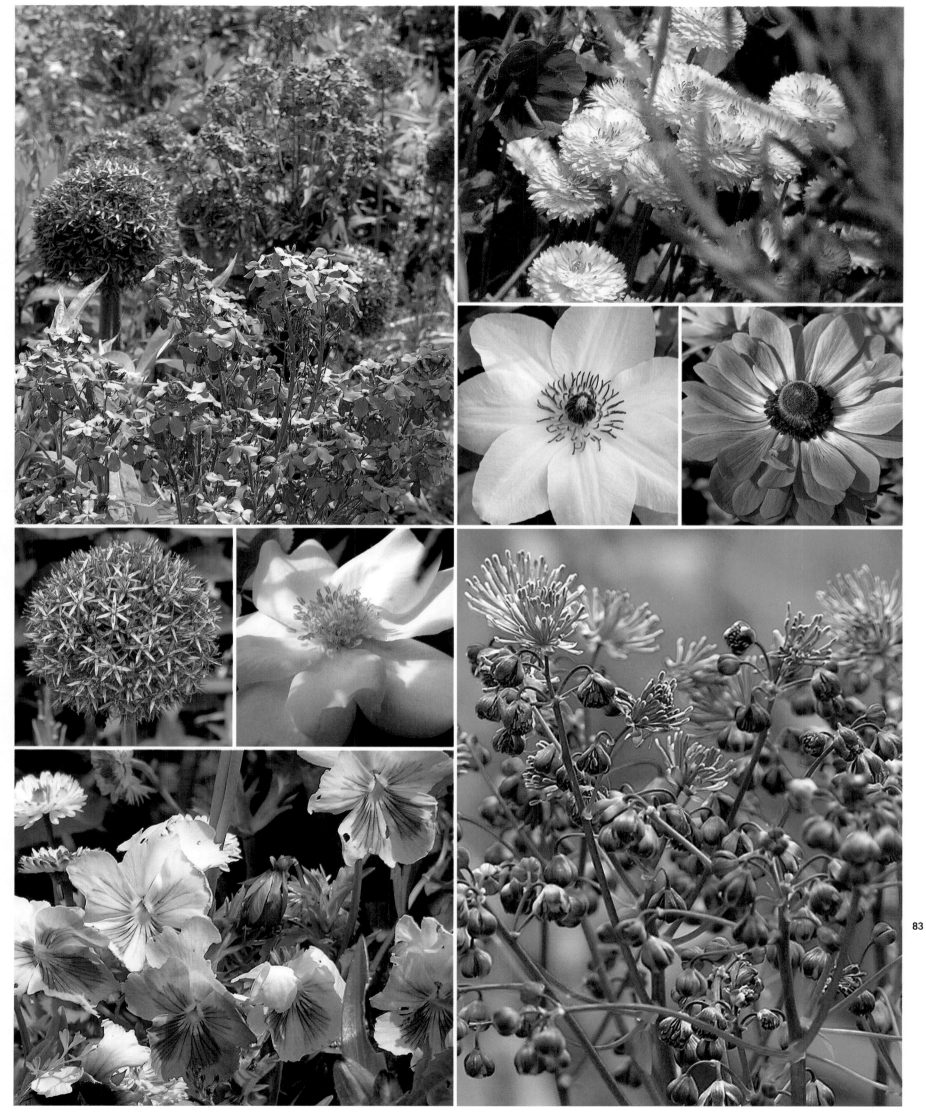

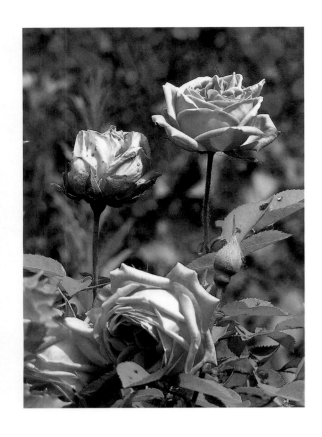

'WHEN I VISIT MONET'S GARDEN SOMEDAY, I'M SURE I SHALL FIND A GARDEN THAT CONSISTS MORE OF COLOURS AND TONES THAN FLOWERS, A GARDEN THAT IS LESS AN OLD-FASHIONED FLOWER GARDEN THAN A COLOUR GARDEN, SO TO SPEAK, WITH FLOWERS THAT ARE FITTED TOGETHER NOT QUITE LIKE IN NATURE, BECAUSE IT HAS BEEN PLANTED SO THAT ONLY THE FLOWERS WITH MATCHING COLOURS WILL BLOOM AT THE SAME TIME, HARMONIZED IN AN INFINITE STRETCH OF BLUE OR PINK...'

Marcel Proust

84 Variations in pink: small roses are included in the compositions (top left and right page), plus dull pink mullein (*Verbascum*), common thrift (*Armeria maritima*), *Anemone tomentosa* and bright *Anemone coronaria*, red champion (*Silene dioica*), columbines (*Aquilegia*) and clumps of sweet william (*Dianthus barbatus*), *Nectaroscordum siculum*, English daisies (*Bellis perennis*), horned pansies (*Viola cornuta*) and hollyhocks (*Alcea rosea*)

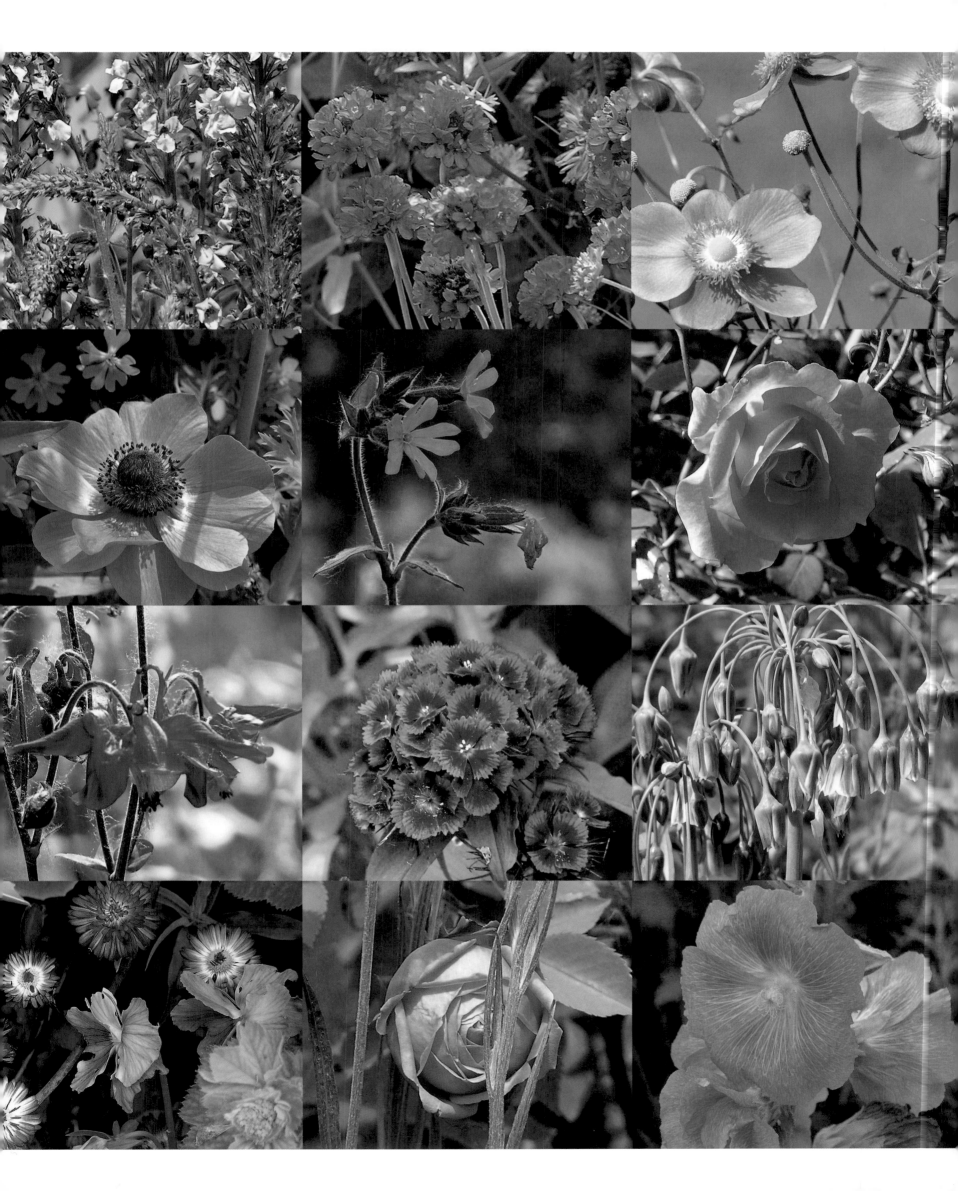

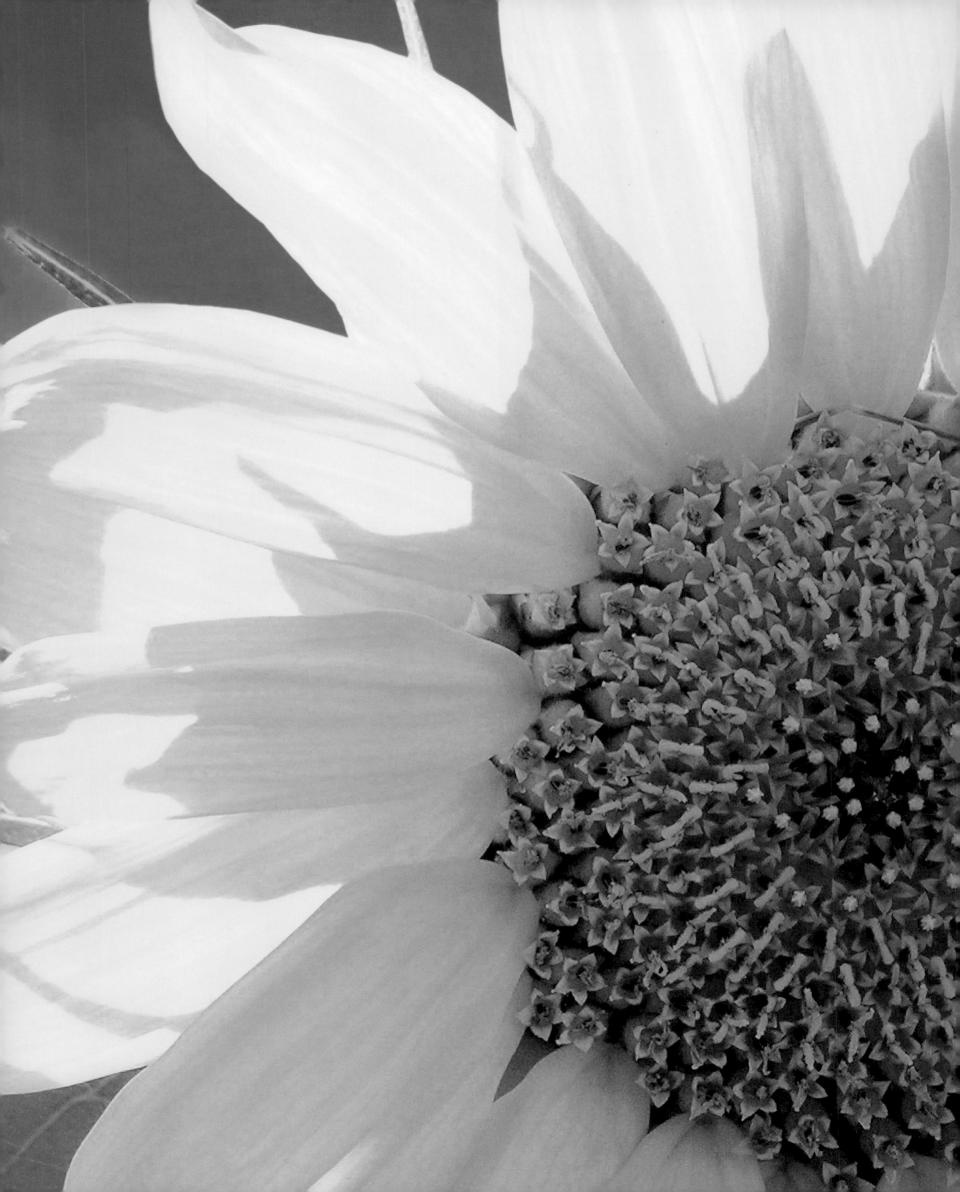

GOLDEN SUMMER

Gold, yellow and purple tones dominate the garden later in the year. The opulent richness of summer flowers blurs the outlines of the layout, as hollyhocks, delphiniums, asters, dahlias, mullein and sunflowers grow tall.

The fifteen long beds in the western part of the garden are called the 'sunset beds'. Originally they were raised, and fringed by tiles or stones. In summer, yellow, orange, red and bronze-coloured as well as brown plants flower here.

In the Grande Allée, tall purple asters form a bright complementary colour contrast to the yellow of the sunflowers (*Helianthus annuus* and *Helianthus pauciflorus*, which grows like a weed) and marigolds. Dahlias of the 'jet' variety constitute bright red highlights between them. The beds on the sides of the main path are heaped up into mounds, making the effect of the plants even more imposing. Particularly attractive in high summer are the nasturtiums, which spread across the path and in the end almost completely cover it (following double page).

Annual sunflower, flowering maple (above) and rudbeckia 'Goldsturm' (*Abutilon*)

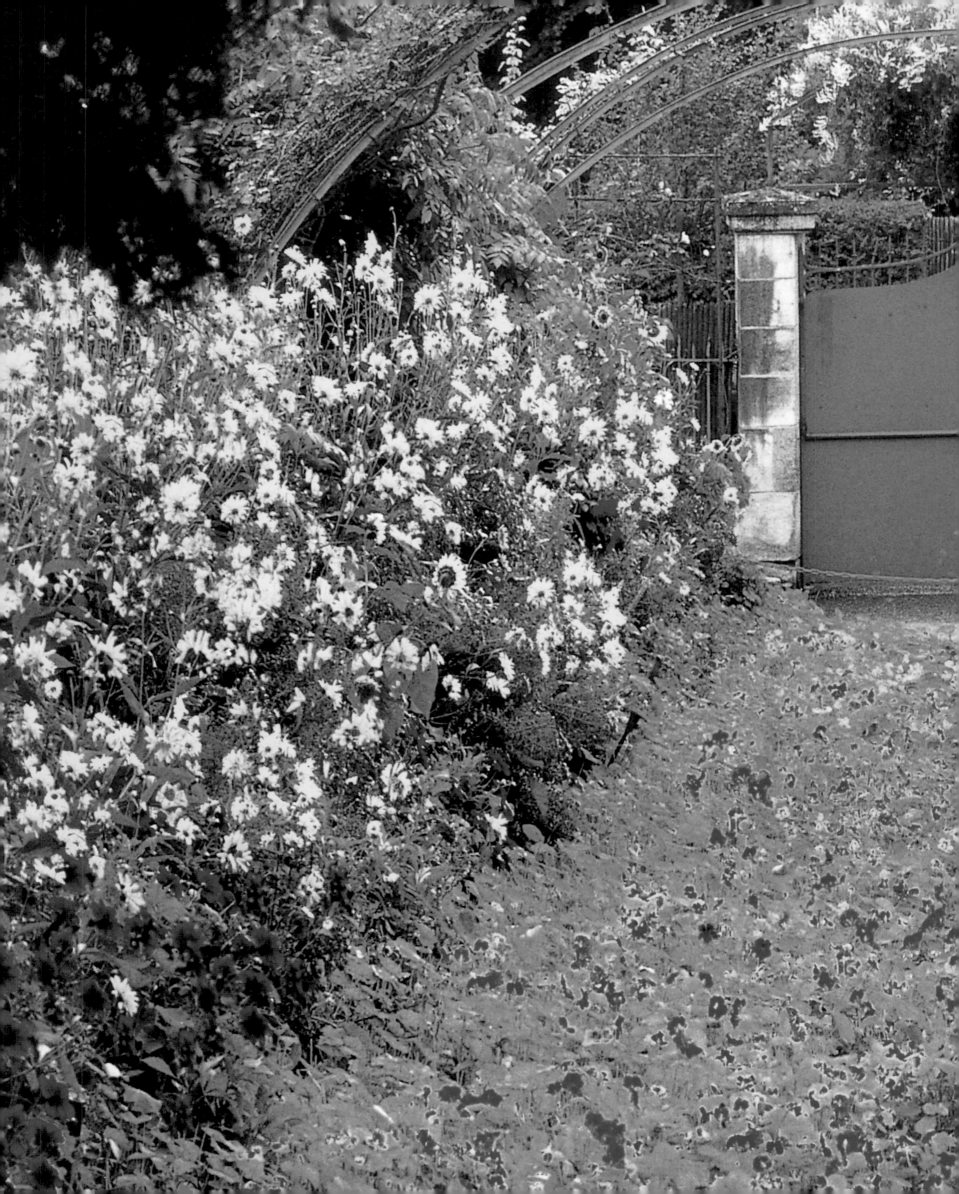

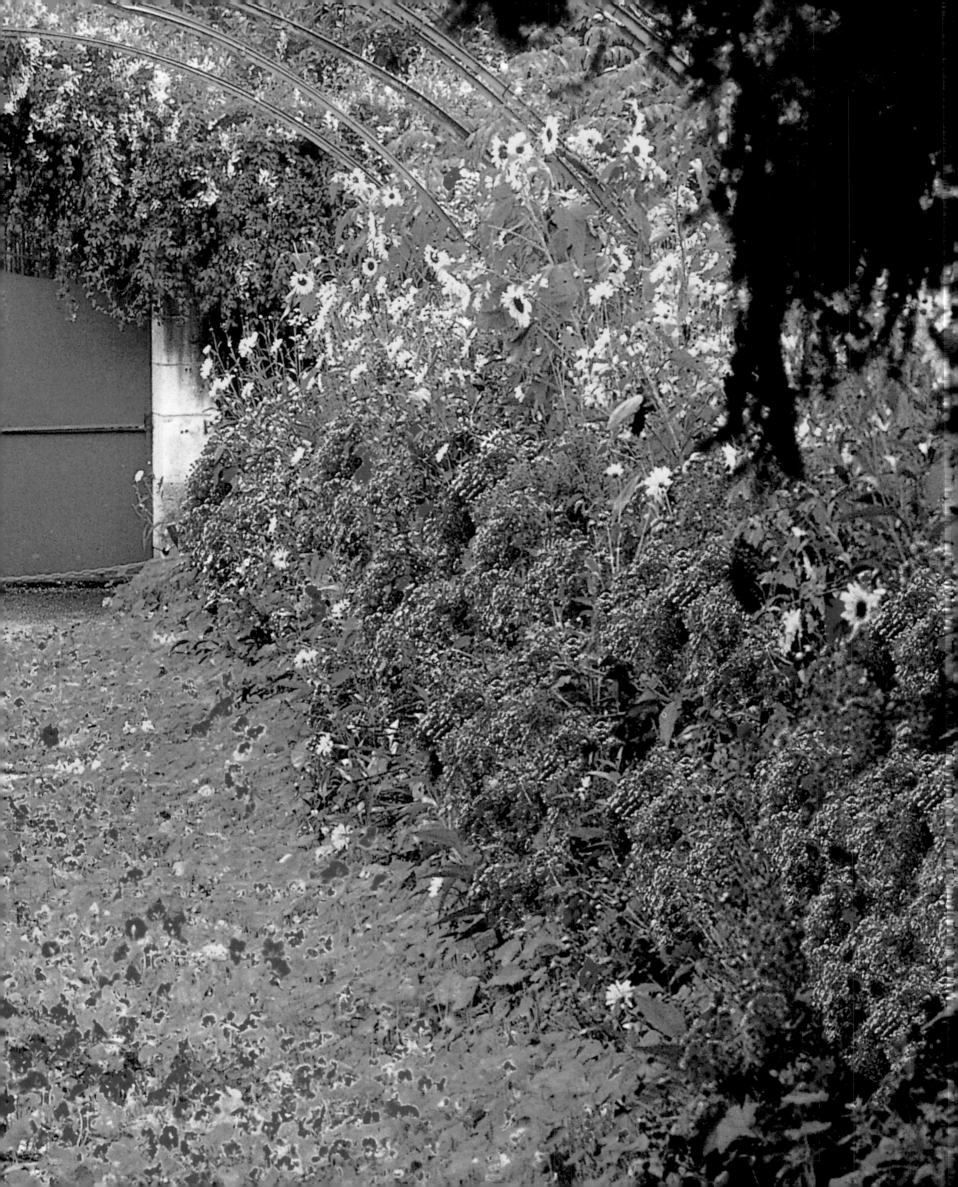

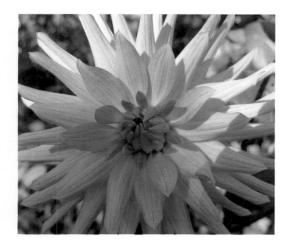

DAHLIAS Monet's love of these exotic plants is documented by paintings from his time in Argenteuil. Imported from Mexico in the seventeenth century, dahlias were the most fashionable flower of all in the nineteenth century. In Monet's time, novel varieties included cactus dahlias, which he was very keen on. Pompon dahlias were less to his taste. Nowadays the simple star-shaped 'Étoile digoinaise dahlia' or 'Stella', which was highly fashionable around 1920 and according to all the sources must have formed a notable feature in Giverny, is scarcely available in the trade. Today, along with various more recent cactus dahlias, there are anemone-flowered dahlias and decorative dahlias.

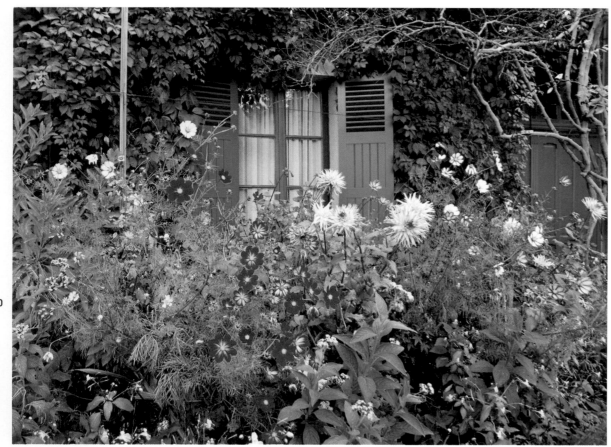

Left:
The dahlias outside Monet's studio window in Giverny flower into the late autumn.

Right:
Monet planted and painted dahlias even in his previous gardens.
Detail from *Monet's Garden in Argenteuil (Dahlias)*, 1873.
National Gallery of Art, Washington, D.C.

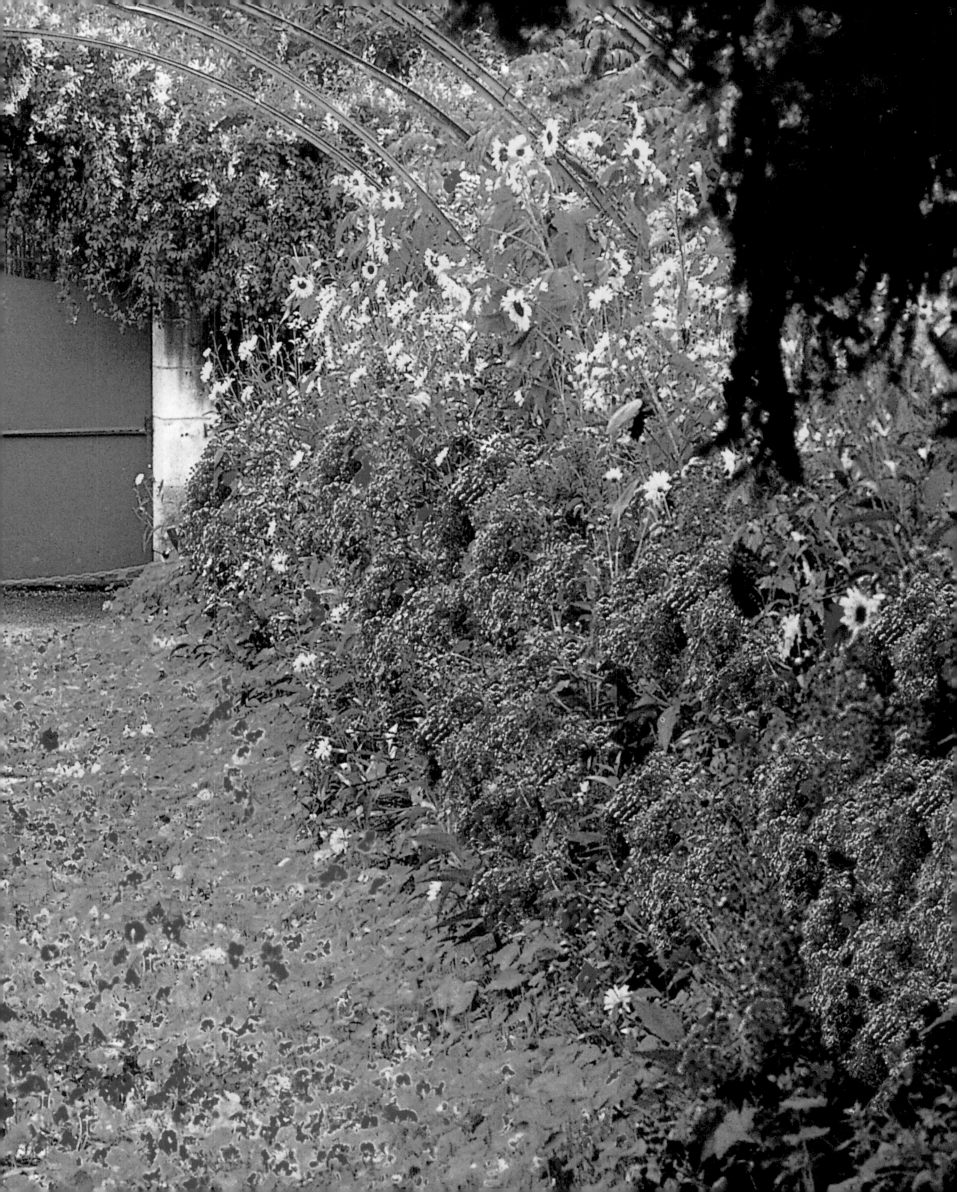

DAHLIAS

Monet's love of these exotic plants is documented by paintings from his time in Argenteuil. Imported from Mexico in the seventeenth century, dahlias were the most fashionable flower of all in the nineteenth century. In Monet's time, novel varieties included cactus dahlias, which he was very keen on. Pompon dahlias were less to his taste. Nowadays the simple star-shaped 'Étoile digoinaise dahlia' or 'Stella', which was highly fashionable around 1920 and according to all the sources must have formed a notable feature in Giverny, is scarcely available in the trade. Today, along with various more recent cactus dahlias, there are anemone-flowered dahlias and decorative dahlias.

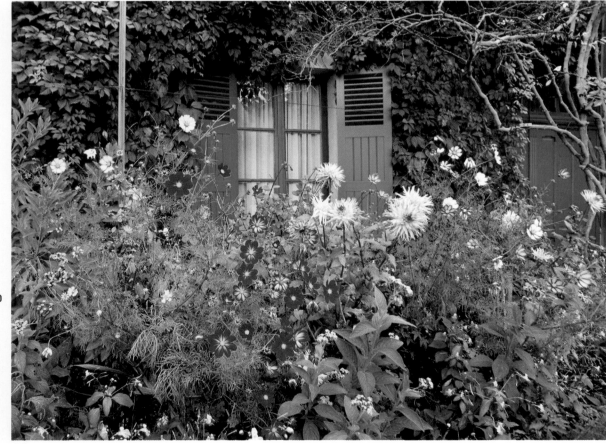

Left:
The dahlias outside Monet's studio window in Giverny flower into the late autumn.

Right:
Monet planted and painted dahlias even in his previous gardens.
Detail from *Monet's Garden in Argenteuil (Dahlias)*, 1873.
National Gallery of Art, Washington, D.C.

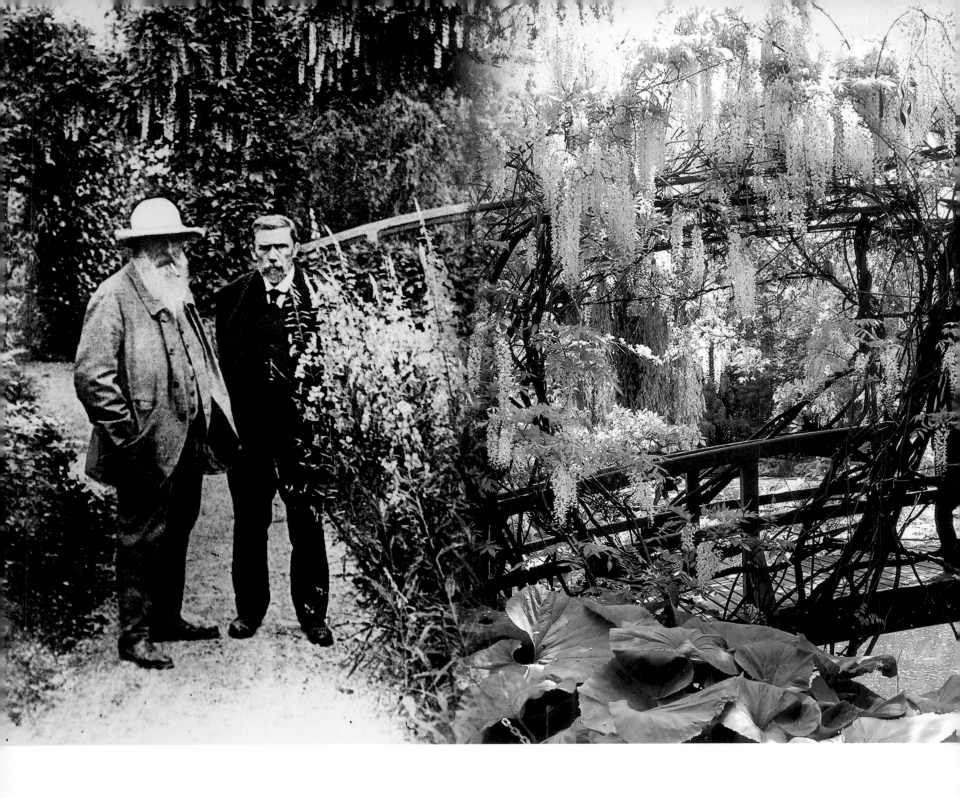

THE MAGIC OF ASIATIC GARDENS That there was

a fashion for the Far East at the time is especially conspicuous in Monet's water garden. Though the layout does not follow the Japanese model, various individual features clearly reveal the *japonisme* of the *fin-de-siècle*.

92

Above:
Claude Monet with Gustave Geffroy in front
of the Japanese bridge. Photo by Sacha Guitry

Above and right:
The Japanese bridge today and as Monet saw it.
The Japanese Bridge, 1919. Kunsthaus, Zurich

The Japanese bridge is of course the most recognizable object in the garden. Lying beyond the road separating the two gardens, it takes up the axis of the Grande Allée, crossing the water lily pond in the water garden. Earlier, this was where the entrance to the garden was, but now you enter it through a tunnel from the west, which unfortunately curtails the effect of the axis linking the two gardens.

Unlike its normally red-painted antecedents, Monet's bridge conforms with the colour scheme of the garden and is painted the same green as the trellises everywhere in the garden.

In later years, the Japanese bridge was overgrown on two levels by Chinese and Japanese wisteria (*Wisteria sinensis* and *Wisteria floribunda*)—lilac flowering wisteria grew on the tall trellis, while the white wisteria originally spread over the balustrades.

Now the wisteria only grows on top. When it flowers in May and June, the air is filled with its lovely scent. Another wisteria grows on a separate trellis on the north-eastern bank of the pool.

In 1919–20, Monet painted a whole series of panels with garlands of wisteria, creating long friezes in huge formats to record the shimmering play of flowers and leaves against the sky (see p. 95).

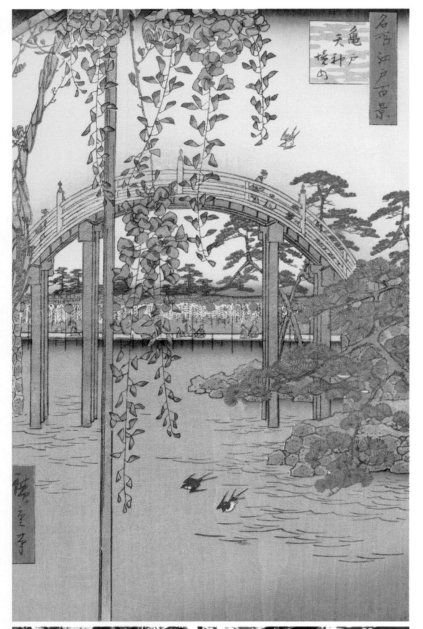

'THE REST OF THE GARDEN IS AS IF IT WERE ONLY A QUIET POOL FLOWERING WITH BRIGHT WATER LILIES, EXTENDING BENEATH THE WISTERIA-CLAD ARCHES OF A PICTURESQUE JAPANESE BRIDGE, THE ONLY CONCESSION TO THE ROMANTICISM OF THIS PLACE.'

Georges Clemenceau

94

Above left:
Ando Hiroshige, *Wisteria*, 1857, from the series
One Hundred Famous Views of Edo

Left:
The *Wisteria sinensis 'alba'* on the Japanese
bridge is the one that Monet planted.

Right:
Giant wisteria, two metres wide.
Wisteria, 1919. Haags Gemeentemuseum, The Hague

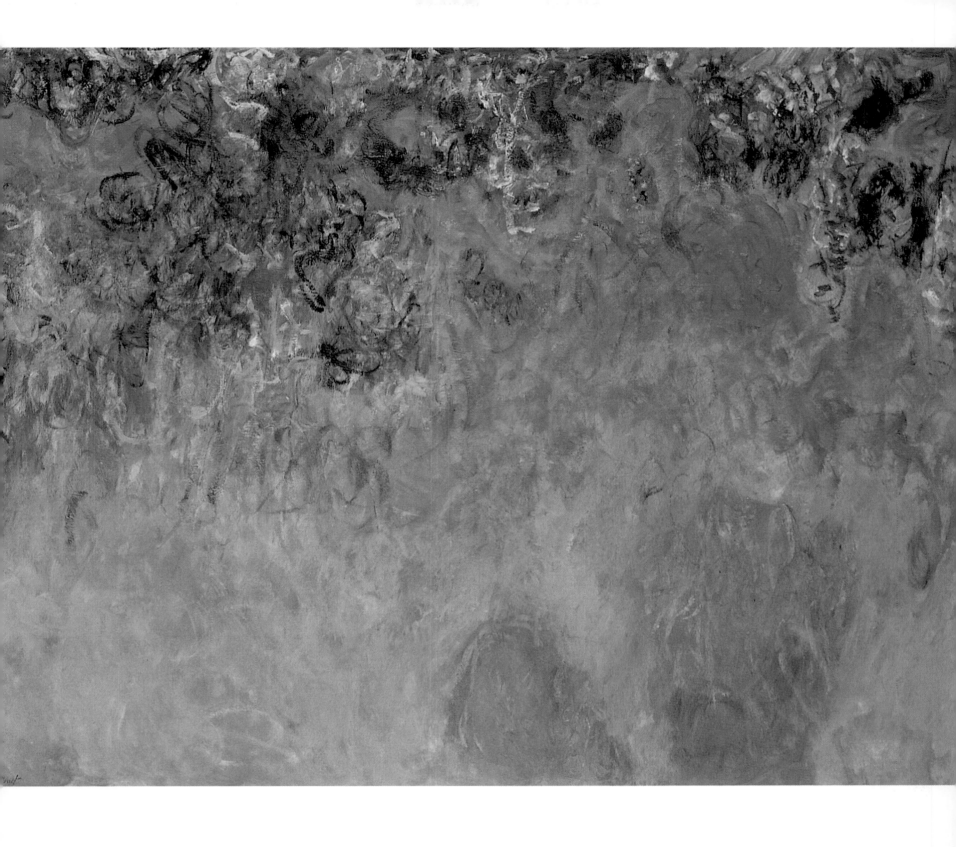

'THE PEONY BORDERS, WHICH RANGE FROM WHITE WITH YELLOW SPOTS TO A VIVID RED SHADING TO VIOLET, BENEATH LABURNUMS, CONVEY THE FEELING OF BEING TRANSPORTED TO THE SUBURBS OF YOKOHAMA.'

Georges Truffaut

Monet's tree peonies, of whose former glory only a few plants survive, used to grow where now a huge copper beech stands. For his exquisite collection of these rare plants, which he ordered directly from Japan, the painter uncovered circular areas in the grass that repeated the shapes of the water lily islands in the pool, thus underlying their Asiatic effect.

Another Far Eastern–inspired motif is the bamboo thicket in the southern part of the garden. Whereas Truffaut felt he might have been wafted off to a Japanese city when he saw the tree peonies, the bamboo is reminiscent of an Asiatic jungle. Monet laid out the thicket himself and it has since developed into an impenetrable wood with a fascinating play of light and shadow.

Above:
One of the last remaining tree peonies.

Left and right:
The bamboo thicket in Monet's
garden as it once was and as it is today.

PARADISE IN THE SHADE

Winding paths, large monumental shapes and a succession of new, surprising views with a shady ambience are the distinctive features of the landscaped park around the water lily pond.

The colours and shapes of the leaves have a structural function in the design of the water garden. Red-leaved trees, shrubs with white variegated leaves or large solitary plants such as giant hogweed (*Heracleum*) provide fascinating highlights.

Among the special features are a gingko tree and the red feathered foliage of Japanese maple (*Acer palmatum*). The large round leaves of *Petasites* form a charming contrast to the lancet-shaped leaves of irises, day lilies (*Hemerocallis*), agapanthus and tradescantia—a formal variant of the water lily leaves Monet painted with lilies and irises.

In early summer, the flowers of the rhododendrons produce some splendid colour effects. These plants require acidic soil, so Monet had large quantities of Giverny's rather chalky soil removed and exchanged for peat.

98

Above:
Large leaves of *Petasites* at the water's edge and white-green flickering dogwood (*Cornus*).

Above right:
The round shapes of the water lilies contrast delightfully with the narrow leaves of the plants on the banks. *Water Lilies with Reflections of Tall Grass*, 1914. Private collection.

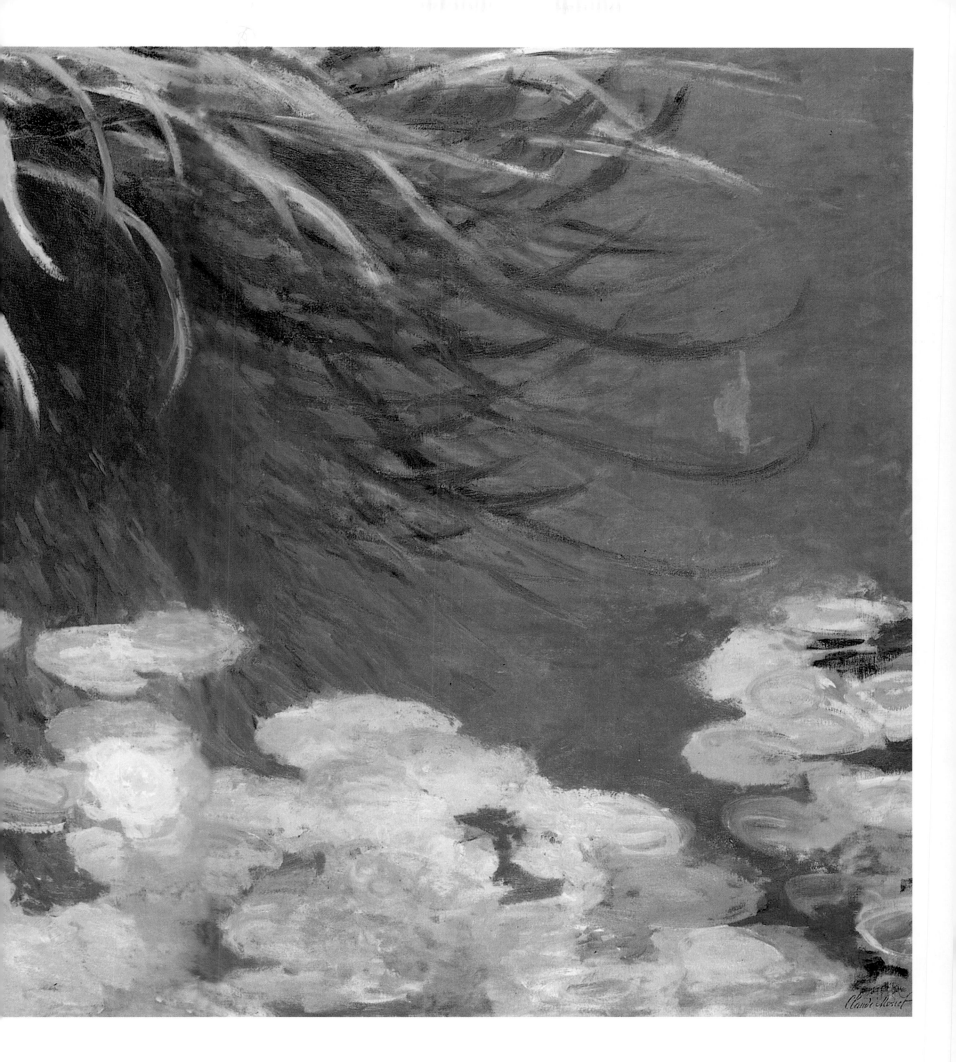

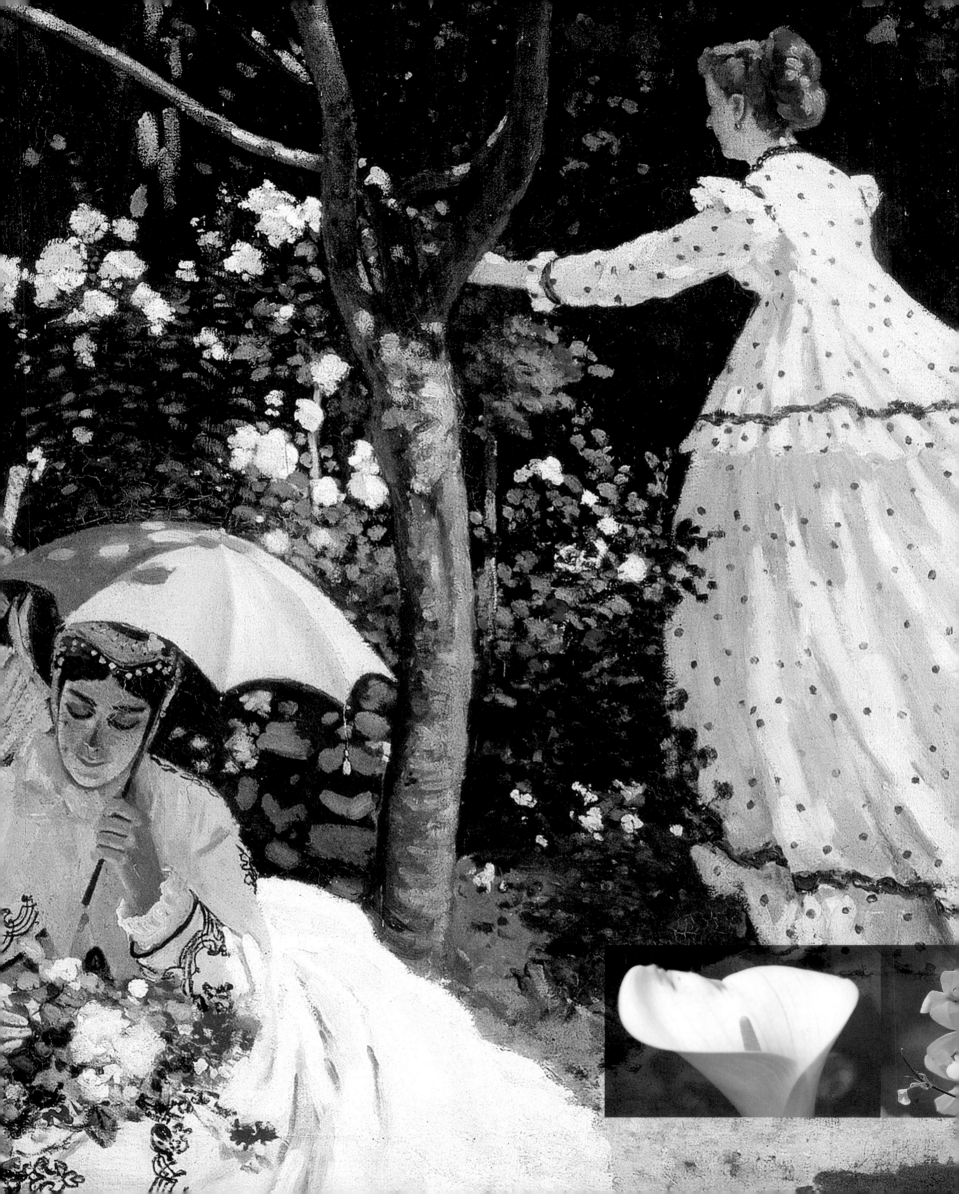

'ON THE BANKS OF THE POND, OVERGROWN WITH GRASS, THE COLUMBINE MEADOW RUE STICKS OUT WITH LEAVES SIMILAR TO THE JAGGED FRONDS OF MANY VARIETIES OF FERN AND, WITH LIGHT PINK WITH WHITE, BLOOMS SIMILAR TO FLOWERING COTTON BLOSSOMS…'

Georges Truffaut

Left and below:

In the dark shadowy areas of the water garden, the white blooms of irises, calla and white dame's violets provide highlights. Dainty pale feathers of columbine meadow rue (*Thalictrum aquilegifolium*), goats beard (*Aruncus*) and grasses gleam delicately against the dark green. The white flowers in Monet's picture *Women in the Garden* stand out against the dark background in exactly the same way.

THE WATERY WORLD

For a time, the plants on the edge of the pond were one of the painter's favourite subjects: the bright orange-red flowers of day lilies (*Hemerocallis*) formed attractive highlights in the blue-green of the water garden (see p. 105), while the round flowers of the blue agapanthus varied the leaf shapes of the water lilies. Irises—in this case the moisture-loving varieties—also played a main role here. Like the lilies and tradescantia, their effect was due not just to their flowers but also to the shape of their long, narrow leaves.

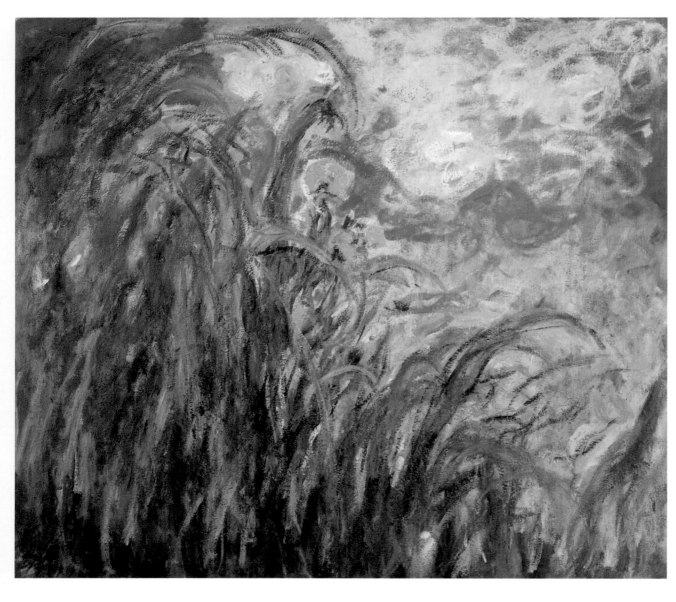

Above:
Yellow irises seen from an unusual worm's-eye view.
Yellow Irises, no date, Musée Marmottan, Paris

Right:
The round flowers of agapanthus gleam bright blue on the edge of the pool.
Water Lilies and Agapanthus Lilies, 1914–17. Musée Marmottan, Paris

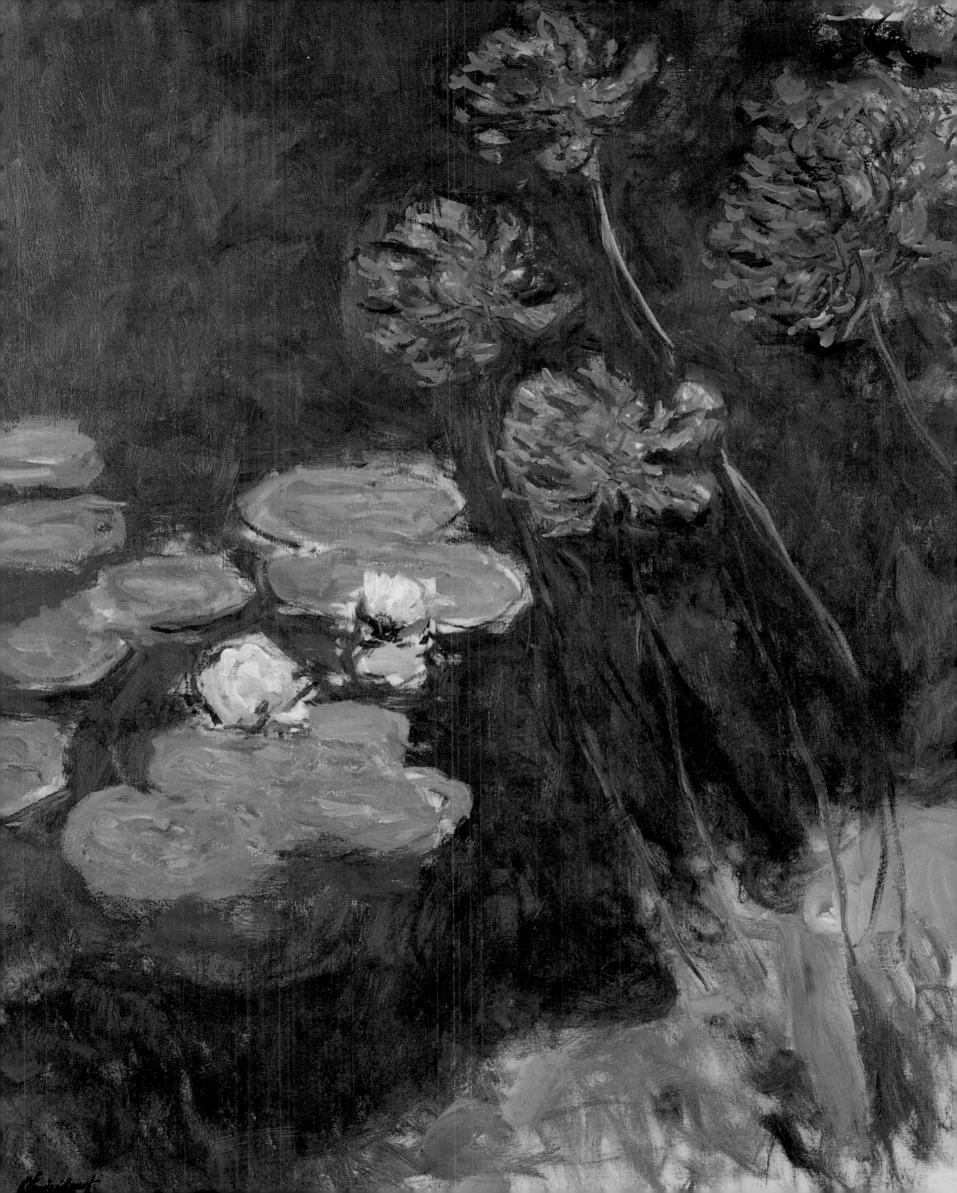

'MONET INSISTED ON THE SURFACE OF THE WATER ALWAYS BEING ABSOLUTELY CLEAN, SO THAT IT WOULD PROVIDE A BETTER REFLECTING SURFACE FOR THE SKY AND CLOUDS, SHADOWS AND REFLECTIONS OF THEIR SURROUNDINGS.'

Jean-Pierre Hoschedé

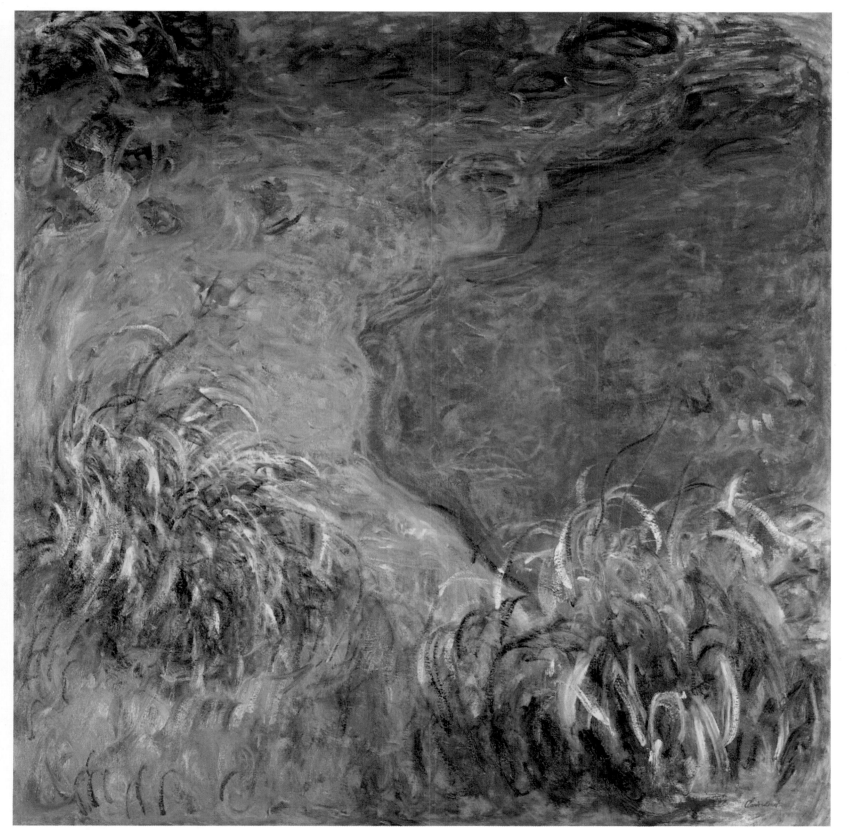

The red blooms of day lilies, which came from China, provide vivid colour effects in this picture. *Day Lilies on the Bank*, 1914–17. Private collection

WATER LILIES Monet's

pond with the water lilies is undoubtedly the most famous part of the garden, thanks to the paintings. The impression, however, is no longer as clear as in the paintings and old photos, because there is a lot of dirt floating on the surface of the water.

Monet employed a gardener specially for the water lily pond: his job was not only to shape the proliferating water lilies into round islands, but also to set out in the boat in the early morning to remove the dirt and ensure the surface was as clear as glass, reflecting the clouds and plants on the banks like a mirror. The condition and flow of the water were adjustable by sliding mechanisms.

To appreciate Monet's water lily pictures properly, it has to be remembered how rare and precious these plants were then. Only in the 1870s did Joseph Bory Latour-Marliac manage to grow hybrid pink water lilies by crossing coloured tropical water lilies with hardy varieties, which had hitherto existed only in white. Monet also acquired a number of tropical varieties, but except for a blue water lily (*Nymphea capensis*) in his glasshouse they all perished. Nowadays the various varieties of water lily in Giverny cannot be distinguished any more as they have become mixed.

The water lilies undoubtedly seemed much more Japanese at the time than now, where they grow in every garden pond. In their close-ups and choice of frame, flatness and clarity, many of Monet's paintings are very close to the Japanese woodcuts with which he covered the walls of his house.

The colour scale of the water lilies in Monet's water garden
ranges from white to pink to even a strong red.
Detail from *Water Lilies*, 1916–19. Private collection

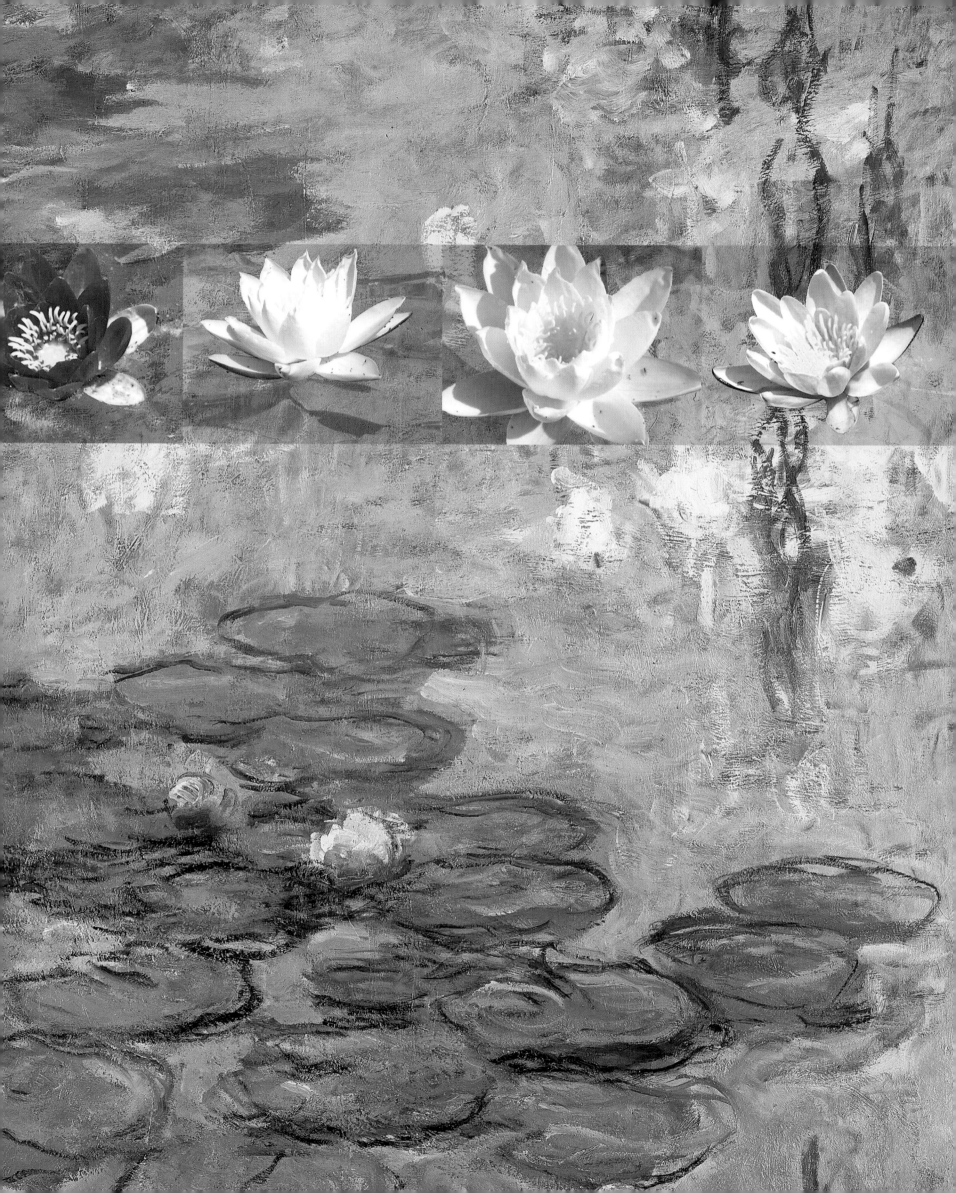

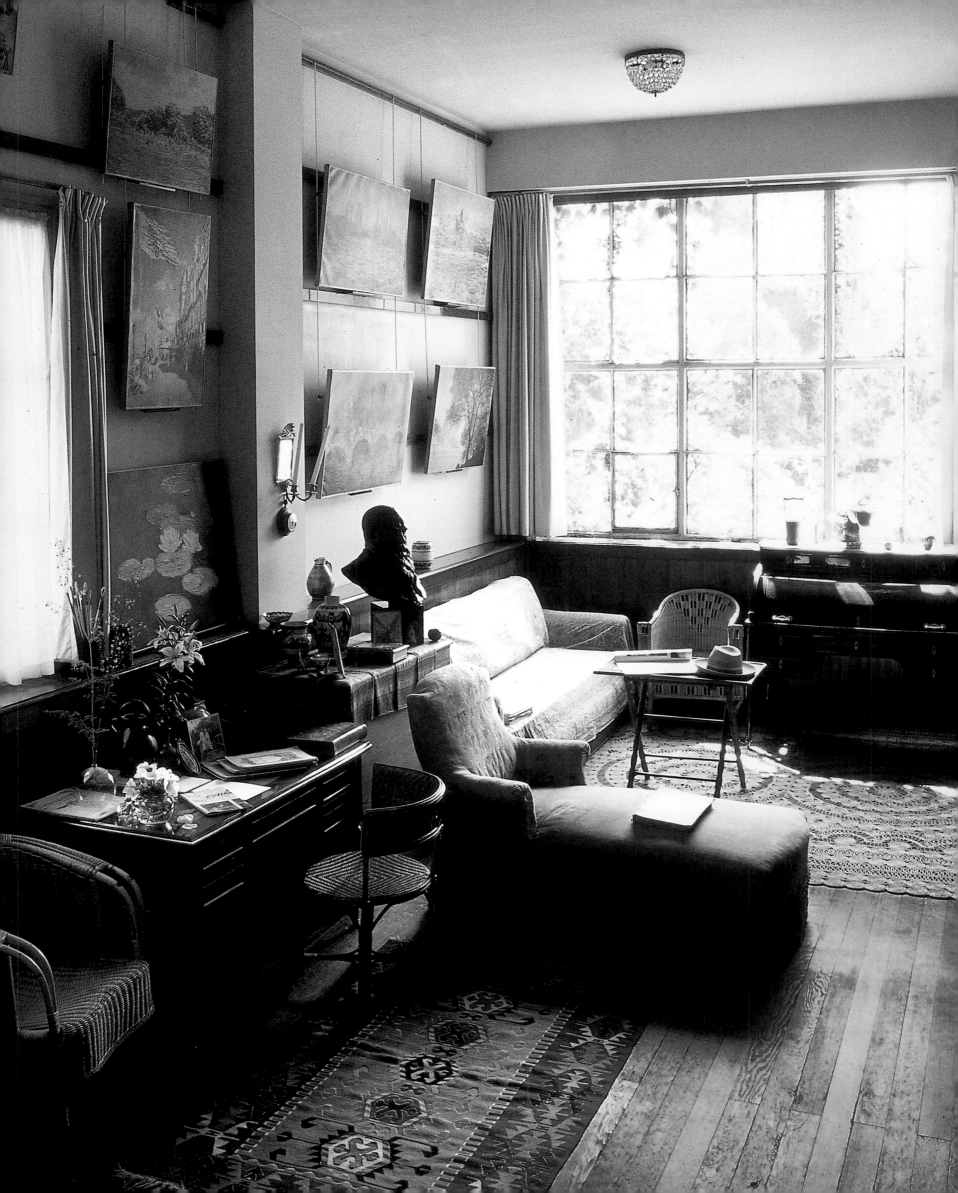

LIVING LIKE MONET IN FRANCE

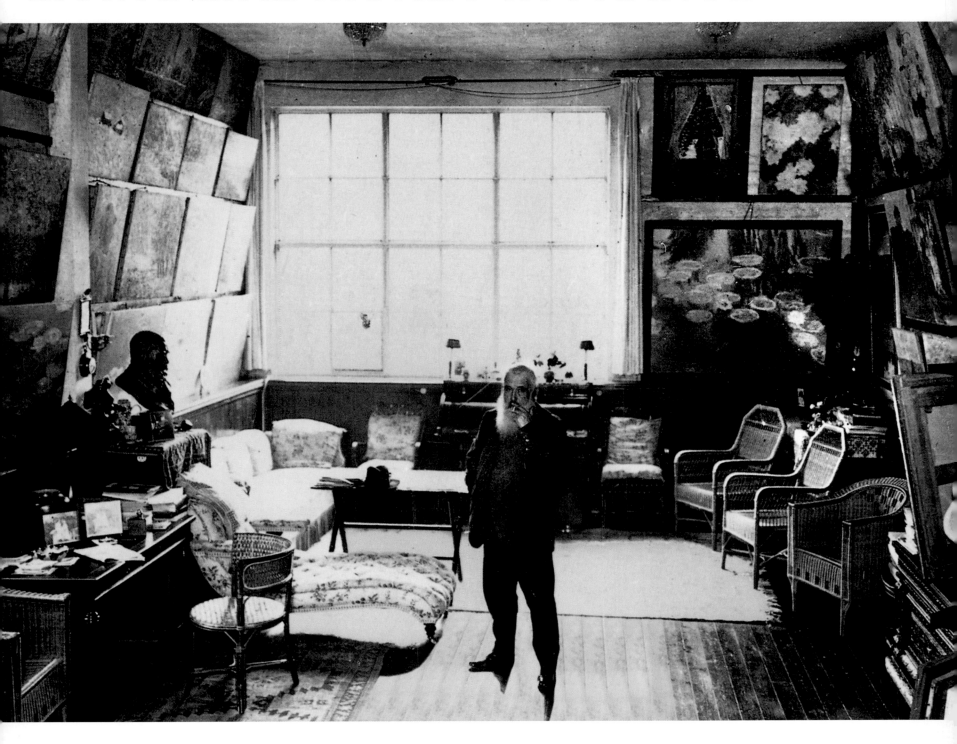

'THIS HOUSE AND THIS GARDEN ARE ALSO A WORK OF ART;
MONET SPENT HIS LIFE CREATING IT AND PERFECTING IT.'
Gustave Geffroy

Above:
A photo from 1913 shows the artist in the studio day room. The walls
are lined with paintings hung in close array, some of which are for sale.

Left:
The first studio in the former barn on the western side of the house was
furnished with numerous chairs and two desks, and later acted as a day room
for the whole family. It is somewhat lower than the rest of the ground floor
and was linked to it via a short flight of steps.

A HOUSE FULL OF COLOUR
During their early years in Giverny, Monet und Alice were on a tight budget, but as his financial situation steadily improved, Monet renovated and enlarged the house to his own taste. The first studio was set up in the former barn in the west wing of the house, but in 1897, he had a spacious studio block constructed on the western edge of the site, upon which the entire first studio became the family living room.

Monet took great pains over the design of the house and in particular the colours. He spent a long time looking for the right blue-green shade for the windows, to go with the pink façade (above), and throughout the house the colours and all the small details are carefully matched to each other. The prevailing furnishing fashion of the time was for dark carved furniture in various revival styles and Art Nouveau, the floor being generally covered with thick carpets and heavy curtains that barely let any light into the rooms. Monet went for quite a different approach, furnishing his house with a feeling for light and colour in which his Impressionist palette came into play. As a result, the interior is light and airy and furnished in a simple rustic style that is quite unlike the normal overfurnished interiors of the time.

Everywhere in Monet's house you come across the same colours as in his pictures and his garden. In effect, his aesthetic concept embraced the entire world that he lived in.

On the walls of his first studio hung closely packed works by the painter from various periods of his career in several rows on top of each other. Some of them were pictures for which no buyer had yet been found, while others were works that Monet was reluctant to part with. The painter spent a lot of time in this room just looking at the paintings.

In the early years, Monet used to keep his private collection of pictures by contemporaries such as Cézanne and Impressionists Renoir, Degas, Pissarro, Berthe Morisot, Manet and Paul Signac on the first floor of the house. There were also works by the Romantic painter Delacroix, and the Barbizon School was represented by Corot. Today, the walls in these rooms, like almost everywhere else in the house, are covered with Japanese woodcuts.

Above:
Monet had the windows, doors and veranda painted green.

Right:
The walls of the house were painted in carefully harmonised, strong and light colours. In the hall, reached through the Grande Allée via the veranda, the turquoise of the doors goes with the clear green of the entrance doors and the soft olive of the walls.

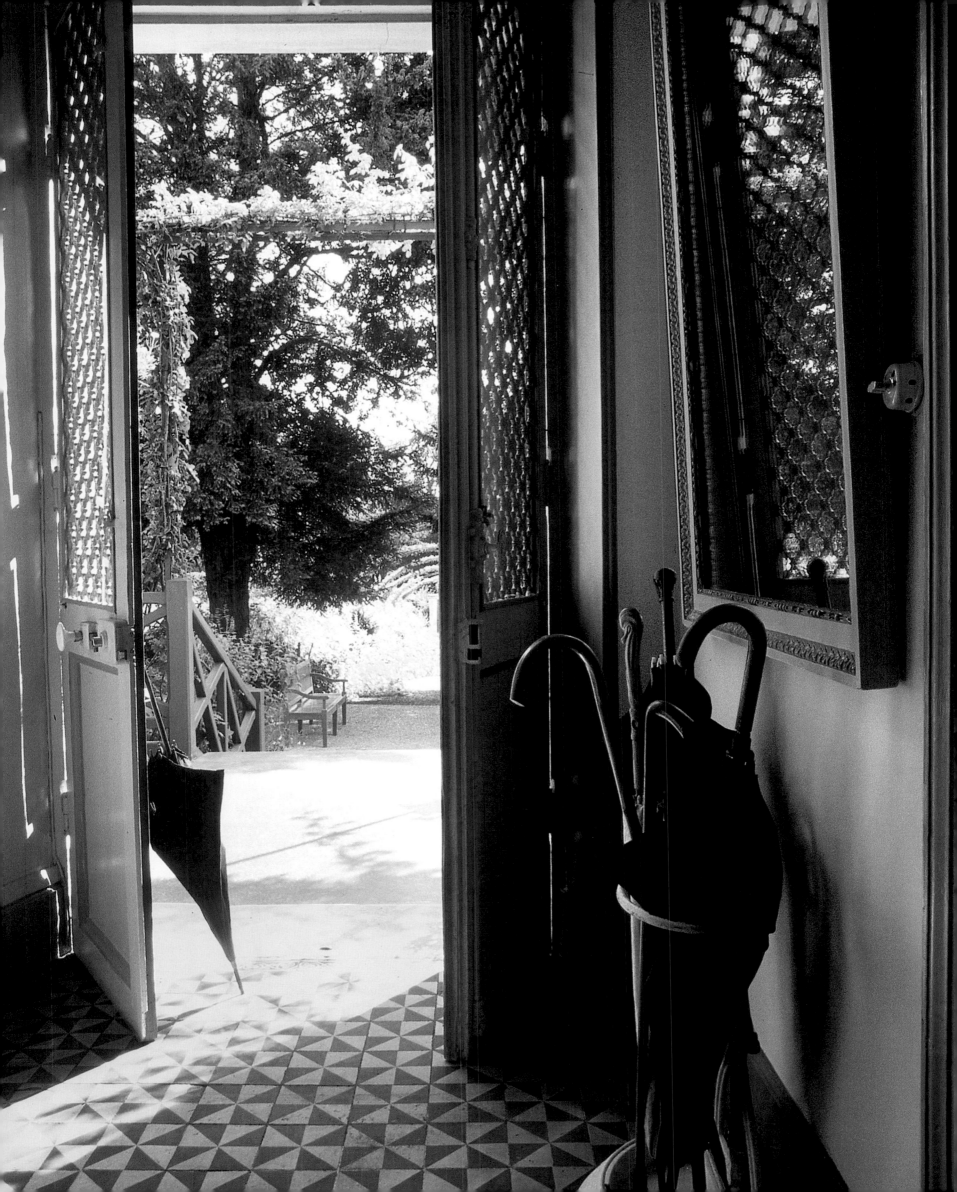

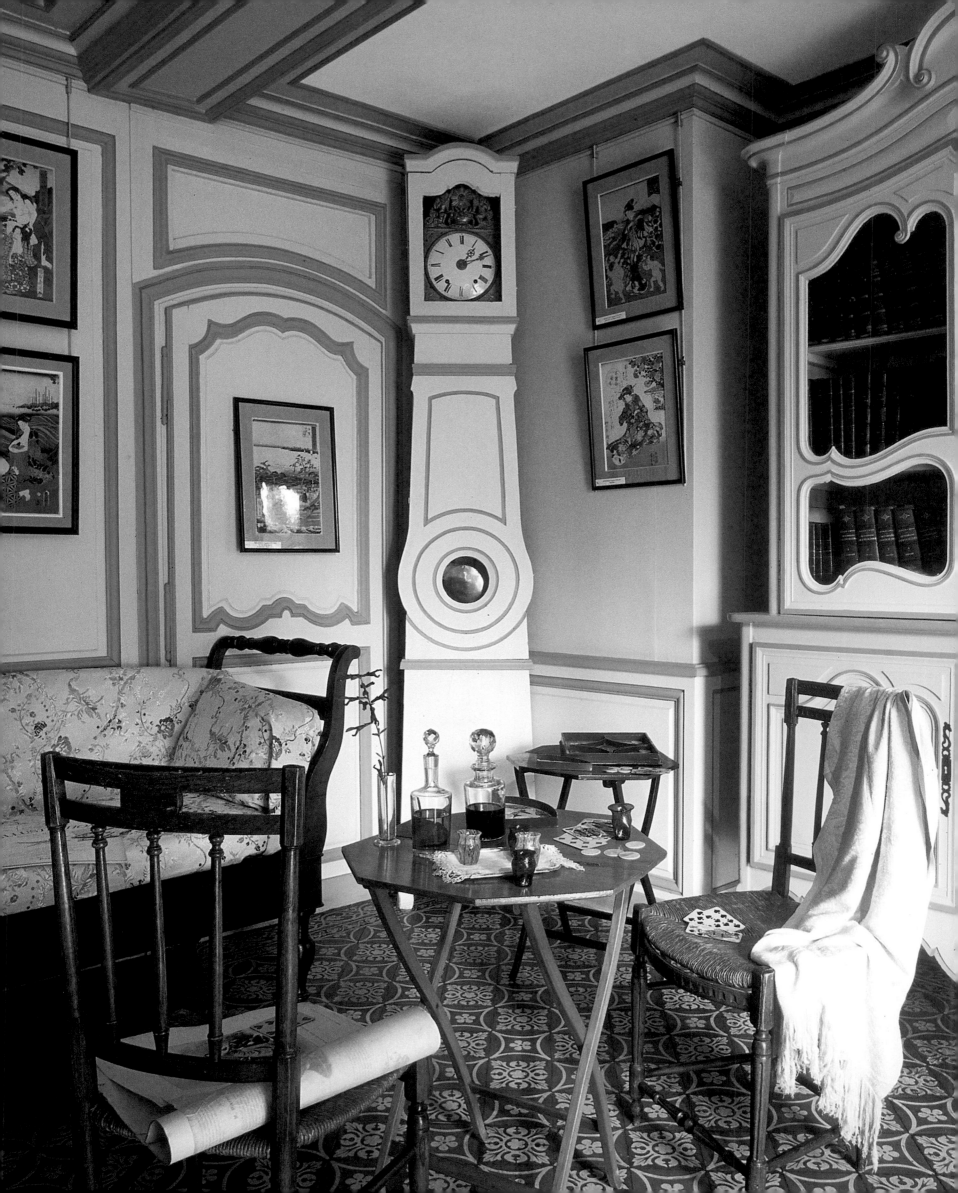

EVERYDAY LIFE IN GIVERNY
Monet and Alice, plus eight children—and later the grandchildren—a cook, a housemaid, a laundress, a chauffeur and up to six gardeners filled the estate with life.

Alice was naturally the fulcrum. She came from a very prosperous family and was accustomed to a chic lifestyle. She was cultivated, sunny tempered and generous, and unlike Monet, probably very religious. It no doubt took a lot of courage to give up life as Madame Hoschedé for a wild existence with a painter whom for ten long years—until the death of her husband—she could not even marry. Alice was used to an elegant life and was a splendid hostess. She certainly made a very decisive contribution to the lifestyle of the Monet household.

It is clear that a great love and intensive relationship bound Monet and Alice together. When he was on his travels, she missed him, even though they wrote each other long letters with all of life minutiae. Living with Monet was certainly not easy. He was rather moody, often laconic and rather pessimistic. As he grew older, he became increasingly choleric. If he was dissatisfied with his work, he attacked or destroyed it. Towards other people he could be very quick-tempered and unfriendly or full of charm, depending on whose company he was in.

The everyday life of the painter and his family in Giverny followed a strict pattern. Every morning, Monet got up between four and five, sometimes had a cold bath, and after a substantial breakfast of bacon and eggs, cheese and jam along with baguettes he began painting at six o'clock. At exactly half past eleven, the first course of a multi-course lunch was put on the table. This was the main meal of the day, and was rounded off with coffee and home-distilled plum brandy. After a tour through the garden, Monet had a brief midday nap, and then in fine weather went outside to paint. Afternoon tea made another break. Supper was around seven, and Monet went to bed at around half past nine.

There were frequent guests and their arrival provided diversity. Generally they were invited to lunch. Monet was not a very sociable man, and especially in his later years he cultivated the image of the artist who kept apart from the hustle and bustle of Paris and had retired to rustic seclusion. Nonetheless, Alice and Monet's hospitality was legendary. An invitation to Giverny always concluded with the master of the house taking the guests on a tour of the garden. In high summer, guests were sometimes entertained in a large marquee in the garden. Otherwise, meals were eaten in the dining room, where the large table, generally only big enough to accommodate the ten members of the family, could be extended. The dining room was furnished entirely in yellow. On the walls there were originally family portraits, but these later gave way to Monet's collection of Japanese woodcuts. This room was the focal point of the house, where hospitality and good eating were always of the highest standard. It was likewise a room that Monet himself had designed, just as the dinner service brought out on special occasions was made to his design. This was plain white porcelain with a broad yellow edging lined with narrow blue lines. On ordinary days, a blue service made in the French town of Creil was used. It had a Japanese-looking decoration of blue fans and cherry motifs. Together with the yellow table cloth, it picked up Monet's particularly favoured colour combination of yellow and blue.

Above: On the upper floor were the bedrooms and Monet and Alice's dressing rooms. As everywhere in the house, there were Japanese prints on the walls, even beside Monet's washstand. They stand out well against soft delicate blue and matte mauve tones of the room.

Left: In the blue drawing room, the family had somewhere more private for reading, making music, sewing or playing cards. This room also contained the library with many books on the subject of gardens and art. Both the walls and the larger pieces of furniture are painted light blue, with contrasting dark vertical and horizontal mouldings. Particularly attractive here is the floral pattern of the floor tiles in white and terra-cotta.

'IN THIS SIMPLE BUT NONE-THELESS SPLENDIDLY DECORATED HOUSE IT WAS A SPECIAL PLEASURE FOR US TO SIT DOWN AT TABLE FOR A MEAL. FOOD WAS SERVED IN LARGE PORTIONS BUT WAS ALWAYS PREPARED WITH GREAT FINESSE AND SPLENDIDLY COMPLE-MENTED BY LIGHT WINES OF ALL COLOURS.'

Gustave Geffroy

Above:
In keeping with the dining room was the best service,
in Limoges porcelain, designed by Monet himself.
Haviland still make the service today.

114

Right:
The walls, windows, furniture and curtains of the dining
room are all in the same two tones of yellow. The arrangement
of Japanese prints on the walls was by Monet himself.

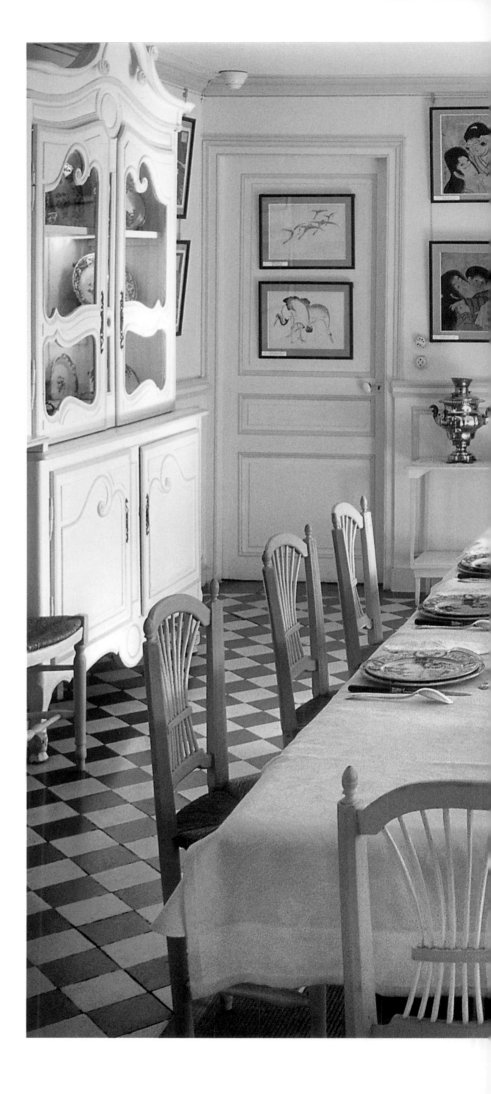

THE 'CARNETS DE CUISINE'

Monet is known to have been an absolute gourmet, and in matters of food he was very fastidious. He loved eating well, though he did not cook himself. Alice drew up the menus, which Marguerite the cook then created according to Alice's detailed specifications. The Monet *carnets de cuisine* (recipe books) have survived, and are very informative about the kitchen and the household's way of life. Most of the dishes are not very complicated to prepare. The ingredients were of the best quality, and were used to make dishes that were deliberately simple and natural. The *carnets* contain numerous recipes from friends or restaurants where Monet had eaten in Paris and elsewhere. Where family members had married away from home or else Monet had been on his travels, they include dishes from other regions or other countries. However, boletus mushrooms in olive oil is the only dish that Monet himself is supposed to have invented.

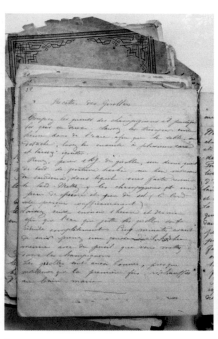

RECETTE DE GIROLLES
Chanterelles (a recipe of Stéphane Mallarmé)

Carefully clean 1 kg (2 lbs) of chanterelles without washing them, and cut the larger ones in half. Dice small 125 g (4 oz) of belly of pork and render in 100 g (3 ½ oz) of pork dripping. Add the chanterelles plus a dash of pepper and salt and simmer on low heat until the mushroom liquid has evaporated. Five minutes before serving, add a chopped clove of garlic and a bunch of parsley chopped fine.

SOUPE AUX HERBES
Herb soup

Wash 1 small handful of sorrel, 1 handful of chervil and a large lettuce and chop small, put in a pot with a tbsp of butter, a tsp of salt and a dash of pepper. Sauté for five minutes, then pour on 1.5 litres (2 ½ pints) of hot water and leave to simmer for half an hour. Add 5 tbsp of rice to the soup, stir, an let it simmer for half an hour. Then stir thoroughly with a whisk and improve the finished soup with 2 tbsp of butter or a little cream.

MA RECETTE POUR LES CÈPES
Monet's recipe for boletus mushrooms in olive oil

Clean the mushrooms and remove the skin. Chop the stems into small pieces, put in a fireproof pan, add the heads and pour on olive oil liberally. Cook in a pre-heated oven at a low temperature until the oil clarifies, spooning the heads frequently with oil from the pan. Sprinkle with chopped garlic and finely chopped parsley, and add salt and pepper to taste.

WELSH RAREBIT
English recipe

Cut the crust off 4 medium-thick slices of bread (not too fresh) and toast lightly. Meantime cut 100 g (3 ½ oz) of Gloucester, Cheshire or Cheddar cheese into thin slices and heat in a frying pan with 2 tbsp beer and a little mustard and pepper, stirring constantly. Spread butter and the melted cheese on the toast, and serve hot as a starter.

116

Above:
The recipes in the *carnets de cuisine* were all written by hand.
The six booklets are still owned by the family today.

Right:
The colour scheme of the large kitchen next to the
dining room was designed to go with the blue wall tiles.

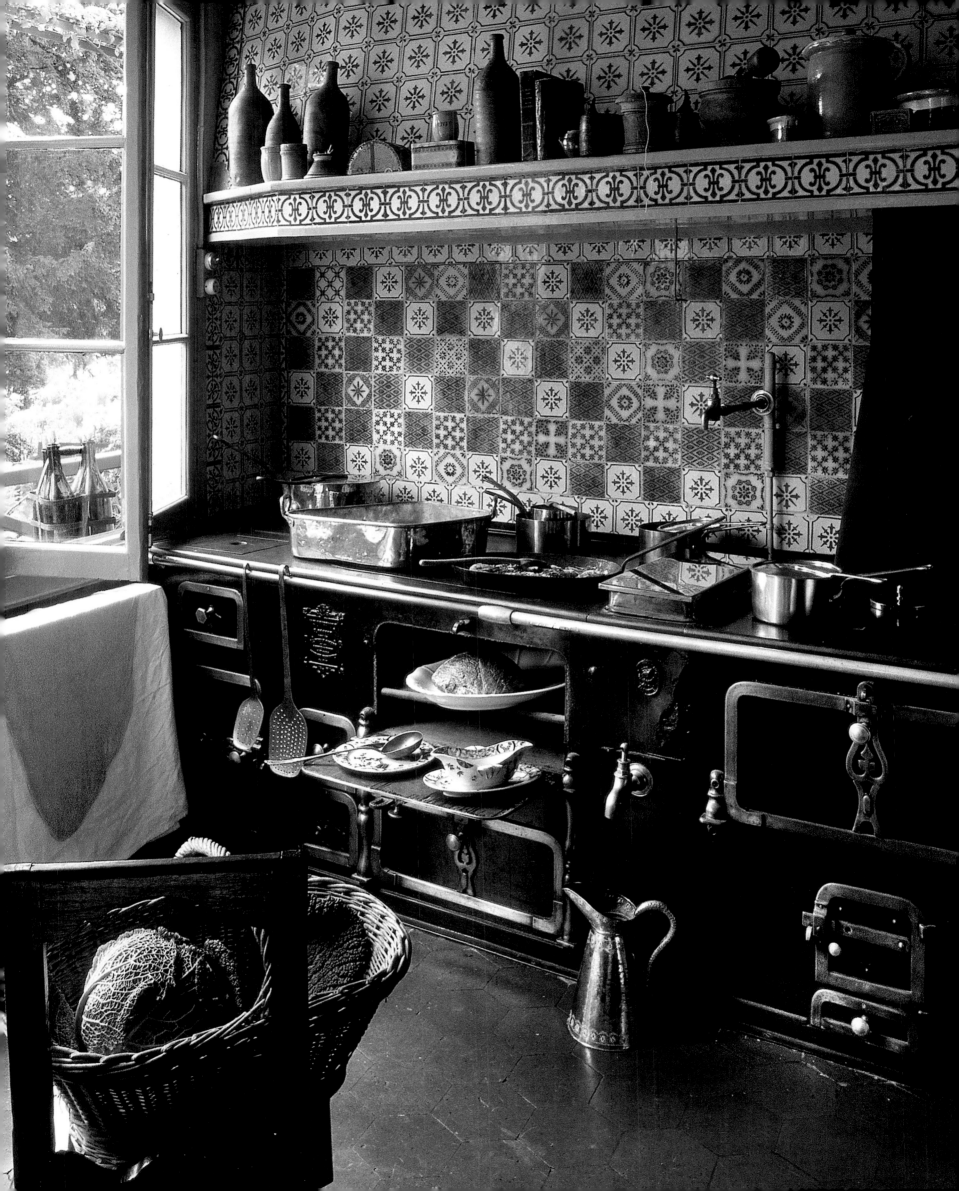

Among the ingredients typical of Norman cuisine are good butter and cream, apples, cider, Calvados and the celebrated Camembert. Even though many specialities came from further afield—for example, truffles from Perigord, *foie gras* from Alsace, olive oil from Provence and exotic spices such as saffron, cinnamon, caraway, nutmeg or cayenne pepper, plus tea from China or Ceylon—Giverny cuisine was mainly dependent on local products, and especially home-grown produce, since retail distribution was less centrally organised then than it is now and great emphasis was placed on freshness.

The poultry yard is still in front of the house, convenient for the kitchen. At that time, various types of duck and chicken were kept there to supply fresh eggs and meat. Shortly after 1900, Monet moved his vegetable garden to the other end of the village, renting the Maison Bleue in the Rue du Chêne and the walled garden with it. There, gardener

Florimond worked with meticulous system to produce vegetables, herbs and spices and even mushrooms could be harvested in the cellar. Monet's enthusiasm for exotic plants extended to vegetables as well, so that these included various home-grown varieties of tomato, artichokes, aubergines, paprika, courgettes and other Mediterranean vegetables.

In high summer, tables were often brought out into the garden and meals were eaten outside. The heat of summer was much more bearable in the shadow of the lime avenue than in the dining room with its large south-facing windows.

Picnics in the open were likewise a frequent pleasure in the summer months. For excursions in the boot or by car, well-filled picnic baskets were packed. The whole family then went out into the country, and close friends were also often invited along.

118 *Above:*
For the Maison Bleue (Blue House), which still stands in the Rue du Chêne, Monet is supposed to have chosen the colours himself. No vegetables are cultivated behind the old door anymore and what was once Monet's vegetable garden is now occupied by modern houses.

Right:
In the cold winter months, Monet sometimes painted still lifes with fruit or even game. *Pears and Grapes*, 1880. Kunsthalle, Hamburg

SOUFFLÉ AUX MARRONS
Chestnut soufflé

Peel and boil 500 g (1 lb) of sweet chestnuts (though nowadays they can also be bought ready cooked), then pound them in a mortar or purée them, gradually working in 1 glass of hot sugared milk spiced with vanilla. As soon as the purée binds properly, mix in 3 beaten egg yokes, and then carefully fold in the three egg whites beaten stiff. Put the mixture in a buttered soufflé dish and get to rise for 30 or 40 minutes with gentle heat at the top and strong heat below. Serve as a dessert.

TARTE TATIN
Tatin apple tart

For this you need a pan you can also put in the oven.
 Sieve 250 g (8 oz) flour and make a hollow in the middle for 125 g (4 oz) soft creamy butter, 1 egg, a pinch of salt and 2 tbsp water. Mix into a dough, and leave to stand in a cool place for at least an hour.
 Meantime, peel 1 kg (2 lbs) of apples, cut into quarters and core. Prepare the bottom of the ban with large knobs of butter, sprinkle 50 g (2 oz) of sugar over it and cover thickly with the pieces of apple. Sprinkle on a further 50 g (1–2 oz) sugar and drizzle 25 g (1 oz) of melted butter over it. Caramelise on the stove for 20 minutes until the sugar is light brown.
 Roll the dough thinly on a surface prepared with flour and cover with apples. Bake in a preheated oven at 200°C for about 25 minutes until golden brown. Turn out the finished tart and serve lukewarm as a dessert.

GÂTEAU À L'ORANGE
Orange cake

Preheat the oven to 180°C. Beat 100 g (4 oz) butter, 120 g (5 oz) sugar and 2 eggs until frothy and add the zest of an untreated orange. Mix in 200 g (8 oz) flour with 2 tsp of baking powder and 60 g (2 oz) of ground almonds and stir alternately 6 tbsp of orange juice and 2 tbsp of lemon juice into the batter. Spread a small cake mould with butter or margarine, put the batter in it and bake the cake for 45 minutes. Leave to cool before cutting into the cake with a knife from above and drizzling with a little Cointreau. Coat the cake with 3 tbsp of marmalade and decorate with almond slices. Orange cake was a favourite at tea time in Giverny.

SCONES

Mix 250 g (1 lb) of flour with 10 g (¼ oz) of baking powder and a pinch of salt. Add a glass of milk and knead to a smooth dough. Roll out on a floury surface, cut out circles with a glass and bake for 15 minutes in a hot oven. Slice the scones and spread with butter to eat for tea.

POULET CHASSEUR

Chicken hunter's style
Cut up the chicken and sauté the pieces in a mixture of butter and oil. As soon as they are nicely browned, remove them from the oil and put aside. Sauté 250 g (8 ½ oz) of cleaned and halved mushrooms in the oil, then add a large glass of white wine and briefly reduce. Add some tomato purée, the flesh of three tomatoes and a sprig of tarragon to the mushrooms, plus salt and pepper to taste, and reduce. Add 1 glass of stock and reduce. Add the pieces of chicken with their juices and leave to simmer on a medium heat.

BOEUF MODE

Marthe Butler's pot roast

Render diced bacon in plenty of butter and thoroughly sauté 1 kg (2 lbs) of boneless beef in it on all sides. Dilute with 1 glass of stock and 1 glass of white wine. Add 5 large carrots chopped into slices and 1 diced onion. Gradually add ½ litre (3 glasses) of wine and another glass of stock. An hour before cooking is completed, add half a glass of schnapps. Cook for seven hours on a low heat, then leave to cool.

CAROTTES FERMIÈRES

Rustic carrots

Cut thick carrots into slices and boil until almost cooked. Drain the fluid into a cup. Prepare a light roux with a little of the fluid, adding finely chopped chervil, parsley and a little tarragon, bring briefly to the boil, then add a little lemon juice, sugar and the carrots. Simmer slowly until cooked, occasionally thinning with the carrot fluid until the carrots are glazed.

The Monets loved eating outside, whether at a table in their
own garden or taking a picnic somewhere in the country.

Right:
Luncheon on the Grass, Central panel, 1865–66. Musée d'Orsay, Paris

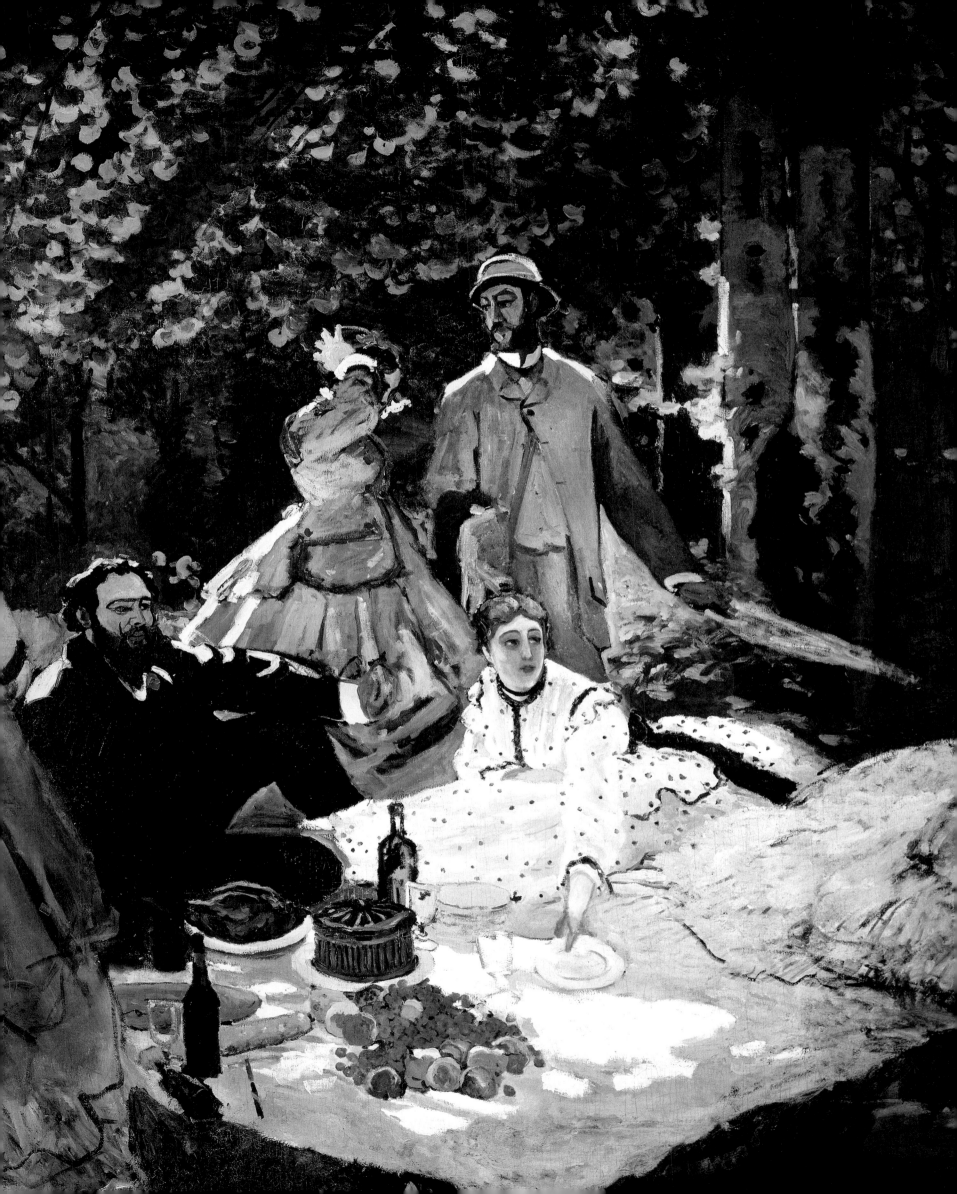

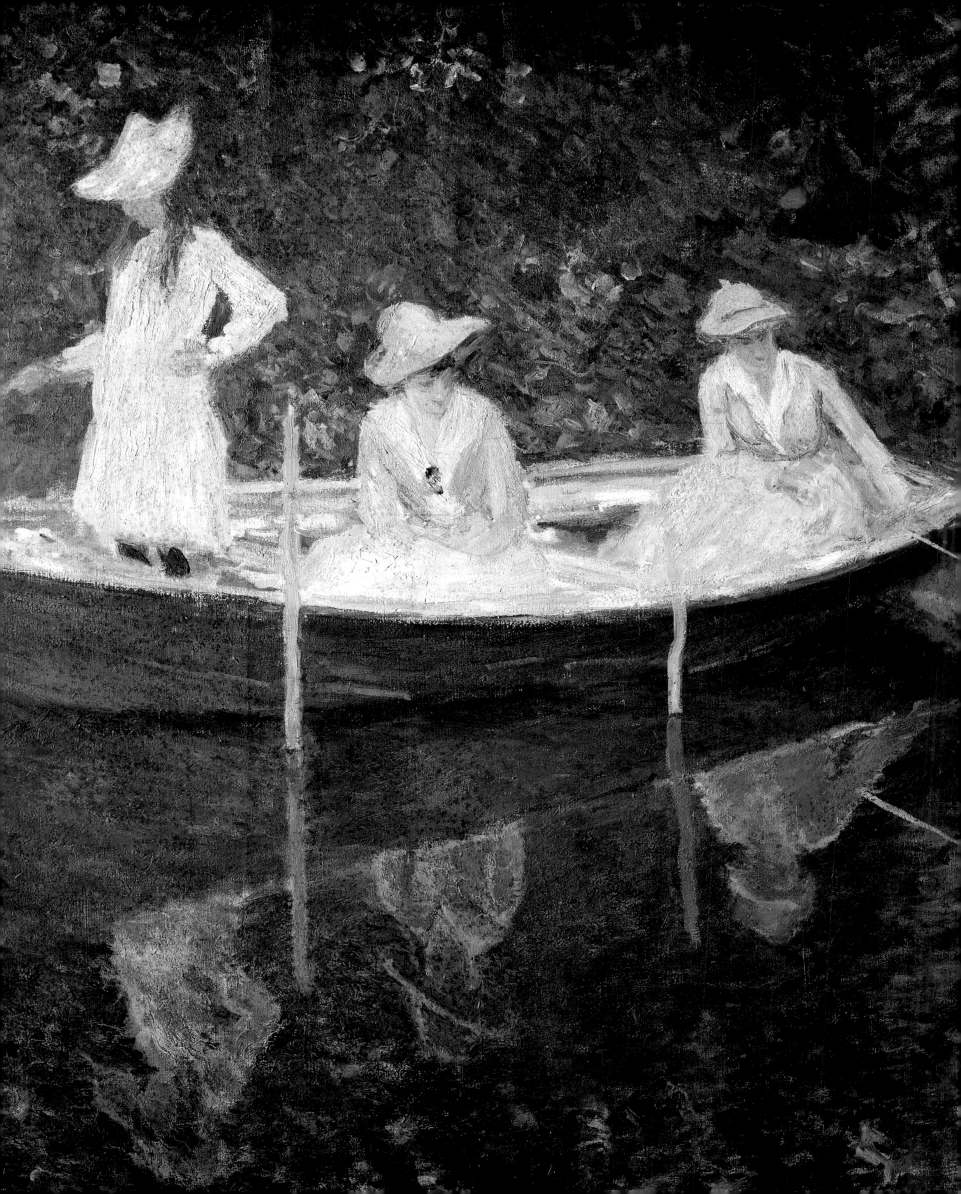

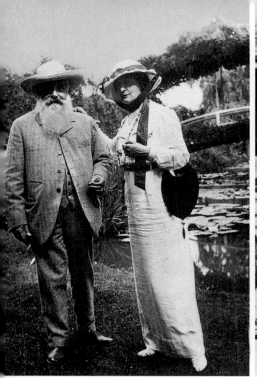
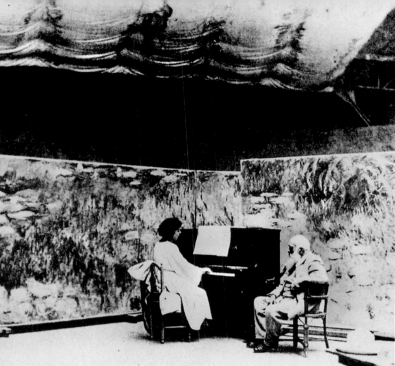

DISTINGUISHED COMPANY The people who might end up having lunch with the Monet family in Giverny were a very mixed bunch, and they must sometimes have seemed a rather exotic element in a small farming village of under 300 souls.

In 1913, Monet was visited by the well-known American opera singer Marguerite Namara (above). The photo shows her by the Japanese bridge, on her tour of the water garden. On a visit in July 1922, she played the piano for Monet in his studio (above centre) and wrote on a photograph: 'The happiest memory of my life, great and dear maestro is . . . to have met you and sung for you.'

A large parasol shielded the painter as he worked outside on his water lily pictures (above right). His stepdaughter Blanche was always close at hand. The child in the foreground was her niece Nitia Salerou. Paul Durand-Ruel (below left, *c.* 1910) was the first to have faith in Monet's art. He supported the artist in the difficult early years, and remained his most important dealer and a close friend throughout his life.

Among the early admirers of Monet were Japanese dealers and collectors. The photo below right shows Mme Kuroki, née Matsukata, who has just bought a painting from him, beside Monet, Blanche Hoschedé-Monet, Germaine Hoschedé-Salerou and daughter Nitia Salerou.

Left:
The whole family enjoyed being on the water. Jean Monet became a keen rower, while Jacques Hoschedé later built boats. Here, Monet's stepdaughters Germaine, Suzanne and Blanche are fishing from the boat. *In the Boat*, 1887. Musée d'Orsay, Paris

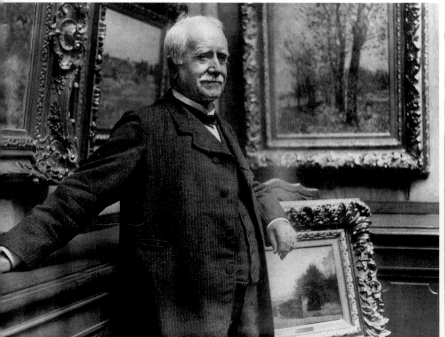
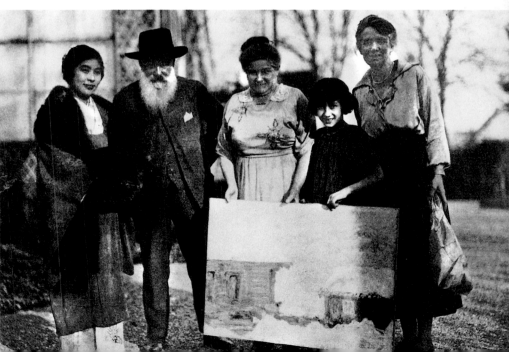

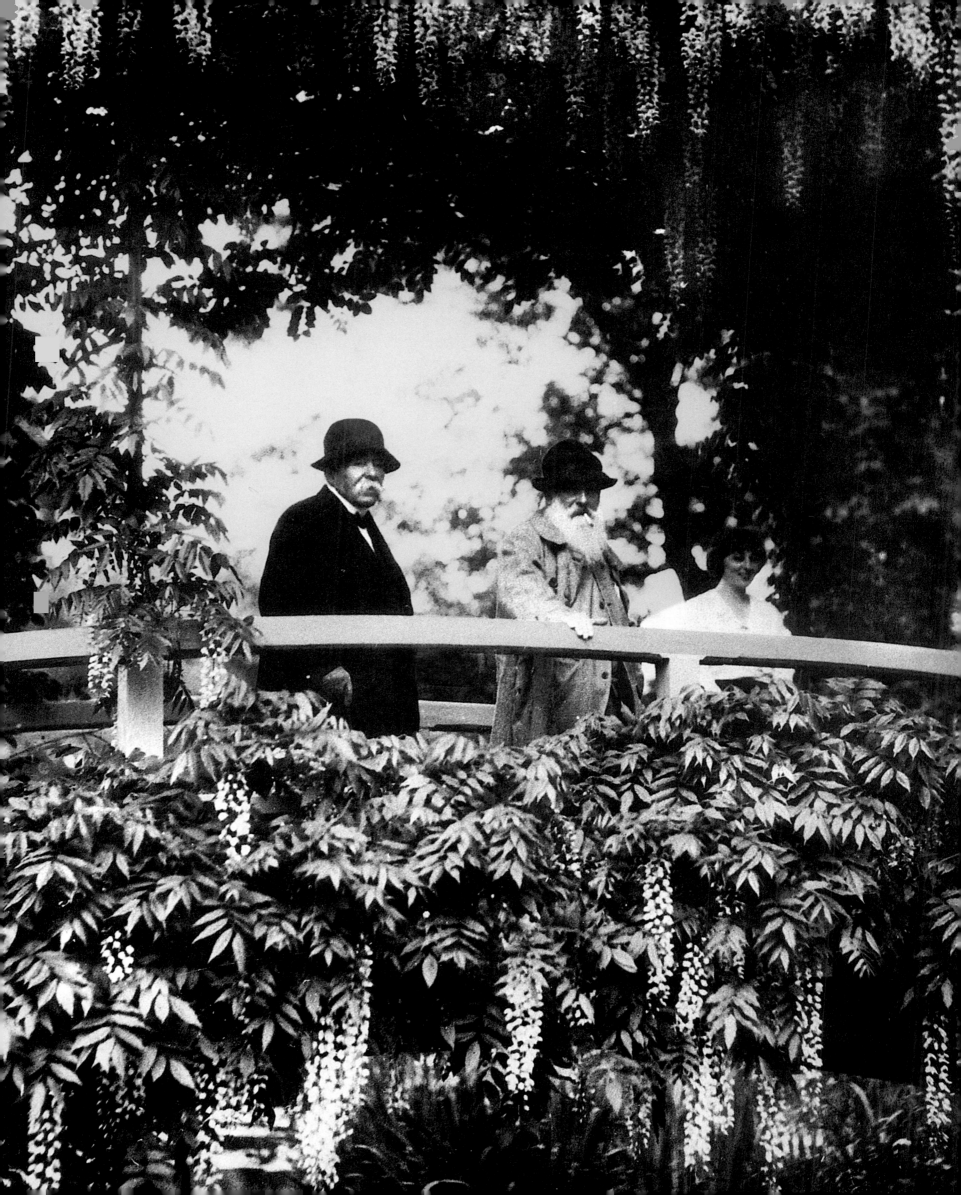

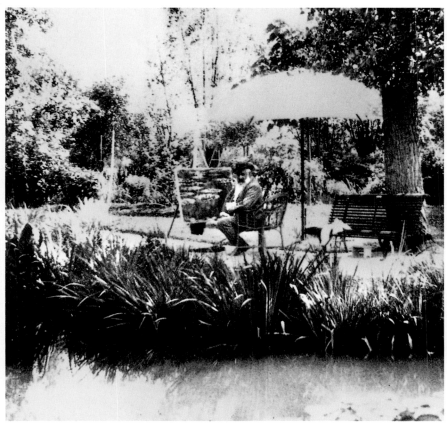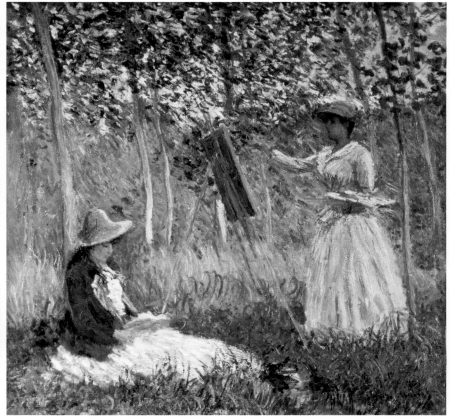

Many friends came visiting from Paris, especially in the summer months. Among Monet's oldest friends from the early days of Impressionism were the painters of his own age—Alfred Sisley, Camille Pissarro and Auguste Renoir—and their families, plus a number of poets and literati. As he steadily became more and more successful, his circle of friends and acquaintances grew. Over time, they included other artists such as painters Edgar Degas, Paul Cézanne, Berthe Morisot and James McNeill Whistler. Another frequent guest in Giverny was the sculptor Auguste Rodin, even if his boorish manners put off the ladies in particular. He is once supposed to have stared so persistently at the daughters of the house that they finally left the room.

Writers Stéphane Mallarmé and Gustave Geffroy, Monet's later biographer, plus journalist and statesman Georges Clemenceau were among his closer friends. The latter had a garden in the Vendée on the Atlantic coast. In 1902, he moved into nearby Bernouville, to be closer to his friend. The writer and art critic Octave Mirbeau was one of Monet's closest friends and even outdid him in his passion for gardens, an enthusiasm that Monet's fellow painter Gustave Caillebotte also shared. Monet and the latter had swapped much gardening lore even during the Argenteuil years. Caillebotte generally came to Giverny with the boat from Petit-Gennevilliers, which was directly opposite on the other side of the Seine. There he had a house with a splendid garden, which pro-vided occasional inspiration for Monet in Giverny.

The visitors to Giverny thus included many distinguished people—artists, poets, publishers, politicians, actors and singers. One account tells of how the famous dancer Isadora Duncan danced for the painter in the large water lily studio. Among the guests in Giverny there were of course art dealers as well—first and foremost Paul Durand-Ruel—collectors and potential buyers, many of whom had come over from the USA and Japan. The whole world found its way to the little farming village near Paris.

Above left:
One of Monet's favourite painting spots was near the copper beech on the southern bank of the water lily pool. He went on painting in the open air right to the end, even though the *Grandes Décorations* were painted in the water lily studio.

Above right:
Blanche Hoschedé was the only one of the eight children to have an interest in as well as a talent for painting. This picture shows her at her easel on the moor near Giverny. Her sister Suzanne sits beside her deeply immersed in her book.
In the Woods at Giverny: Blanche Hoschedé at her Easel with Suzanne Hoschedé Reading, 1887. The Los Angeles County Museum of Art, Los Angeles

Left:
Georges Clemenceau, one of the most important French politicians of the early 19th century, was a close friend of Monet's for many long years. The photo shows the two old friends together on the Japanese bridge in June 1921, along with Lily Butler, daughter of Suzanne Hoschedé and Theodore Butler.

THE AMERICAN ARTIST COLONY

The extraordinary popularity of Claude Monet extended far beyond the frontiers of France, even during his lifetime. In April 1886, when he was still a not very successful painter, his dealer Paul Durand-Ruel had taken works of Monet to New York and found a readier welcome for them there than in France. In 1888, Durand-Ruel opened a gallery in New York, and the American end of his business continued to prosper, so that the name Monet was soon identified with modern art and the European avant-garde. It also came to mean something for the countless young American artists who made pilgrimages to Paris to study modern European painting.

The story is that one of these young artists, Willard Metcalf, ended up more or less by chance in Giverny on an excursion to the banks of the Seine one day in spring 1886. He was quite taken with the landscape and the apple blossom, and returned two weeks later with his canvas and paints and two fellow painters. When the three of them learned that Claude Monet lived in Giverny they were thrilled, and paid a visit to the master, who accorded them a friendly reception.

Scarcely had word of this got around in Paris than an almost unimaginable invasion began. Although Monet never took students, just his presence in the village was enough, and legions of young American painters descended on the little Norman backwater. The former village tavern was extended to become the Hôtel Baudy, named after the owners Angelina and Gaston Baudy. For a few francs you could sleep, eat and drink red wine there to your heart's delight. The proprietors met the needs of their guests, put American dishes on the menu and constructed

not only a tennis court and billiards room but a studio as well. The wonderful rose garden also offered subject matter and space for guests to paint in the open.

In 1887, a group of six or seven artists rented a house in Giverny for a year. Some of them, including Theodore Robinson and John Leslie Breck, made friends with Monet and returned again and again.

Breck, who in his lifetime counted as the leading American Impressionist and was the driving force behind the group, would become one of the few painters who was allowed to paint jointly with Monet, and even do so in his garden. Monet did however put an end to a romance between the American and his stepdaughter Blanche Hoschedé. Monet was also on friendly terms with his neighbour Lilla Cabot Perry, who lived in Le Hameau, the property next to him on the western side, from 1894 to 1896. John Singer Sargent was among those who met him more often, and Mary Cassatt was among his acquaintance. Otherwise, few of

Above:

Edmund Tarbell (1862–1938) painted his wife, her sisters and the baby here in a style unmistakably influenced by French Impressionism.
This was the first important Impressionistic work by the painter following his return to Boston in 1886, after a lengthy stay in Europe.
Edmund C. Tarbell, *In a Garden* (originally *The Three Sisters—a Study in Sunlight in June*), 1890.
Milwaukee Art Museum, gift of Mrs Montgomery Sears

Above left:

John Leslie Breck (1860–99) studied at the Académie Julian in Paris in 1886. He was one of the first American artists to come to Giverny,
and one of the very few to have close personal contact with Monet and his family. This painting shows a view of Monet's garden in Giverny.
John Leslie Breck, *Garden in Giverny* (*Monet's Garden*), c. 1887. Musée d'Art Américaine, Giverny

Above right:

The American painter Theodore Butler was married to Monet's stepdaughter Suzanne Hoschedé. After Suzanne's premature demise,
Butler married her sister Marthe on 31 October 1900. This photograph captures the wedding party in front of Monet's house.

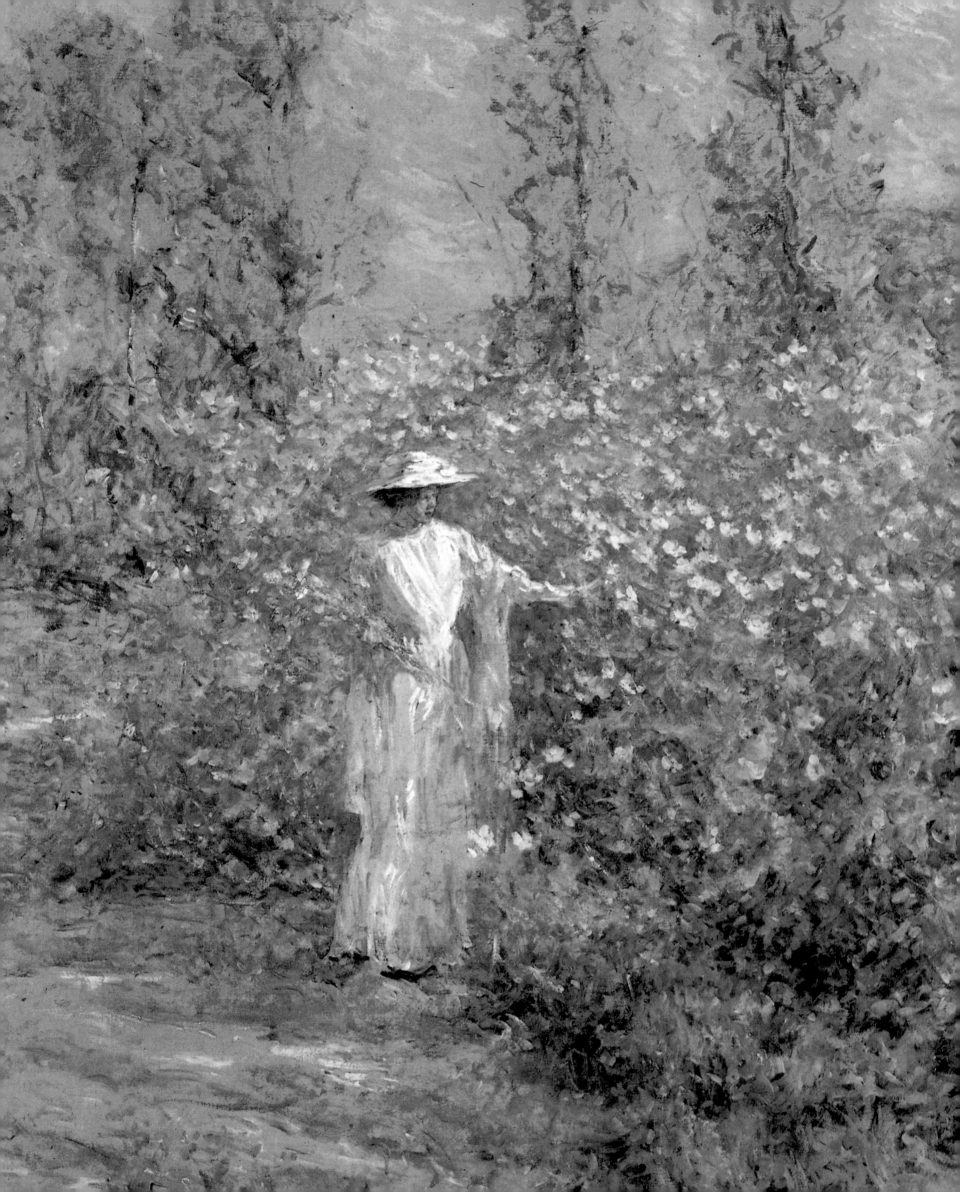

the young Americans artists ever came personally face to face with Monet.

When Suzanne Hoschedé married the American painter Theodore Butler in 1892, family links were established between Monet and the American colony. But even at the wedding party a distinct lack of enthusiasm on his part was noticed, and all the goings on in the village quickly became too much for him. Theodore and Suzanne Butler lived permanently in Giverny with their children James and Lili, and after the premature death of Suzanne in 1899, Butler married her sister Marthe (see p. 126).

Despite Monet's withdrawing completely behind the walls of his property, restricting his social doings to a few close friends and even considering moving, America's Bohemians still flocked to the small village. In consequence, Giverny changed from a sleepy backwater into an active artists' colony. 'I know a village/Not far from Paris/Where no one behaves/And everyone laughs' is how Richard Hovey described Giverny life in 1897. Though there were Germans, Britons, Norwegians and even Australians among the many young artists who spent some time there, most of them were Americans. Many of them such as Lilla Cabot Perry or Mary MacMonnies and her husband, the sculptor Frederick, settled there for longer periods, bought or rented houses and painted their own gardens, while others remained only a short time. Almost all well-known American Impressionists were in Giverny at some point. But among the numerous artists who remained here for a time there were also a whole series of outstanding painters who are, unjustly, scarcely known in Europe.

With the outbreak of World War I, the Impressionist colony came to an end, but even today the spirit of the American painters is occasionally still noticeable in Giverny—not least of course due to the commitment and financial support of American benefactors such as Gérald van der Kemp and his wife Florence that Monet's house and garden in Giverny were able to be saved from total rack and ruin.

Right:
John Henry Twachtman (1853–1902), the son of German immigrants, studied art in Munich and Italy and later travelled to Europe several times. His stay in Paris from 1883 to 1885 rang in an Impressionist phase in his painting. In 1897, he was one of the co-founders of the 'Ten American Painters', a group of artists from New York and Boston, who exhibited together for a number of years from 1898 on.
John Henry Twachtman, *On the Terrace*, c. 1897.
Smithsonian Institution, National Museum of American Art, Washington, D. C.

Left:
Robert Lewis Reid (1862–1929) was also unmistakably influenced by French Impressionism when he returned to the USA in 1889 after spending a number of years in Europe.
Robert Lewis Reid, *In the Flower Garden*, c. 1900.
Private collection.

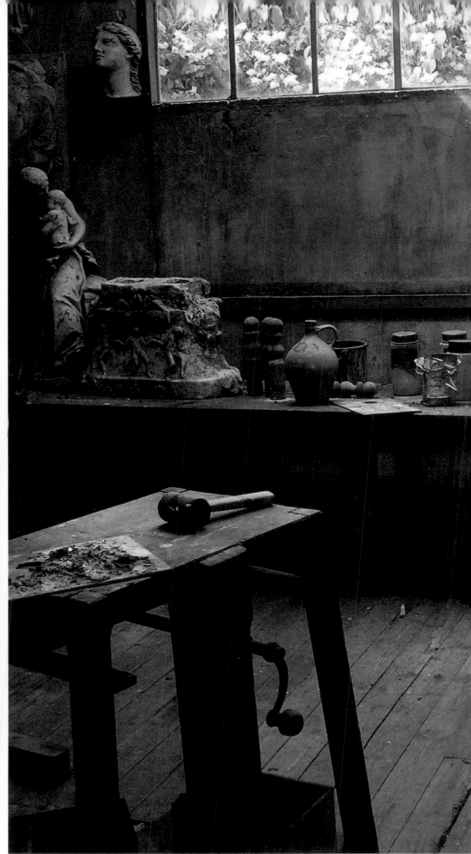

Above and right:
The Hôtel Baudy in Giverny had (and still has) a flair for attracting art-minded visitors from all over the world, and its charm remains today. Its romantic garden and the studio in it were used mainly by American artists, who enjoyed the free and easy lifestyle in Giverny—and many a time paid the bill with a painting or two.

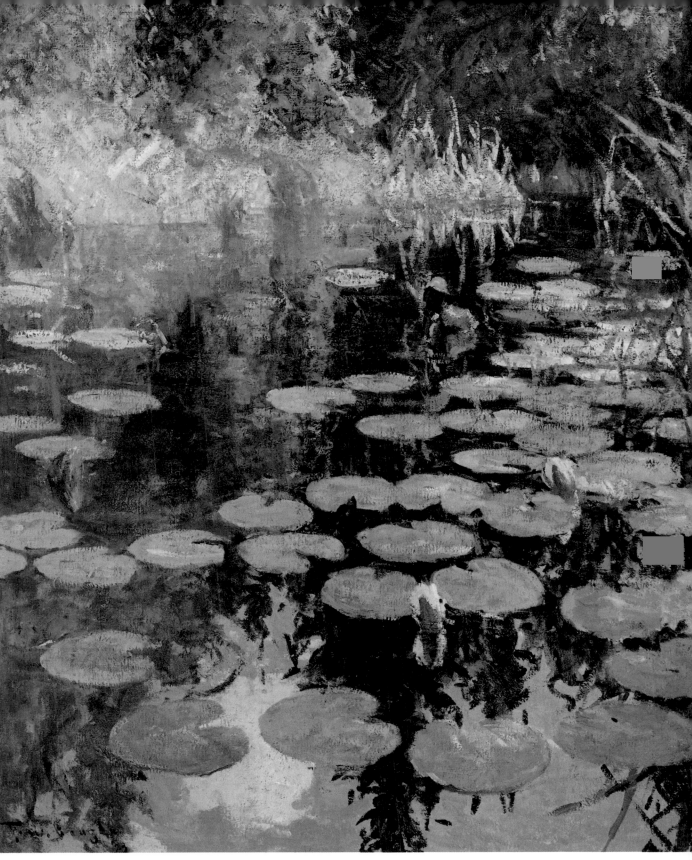

Above:
Frank W. Benson (1862–1951) went to Paris in 1883 and studied at the Académie Julien there for two years.
Only much later—from 1901—did he adopt an Impressionist style. He was also a founding member of the
'Ten American Painters'.
Frank W. Benson, *Water Lily Pool*, 1923. Orlando Museum of Art, FL

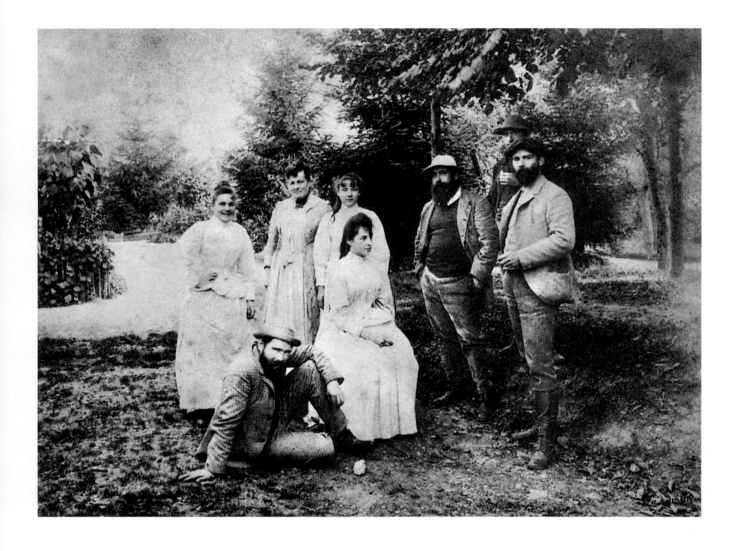

AS THERE ARE SO FEW CONVENTIONALITIES IN FRANCE, AN ARTIST CAN PAINT WHAT HE WISHES. I CAN PAINT A NUDE IN MY GARDEN OR DOWN BY THE FISH POND AND NOT BE RUN OUT OF THE TOWN.

Frederick Carl Frieseke

Above:
This group photograph shows foreign painters who were a part of the Monet family circle. In front sits John Leslie Breck (1860–1899), standing behind him are Blanche Hoschedé, Alice, Maine and Suzanne Hoschedé. Next to them on the right is Claude Monet and next to him the Canadian William Blair Bruce (1859–1906) and Henry Fitch Taylor (1853–1925).

132

Right:
Frederick Carl Frieseke (1874–1939) first came to Giverny in 1900 and from 1906 lived with his wife for a while in Le Hameau, the property immediately adjacent to Monet's garden.
Frederick Carl Frieseke, *Good Morning*, c. 1912–13. Butler Institute of American Art, Youngstown, OH

Following double-page spread:
Water Lilies at Sunset, 1915–26. Musée de L'Orangerie, Paris

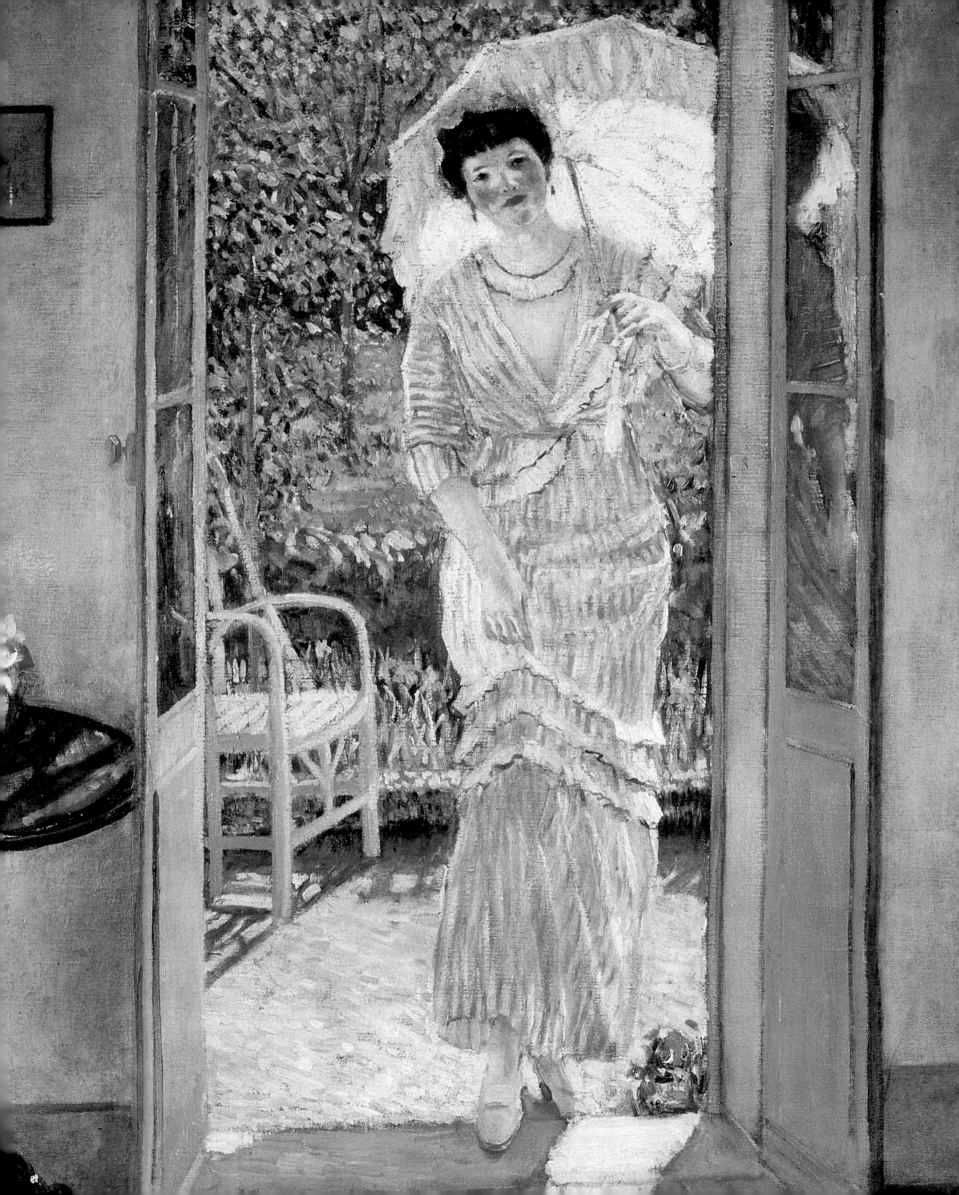

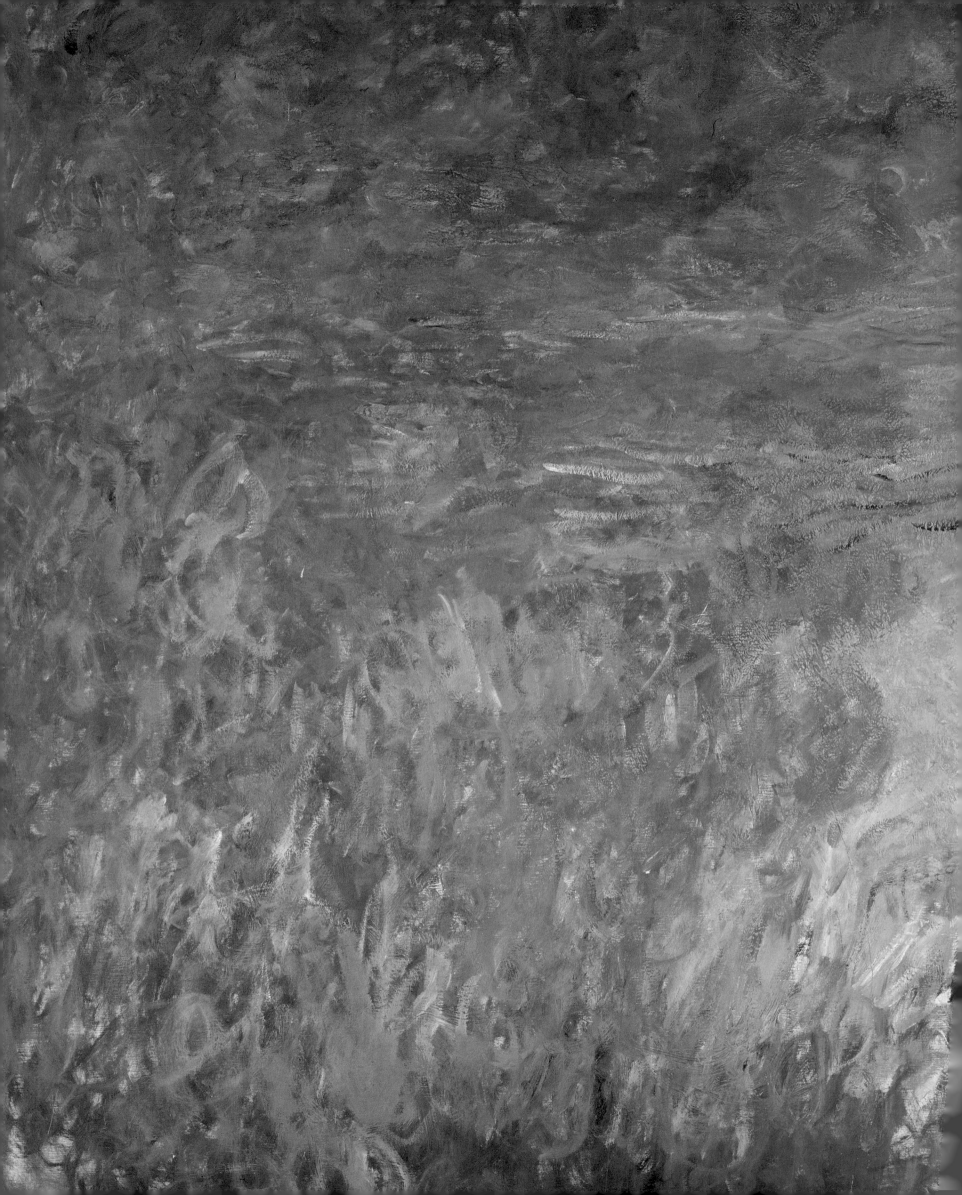

CLAUDE MONET'S BIOGRAPHY

1840

Claude Oscar Monet born in Paris on 14 November.

c. **1845**

The family moves to Le Havre, France, where Monet's father, Adolphe, is in the wholesale trade.

c. **1856**

Claude—then usually known as Oscar—earns pocket money doing caricatures, which he exhibits in the window of an art and frame dealer.

1857

His mother dies. His aunt Marie-Jeanne Lecadre takes an interest in him and is the only one in the family to support his ambition to be an artist.

1858

Monet's first teacher in Le Havre is landscape painter Eugène Boudin, who introduces him to open-air painting.

1860

Monet goes to the private Académie Suisse in Paris but rejects a standard academic training. He makes the acquaintance of painter Camille Pissarro.

1861

Military service in Algeria. When he falls ill with typhoid, he returns to Paris and leaves the army.

1862

Makes the acquaintance of painters Auguste Renoir, Alfred Sisley and Frédéric Bazille. He is strongly influenced by Dutch landscape painter Johan Barthold Jongkind.

1865

Two of his paintings are accepted by the Salon—the official art exhibition in Paris—for the first time after vetting by the customary strict jury procedure. He does a large painting of *Déjeuner sur l'Herbe* (The Picnic) in the woods of Fontainebleau.

1866

Makes the acquaintance of his model Camille Doncieux, who later becomes his wife. He has his first success at the Salon with a portrait of her (*Camille* or *The Woman in a Green Dress*).

1867

The Salon jury turns his submissions down. His first son Jean is born in August. His family presses him to leave Camille. When he refuses, all further financial assistance is cut off.

1868

He lives with Camille and Jean in great poverty in Bennecourt near Giverny.

1870

He marries Camille. When the Franco-Prussian War breaks out, they go into exile in London, where he makes the acquaintance of his future dealer Paul Durand-Ruel and admires the works of English landscape painters William Turner and John Constable.

1871

The Monets travel to Holland. Monet is impressed by the colours of the huge tulip fields in Zaandam. On their return to Paris, the Monets settle in Argenteuil.

1874

The first independent Impressionist exhibition takes place on the premises of photographer Nadar in Paris, and causes an uproar. Art critic Louis Leroy sneeringly calls the group 'Impressionists', after Monet's picture *Impression—Sunrise*. The Impressionist group includes (besides Monet) Renoir, Bazille, Pissarro, Sisley and Cézanne. Despite the persistent hostility of the critics, they put on seven further exhibitions up to 1886.

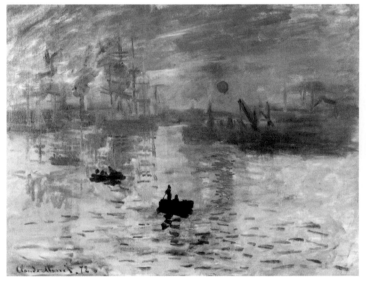

Impressionism was named after this picture. *Impression—Soleil levant* (Impression—Sunrise), 1873, Musée Marmottan, Paris

1876

Second Impressionist exhibition. Monet makes the acquaintance of Ernst Hoschedé and his wife Alice, and paints the park of their Château Montgeron.

1877

Third Impressionist exhibition. Sales are poor, leaving the Monets in dire financial difficulties.

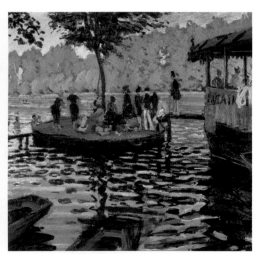

The colours in Monet's paintings begin to dissolve. *La Grenouillère,* detail, 1869, Metropolitan Museum of Art, New York
H. O. Have-meyer Collection, Bequest of Mrs H. O. Havemeyer, 1929

Monet's fascination for the achievements of modern technology is combined here with Impressionist techniques. *The Gare Saint-Lazare: Arrival of a Train*, 1877 Fogg Art Museum, Harvard University Art Museums, Cambridge (MA) Bequest from the Collection of Maurice Wertheim, Class of 1906

1878

They move to Paris, where their second son Michel is born. Camille is by now seriously ill. The Monets move to Vétheuil, setting up a joint household with the now impoverished Alice Hoschedé and her six children following the bankruptcy of her husband.

1879

Camille dies. Monet's morale hits rock bottom.

1880

Fifth Impressionist exhibition, but Monet does not take part, instead having his first solo show in the rooms of publisher Georges Carpentier.

From 1880, Monet did a number of now famous paintings of the coast of Brittany.
The Stacks at Port Coton, Rough Sea, 1886, Pushkin Museum, Moscow

1881

He skips the sixth Impressionist exhibition as well. He moves to Poissy with Alice and all his eight children.

1882

He takes part in the seventh Impressionist exhibition, and is successful with his views of Vétheuil and Fécamp on the coast of Normandy.

1883

Paints in Le Havre and Etretat, and has a solo show at Durand-Ruel's, for whose home he also does a series of wall panels with flower motifs. In April, the family settles in Giverny.
Monet and Renoir travel to the Riviera together.

1884

Monet makes the acquaintance of Octave Mirbeau.

1885

He becomes friends with writer Guy de Maupassant.

1886

The Impressionists regularly meet in the Café Riche. Emile Zola's novel *The Masterpiece* contains allusions to the Impressionists that annoy both Monet and Cézanne considerably. The first exhibition of works by the group put on by Durand-Ruel in New York is a great success. Monet also takes part in the eighth and last Impressionist exhibition. He makes the acquaintance of poet Stéphane Mallarmé and his own later biographer Gustave Geffroy.

1887

Successful exhibition of paintings from Brittany at the Galerie Georges Petit.

1888

Travels to Antibes and London.

1889

Solo exhibitions in Paris and London. A major retrospective jointly with sculptor Auguste Rodin marks Monet's artistic breakthrough in Europe.

1890

Monet buys the house in Giverny. He does the *Haystack* series.

1891

The *Haystack* series is successfully exhibited at Durand-Ruel's. He begins work on the poplar tree series, exhibiting them the following year likewise with great success. He travels to London and visits James Whistler. Ernest Hoschedé dies.

Monet painted the famous poplar pictures near Giverny.
Poplars on the Banks of the River Epte, 1891, privately owned

1892

Monet marries Alice Hoschedé and her daughter Suzanne Hoschedé marries the American painter Théodore Butler. Monet begins the major Rouen Cathedral series (completed 1894).

Monet did several paintings of the façade of Rouen Cathedral in different lighting conditions. *The West Doorway Seen from the Front*, 1894, Musée d'Orsay, Paris, and *The Cathedral of Rouen*, 1893, Narodni Muzej, Belgrade

137

1893

He buys an adjacent plot in Giverny and lays out his water garden.

1894

American painter Mary Cassatt and Paul Cézanne visit Monet in Giverny.

1895

Monet and stepson travel to Norway. He builds the Japanese bridge in Giverny.

1897

Monet's son Jean marries Blanche Hoschedé.

1899

Suzanne Butler-Hoschedé dies. Monet travels to London.

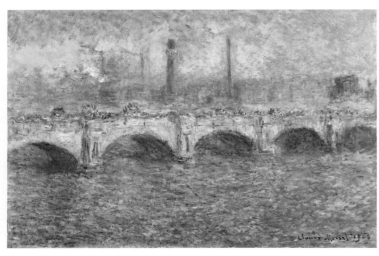

In visits to the city of London Monet painted a series of well-known views. *Waterloo Bridge, Sunlight Effect*, 1899–1901 (dated 1903). Private collection

1900

Trip to London. Monet puts on his first show of water garden pictures in a solo show at Durand-Ruel's.

1901

Trip to London. Rebuilding and enlargement of the water garden.

1902

Solo exhibition at Durand-Ruel's in New York.

1904

A solo show of London pictures at Durand-Ruel's is very successful. Monet takes Alice to Madrid and visits London again.

1908

First symptoms of cataracts. Monet and Alice travel to Venice.

1909

Alice seriously ill. A planned second trip to Venice has to be put off.

1910

Major floods cause extensive damage to his water garden, requiring substantial renovation work.

1911

Alice dies.

1914

His son Jean dies. Henceforth, Blanche Hoschedé tends to her stepfather's home in Giverny. Major retrospective at Durand-Ruel.

1915

Construction of the third studio in Giverny for the huge water lily *Décorations*.

1917

Paints on the coast of Normandy.

1918

Plans to make a donation of paintings to the French state to mark the end of World War I. Clemenceau suggests he give a more substantial donation than intended.

1919

Increasingly serious problems of vision due to cataracts.

1920

Plans for converting the Hôtel Biron to take Monet's water lily pictures fails on cost grounds.

1921

Agreement reached to house the *Grandes Décorations* at the Orangery of the Tuileries in Paris, which is to be rebuilt especially for the purpose. Retrospective at the Galerie Bernheim-Jeune.

1922

The document making over the *Grandes Décorations* series to the state is signed. Gustave Geffroy's biography of Monet is published. Because of his eyesight problems Monet can hardly work, and fears he will not be able to finish his magnum opus.

1923

Operation on his right eye. Following this, Monet initially has problems with his perception of colour. He resumes work on the *Grandes Décorations*.

1924

Retrospective at the Galerie Georges Petit. New glasses improve his vision only briefly. He falls into a profound depression.

1926

Sclerosis of the lungs. Monet dies on 5 December.

1927

The *Grandes Décorations* are officially opened at the Orangery in Paris on 17 May.

Palazzo Contarini del Zaffo,
Venice, 1908,
Kunstmuseum St. Gallen,
Switzerland

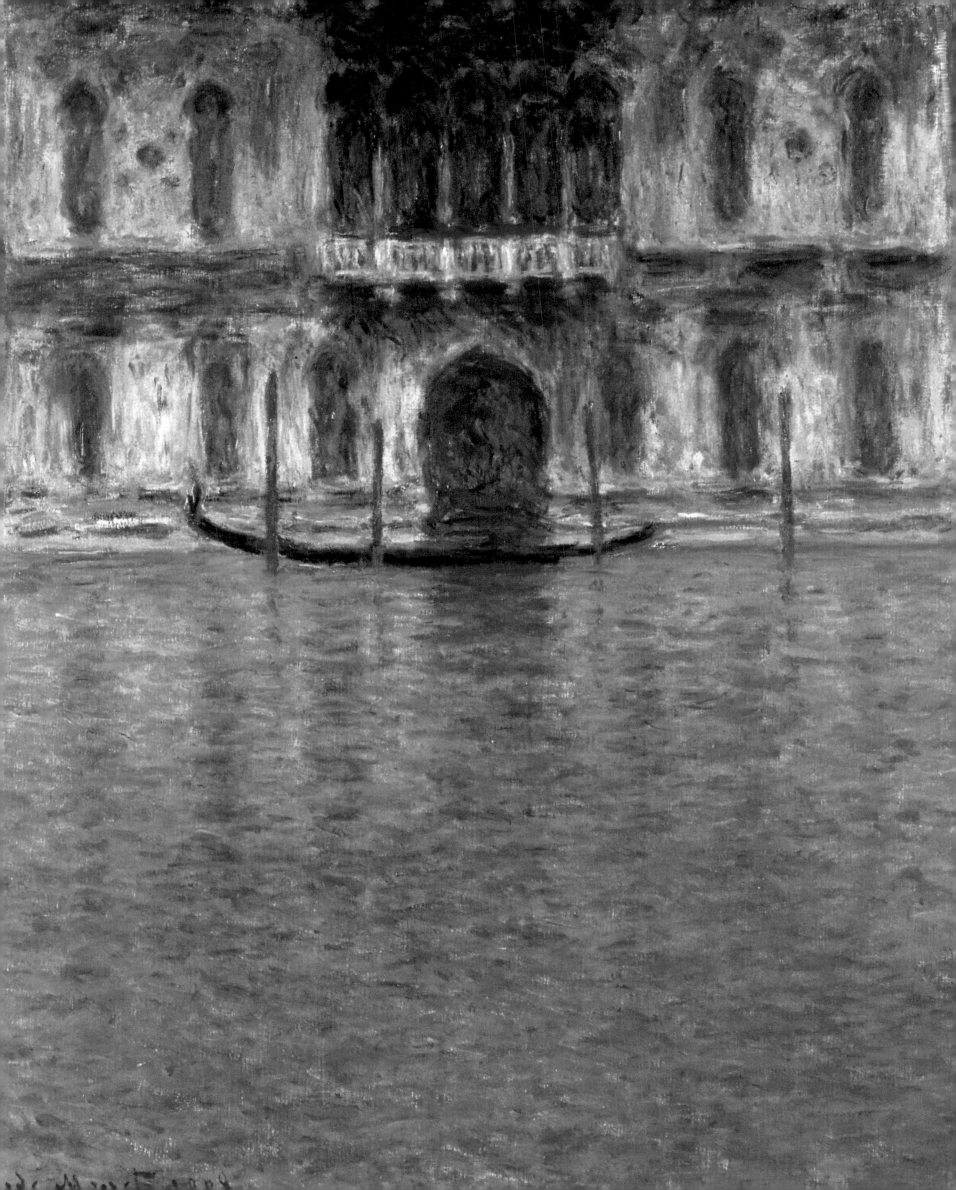

ON THE TRAIL OF CLAUDE MONET

Visiting Giverny

The village of Giverny is near Vernon, not far from Paris, and can be reached by train from the Gare St Lazare in Paris in about an hour, changing in Vernon for the bus to Giverny. Travellers coming by car will find adequate parking space in Giverny.

The property with the painter's house and garden is now a museum. The Musée Claude Monet attracts around half a million visitors from all over the world to Giverny. It is open every day from 9:30 am to 6 pm from April to November.

The tomb of the painter and his family can be seen in the cemetery beside the old church in Giverny.

Even in Monet's lifetime many American Impressionists made the pilgrimage to Giverny, and works by them are on show in the Musée d'Art Américain in Giverny. This also has a fine garden, where among other things painting courses are organised.

The Hôtel Baudy and its romantic rose garden with benches, walls, pavilions and a picturesque studio also make an interesting visit. Entrance is free and the food is good. It is worth having something to eat there if only to enjoy the atmosphere of a place where so many artists used to meet up.

After all the tourist buses have left in the evening, Giverny relapses into a sleepy village. Few outsiders spend the night in the small hotel or one of the private houses offering bed and breakfast.

For further information, visit www.giverny.org.

The plaque to Claude Monet on the family grave in Giverny.

Museums in Paris

Major works by Claude Monet are now in museums in Paris.

The Musée Marmottan Monet has not only the painter's glasses and palette but also a substantial collection of paintings by him, some of which were left to the museum by Monet's son Michel. They are on show on the lower floor of the historic building. The museum is at no. 2, Rue Louis-Boilly. Take metro Line 9 to Muette station. Open daily except Mondays from 10 am to 6 pm. Information: www.marmottan.com.

The *Musée d'Orsay* with its famous Impressionist collection, and many of the most important paintings by Monet, is at no. 1, Rue de la Légion d'Honneur. Catch metro Line 12 to Solférino. Open daily except Mondays from 9:30 am to 6 pm, Thursdays to 9:45 pm. There is generally a long queue to get in. Information: www.musee-orsay.fr.

The water lily rooms at the *Musée de l'Orangerie* can be visited, except Tuesdays, from 9 am to 6 pm in the Jardin des Tuileries off Place de la Concorde. Take metro Lines 1, 8 or 12 to Concorde. Information: www.musee-orangerie.fr

The village of Giverny still attracts many painters.

The Musée d'Art Américain in Giverny likewise has a wonderfully mature garden. It is divided into individual areas with colour themes.

141

FURTHER READING

On Monet the artist:
Gustave Geffroy, *Claude Monet, His Life, His Times, His Works*, Paris 1922. This was Monet's first biography, which appeared in his lifetime.

Georges Clemenceau, *Claude Monet, The Water Lilies*, New York 1930. A very personal book of the painter and his art by his close friend.

Karin Sagner-Düchting's book *Monet in Giverny* focuses on the artistic development of the painter during his years in Giverny. Munich, London, New York 1994

Daniel Wildenstein, *Monet, or the Triumph of Impressionism*, Cologne 1996. The first volume of a four-volume catalogue of works. Vols. II to IV contain the *catalogue raisonné*, with illustrations of (almost) all paintings by Monet. The reference book for anyone closely involved in Monet's works.

Christoph Becker (ed.), *Monet's Garden*, exhib. cat., Kunsthaus Zurich, 29 October – 27 February 2005, with comprehensive documentation and numerous source quotes.

On the garden and its plants:
A colourful, photographic tribute to the gardens celebrated in Monet's paintings is *The Gardens at Giverny, A View of Monet's World* by Gerald van der Kemp et al, with photos commissioned from Stephen Shore by MoMA in 1977, New York 1985.

Elizabeth Murray, *Monet's Passion. Ideas, Inspiration and Insights from the Painter's Garden*, San Francisco 1989. Contains suggestions for flowerbeds on the model of Giverny and brief information on individual plants.

Vivian Russell, *Monet's Garden. Through the Seasons at Giverny*, New York 1996. The American author is a great connoisseur of the garden and plants in Giverny.

A particularly fine book about the painter and his garden in Giverny is by garden historian Caroline Holmes, *Monet in Giverny*, London 2002.

The colour schemes in the garden at Giverny are the subject of Vivian Russell's *Planting Schemes from Monet's Garden*, London 2003.

About life in Giverny:
Claire Joyes, *Claude Monet. Life at Giverny*, London 1985. The wife of a great-grandson of Alice Monet, Claire Joyes describes life in Giverny.

Claire Joyes and Jean-Bernard Naudin, *Monet's Cookery Notebooks*, London 1993. An amusing and entertaining cookbook with numerous original recipes from the Monet household's *carnets de cuisine*.

Heide Michels, *Monet's House*, London 1997. A picture book about the artist's house in Giverny, with wonderful photos by Guy Bouchet.

For children:
A book very popular with children is *Linnea in Monet's Garden* by Christina Björk and Lena Anderson, Stockholm 1987.

An introduction to the painter is *Claude Monet—the Magician of Colour*, by Stephan Koja, Munich 1995 (*Adventures in Art* series).

The recipes on pages 116–120 were selected from the book *Monet's Table: The Cooking Journals of Claude Monet* written by Claire Joyes, photographs by Jean-Bernard Naudin, Simon and Schuster 1990; at times, slightly modified by the author.

Index of quotes
p. 7: Claude Monet in a conversation with Hermann Bang, published in *Bergens Tiede*, 1895 (Holmes 2002); p. 9: Armand Silvestre in a critical essay on the first Impressionist exhibition 1874 (Wildenstein 1996, vol. 1); p. 29: Claude Monet (Becker 2005); p. 32: Claude Monet in a conversation with Hermann Bang, published in *Bergens Tiede*, 1895 (Holmes 2002); p. 34: Georges Clemenceau (1930); p. 38: Georges Truffaut quoted in *Jardinage*, no. 87, 1924 (Becker 2005); p. 43: J.C.N. Forestier in *Fermes et châteaux*, 1908 (Wildenstein 1996, vol. 4); p. 53: Georges Truffaut in *Jardinage*, no. 87, 1924; p. 54: Georges Clemenceau (1930); p. 61: René Gimpel, 1918 (Becker 2005); p. 64: Claude Monet in a letter to Georges Clemenceau, 1922 (Holmes 2002); p. 69: Claude Monet (Russell 1996); p. 74: Georges Clemenceau (1930); p. 78: Alice Kuhn quoted in *La femme d'aujourd'hui*, 1912 (Russell 1996); p. 84: Marcel Proust quoted in *Le Figaro*, 15 June 1907 ; p. 94: Georges Clemenceau (1930); p. 96: Georges Truffaut quoted in *Jardinage*, no. 87, 1924 (Russel 1996); p. 100: Georges Truffaut quoted in *Jardinage*, no. 87, 1924 (Russel 1996); p. 105: Jean-Pierre Hoschedé, *Claude Monet: ce mal connu*, Geneva 1960; p. 109: Gustave Geffroy, *Monet: Sa vie, son temps, son oeuvre*, 1924 (Holmes 2002); p. 114: Gustave Geffroy (Michels 1997); p. 132: Frederick Carl Frieseke quoted in *The New York Times*, 7 June 1914

Photo credits
The pictures in this book were graciously made available by the museums and collections mentioned below each image, have been taken from the Publisher's archive, or are from the author's archive.
Bridgeman Art Library: Endpapers and pages 1, 30–31, 37, 39, 44–45, 56–57, 60–61, 94 top, 106–107, 122, 125 right, 133, 134–135, 144
Doris Kutschbach: pages 32, 35 bottom, 37 right, 38, 40–41 bottom, 42, 70 bottom, 71 top, 72 top, 73, 75, 76, 78, 79 left, 82 left, 83–87, 90 top, 92 right, 94 bottom and right, 96 right, 97, 98 top, 100 top and bottom, 104 left, 105 right, 106–107 top, 110, 118, 130, 131 left bottom, 140–141
Artothek Weilheim: pages 8, 10–11, 12–13, 18–19, 20–21, 33, 36, 48, 55, 74, 77, 101, 121
The Metropolitan Museum of Art, New York: pages 16, 19, 24
Photography © The Art Institute of Chicago: pages 16–17
© Board of Trustees, National Gallery of Art, Washington: Pages 22–23, 91
© Baback Haschemi, haschemi® edition cologne: pages 34 top, 70 top, 71 bottom right, 88–89, 90 bottom
© 2006 Photo SCALA, Florence: pages 47 top, 51
Guy Bouchet: pages 108, 111, 112, 113, 115, 117
gettyimages®: top cover

Water Lily Pond (The Clouds), 1902. Private collection Endpapers (front and back): Claude Monet: *Waterlilies—Morning with Weeping Willows*, detail of the left section, 1915–26, Musee de l'Orangerie, Paris
Claude Monet: *Waterlilies—Morning with Weeping Willows*, detail of the central section, 1915–26, Paris, Musée de l'Orangerie
Contents page: Claude Monet : *Roses*, 1925–26. Musée Marmottan, Paris

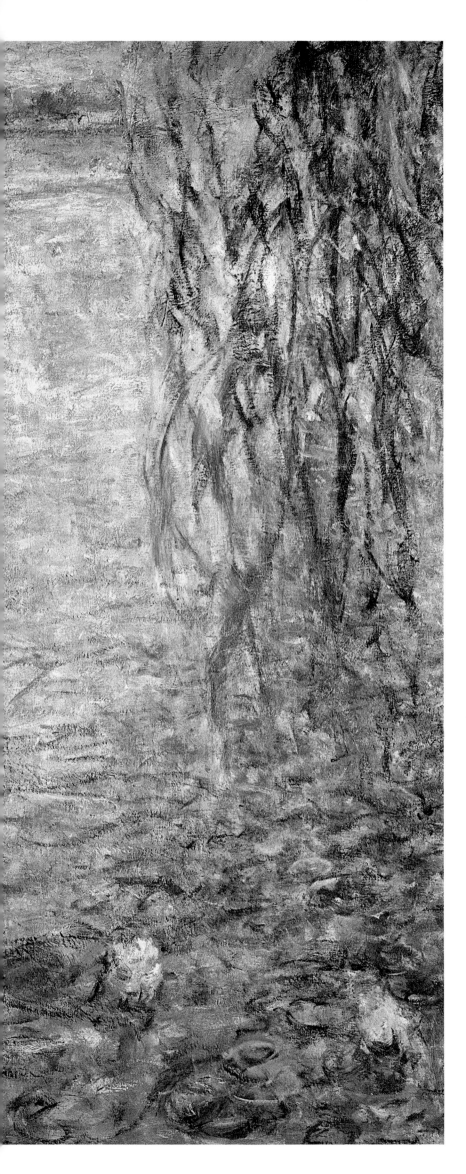

© Prestel Verlag
Munich · London · New York 2012
First published in 2006

Prestel Verlag Munich
A member of Verlagsgruppe Random House GmbH
Prestel Verlag
Neumarkter Strasse 28
81673 Munich
Germany
Tel. +49 (0) 89 41 36 0
Fax +49 (0) 89 41 36 23 35
www.prestel.de

Prestel Publishing Ltd.
4, Bloomsbury Place, London WC1A 2QA
Tel. +44 (20) 73 23-50 04
Fax +44 (20) 76 36-80 04

Prestel Publishing
900 Broadway, Suite 603
New York, N. Y. 10003
Tel. +1 (212) 995-27 20
Fax +1 (212) 995-27 33
www.prestel.com

Library of Congress Control Number: 2011940183

British Library Cataloguing-in-Publication Data
A catalogue record for this book is available from
the British Library.

The Deutsche Bibliothek holds a record of this publication in the
Deutsche Nationalbibliografie; detailed bibliographical data can be found
under: http://dnb.ddb.de

Prestel books are available worldwide. Please contact your nearest book-
seller or one of the above addresses
for information concerning your local distributor.

Translated from the German by Paul Aston
Editorial direction by Claudia Stäuble
Copy-edited by Curt Holtz and Reegan Finger
Cover and layout concept by LIQUID
www.liquid.ag
Design and production by Cilly Klotz
Typset by Setzerei Vornehm GmbH, Munich
Origination by Repro Ludwig, Zell am See
Printed and bound by Mohn media, Gütersloh

Verlagsgruppe Random House FSC-DEU-0100
The FSC-certified paper Hello Fat Matt 1,1 has been supplied by Condat,
Le Lardin Saint-Lazare, France.

Printed in Germany

ISBN 978-3-7913-4695-3

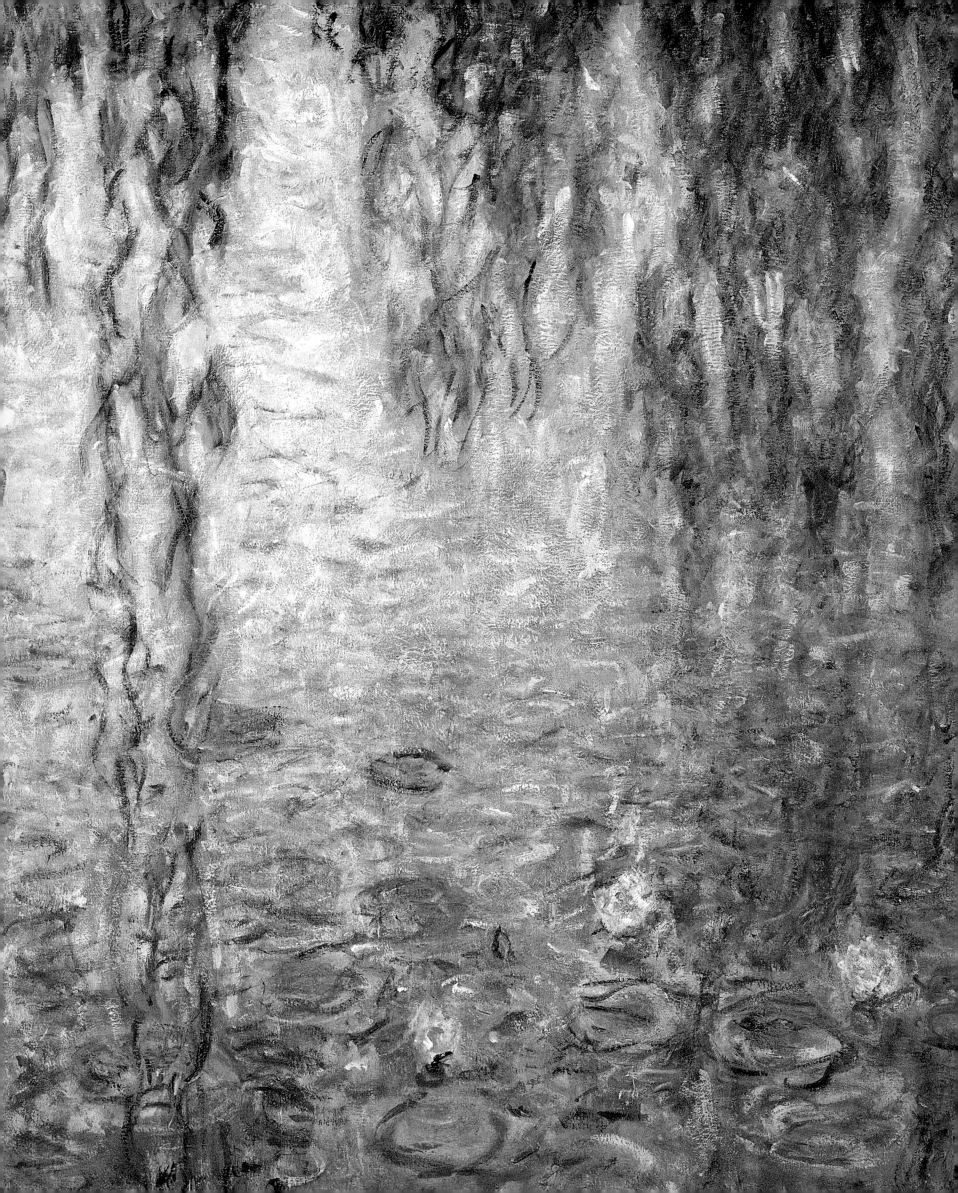

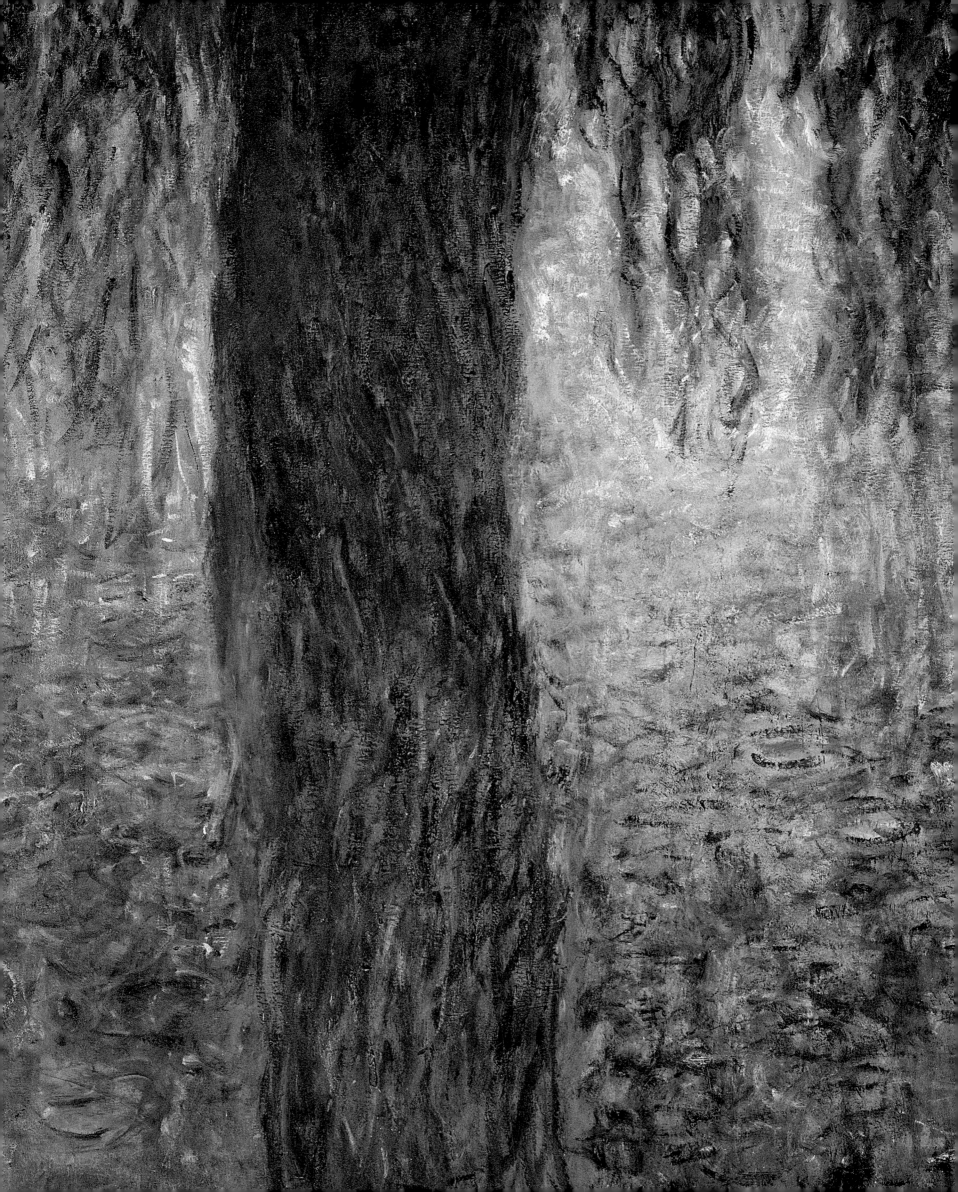

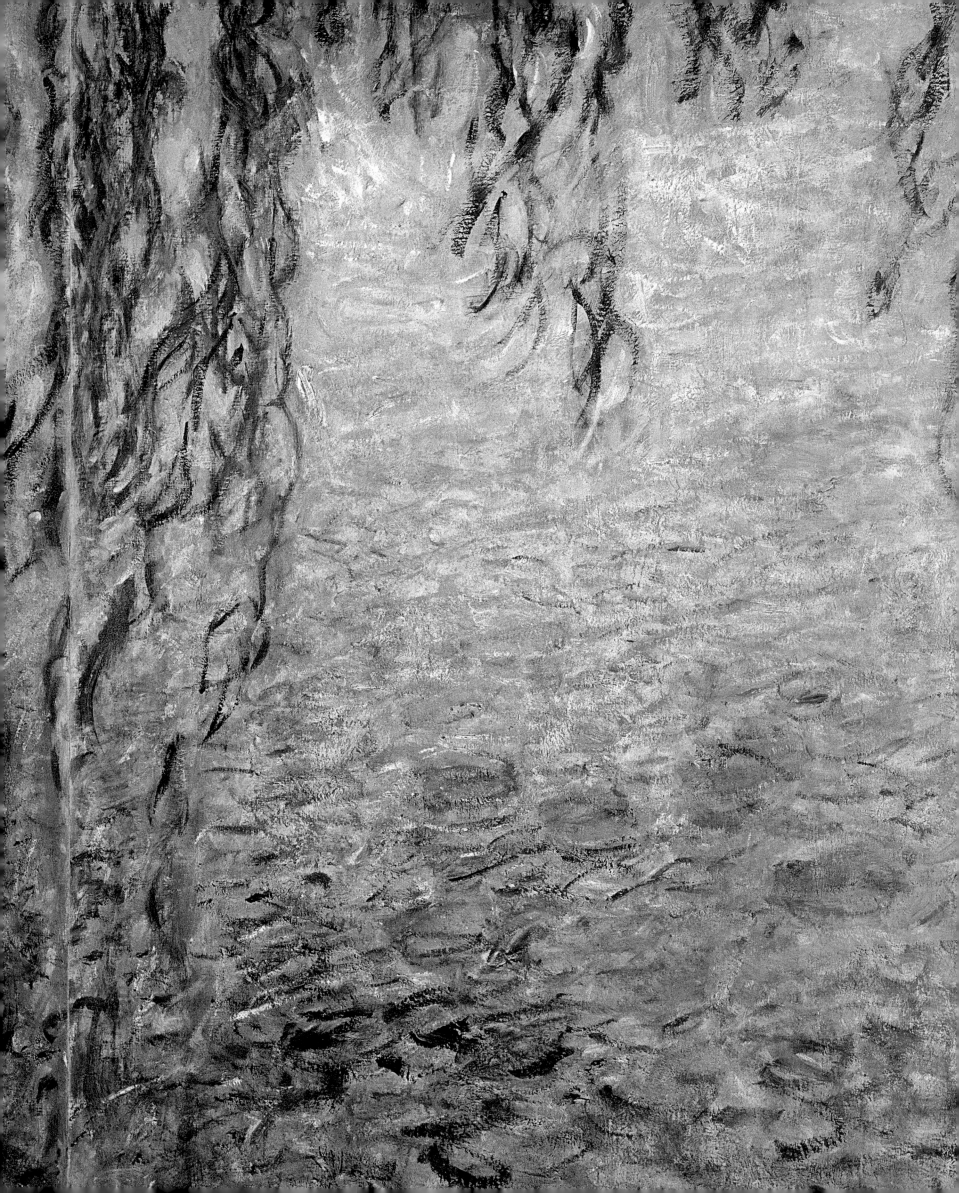